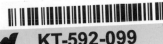
BLACK AFRICA

MASKS

SCULPTURE

JEWELRY

**LAURE
MEYER**

TERRAIL

Cover illustration

Large dance mask with curved horns.
Gabon. Kwele. Painted wood. H: 42 cm, L: 62 cm. Musée Barbier-Mueller, Geneva.

Previous page

Wooden Akua ba doll.
Ghana. Akan. Wood, painted or stained black. H: 44.5 cm. Musée Barbier-Mueller, Geneva.

Right

Male statuette.
Mali. Segou region. Terracotta. H:44.3 cm, Musée Barbier-Mueller, Geneva.

Editors: Jean-Claude Dubost and Jean-François Gonthier
Art Director: Bernard Girodroux
Translation: Helen McPhail in association
with First Edition Translations Ltd, Cambridge, UK
Filmsetting: Compo Rive Gauche, Paris
Lithography: Litho Services T. Zamboni, Verona

© FINEST S.A./EDITIONS PIERRE TERRAIL, PARIS 1992
ISBN: 2-87939-035-4
Printed in Italy

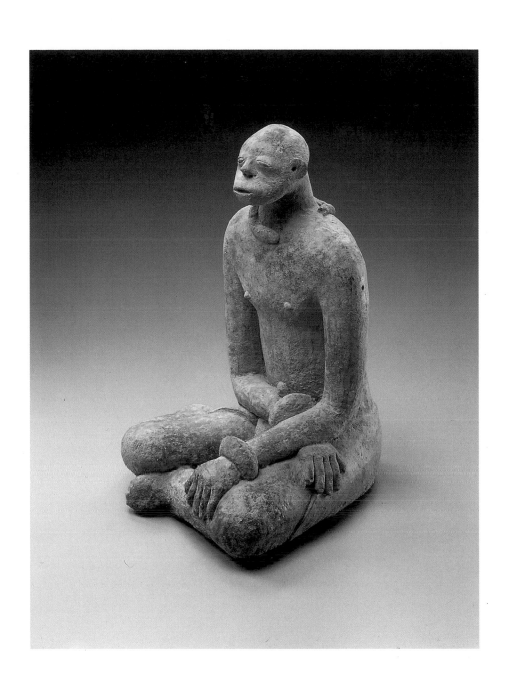

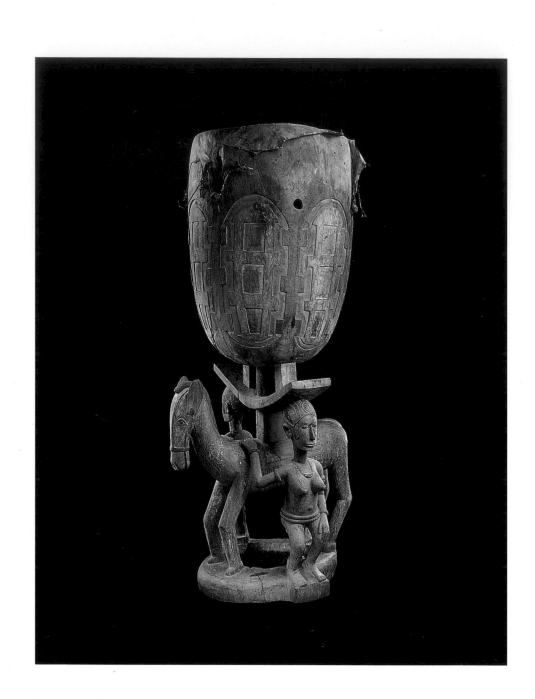

Contents

Left
Drum.
Guinea Baga. Hardwood
and skin. Polychrome,
partly worn away, red,
white, blue, black. H: 172
cm. Musée Barbier-Mueller,
Geneva.

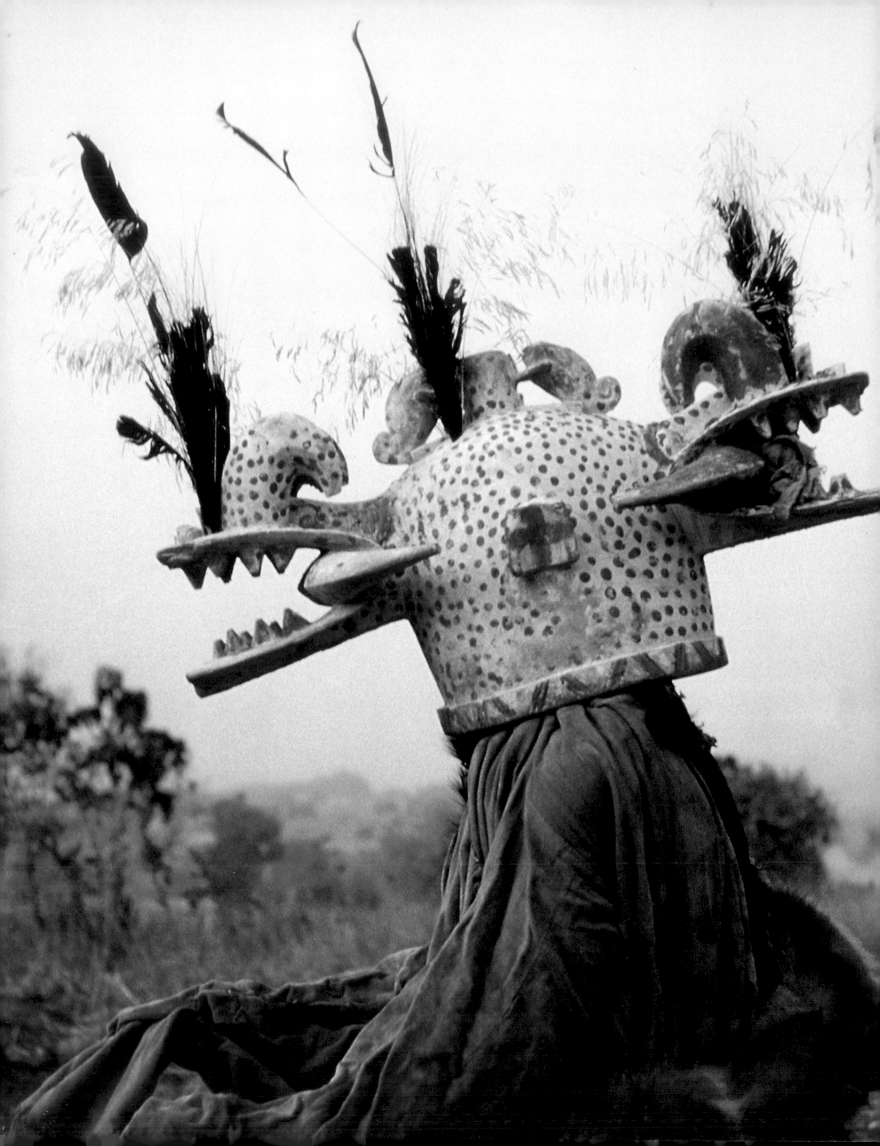

Introduction

The preparation of a book on the arts of Black Africa inevitably poses a delicate question of balance between ethnology and aesthetics, two equally essential elements.

An exclusively aesthetic approach to African arts would exclude much of their significance and the full range of their humanity, just as Europeans ignorant of the Bible's full narrative richness would lose much of the value and beauty of the tympanum of a Norman cathedral or a Renaissance *Descent from the Cross*. In Black Africa too, in order to experience the full beauty of a work we must understand its origins and its aims, its mythic sense for the African who created it and for those who experienced it. Without that understanding, the work is greatly diminished.

Although artists from the early 20th century - the Fauves, the Cubists, Matisse, Vlaminck, Picasso and Juan Gris - were the first to appreciate the beauty and interest of certain "Negro Art" statuettes, without previous ethnological knowledge, how can we be sure that their view of such works was comprehensive? Surely they were primarily seeking the solution to certain problems of dealing with form. And, conversely, would notions of ethnology have hindered their appreciation? Would not such knowledge have given them more direct access to the work in its deepest essentials and its totality?

Left

Wambele dance mask.
Northern Ivory Coast.
Senufo region. Barbier-
Mueller Archives, Geneva.

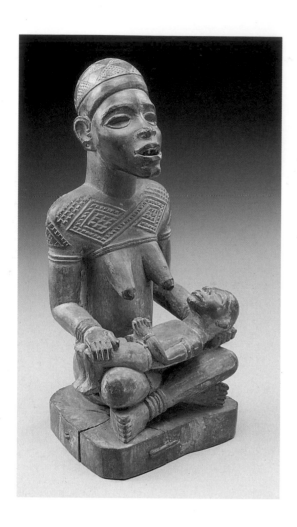

The opposite approach - stressing ethnological factors at the expense of aesthetics - leads to an equally diminished understanding of a creation, reducing it to the level of an object even though it may have a religious purpose. What justification can there be for denying values of beauty in sculptures created on African soil? Should the canons of European classical art be the only valid standards? Certain African works of art must be acknowledged for their value to all humanity's artistic heritage, on equal terms with other masterpieces which have enjoyed longer fame.

The purpose of this book is therefore to provide some basic principles of ethnology, in order to offer the non-specialist reader a potentially greater depth of feeling for the beauty, power, delicacy or fearsome nature of certain aspects of African art.

The works of art are not shown by geographical location, which has frequently and very successfully been done. They are evoked through different themes, providing guidelines for consideration of specific traits of African cultures. Art appears here as the final destination, the perfect realisation of a certain moment in life. Each theme is independent and should offer a better grasp of the specifically African approach.

A full appreciation of African art requires a deliberate effort from the European observer, a rejection of accustomed styles of reasoning and a determination to see the work of art through the eyes of the artist who created or used it. This is particularly important with the most dangerous concept of all, that of "art".

In fact, it should be clear that the European concept of "art" is alien to traditional African thought. "Art for art's sake" was extremely rare in Africa, as it was in mediaeval art. This did not prevent the flowering of beauty in Africa in many domains, even if not under the heading of "art", and for purposes different from those of western art.

We may therefore seek an equivalent of the western understanding of art in African thinking. How does an African feel and express beauty in an object? Susan Vogel, Director of the New York Centre for African Art, attempted to reply to this question in *Aesthetics of African Art*. Condensing the results of research carried out among

various ethnic groups, and many African languages, she considers that the concepts of "beauty" and "good" overlap to a large extent and cannot be disentangled. In many cases the same word means both "beautiful" and "good". To an African this may be the equivalent of "well made" or "pleasing to look at", i.e. conforming to moral precepts, useful and well suited to its purpose, functional, conforming to tradition. In earlier times, classical Greece experienced similar overlaps.

Figures created with this intention generally have a religious aim: to reanimate fundamental myths, to perpetuate ancestral memory or to work productively on supernatural forces or emanations from the spirit world. Beneath the material appearance of the work of art, beyond its aesthetic appeal, we should be aware that there is almost always a philosophical dimension: the object forms part of a ritual or a principle of life.

In Africa certain sectors of art are also dedicated to the ruler's glory. The important royal courts inspired a splendid body of works deliberately created to enhance the prestige of the sovereign; but ultimately this remains an art founded on religion, because the king is believed to be divine.

This religious art has many implications in the areas of morality and sociology. Using masks, it offers an assurance of social cohesion and hierarchy, respect for accepted laws and repression of unacceptable behaviour.

This very particular orientation of the arts in Africa means that the human figure is the most frequently represented image, the simplest way of representing the supernatural in earthly form. Animals are present only to the extent that they complete, modify or characterise human behaviour. Landscape and plant life are virtually unknown.

The African artist always worked to a commission from the ruler, the officiating priest of a cult, a soothsayer, or the members of a secret society. He was not permitted to follow a wholly free and unfettered "inspiration": he worked within the framework of traditional norms and programmes, but this framework always allowed for variety for important creations.

The geographical range is equally great. Only a very superficial view could lead to references to a single body

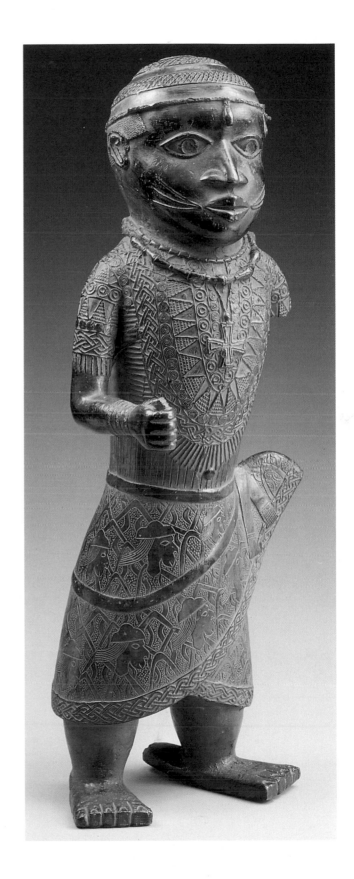

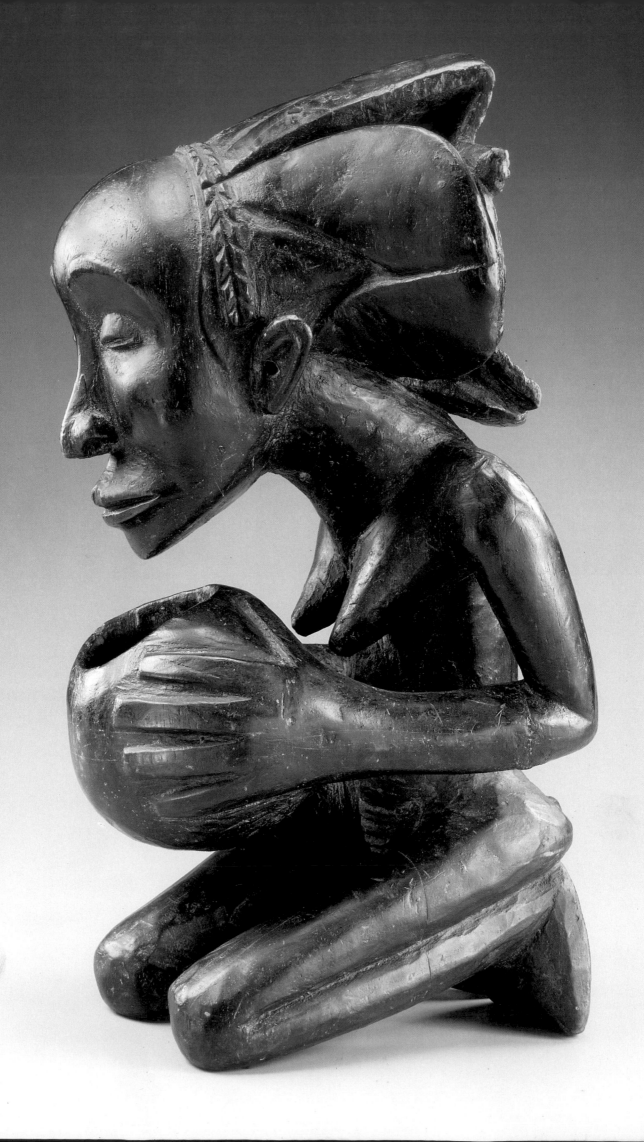

of African art, identifiable by certain immutable characteristics - in fact every region of Africa has given birth to art forms unique to that region, derived from its own particular history and representing at any given moment a visible expression of trends and the collective cultural psyche.

In every tribe plastic creativity is apparent in all daily activity, far exceeding the traditional areas of statues and masks and including decorated and carved objects, musical instruments, weapons - not forgetting body-art, hair arrangement and scarification. The ethnological "style" is indeed the expression of a particular view of the world, unspoken, unconscious and spontaneous, resulting in the creation of an all-encompassing experience which was lived, understood, appreciated or feared by all members of the tribe.

It should also be noted that, even when limiting consideration to the nations of Africa, not all have been equally creative. When surveying their productions in the plastic arts, we turn most frequently to the peoples of western and central Africa, north and south of the Equator from Senegal to Zaire and Angola, although other populations are not wholly excluded. Greater awareness of their cultures may enable us to appreciate their work better in future.

Unfortunately we can only look here at African work dating from before the middle of the 20th century. Political and social upheavals occurring from that time onwards have led to new ways of life which will require further research before they can be fully understood.

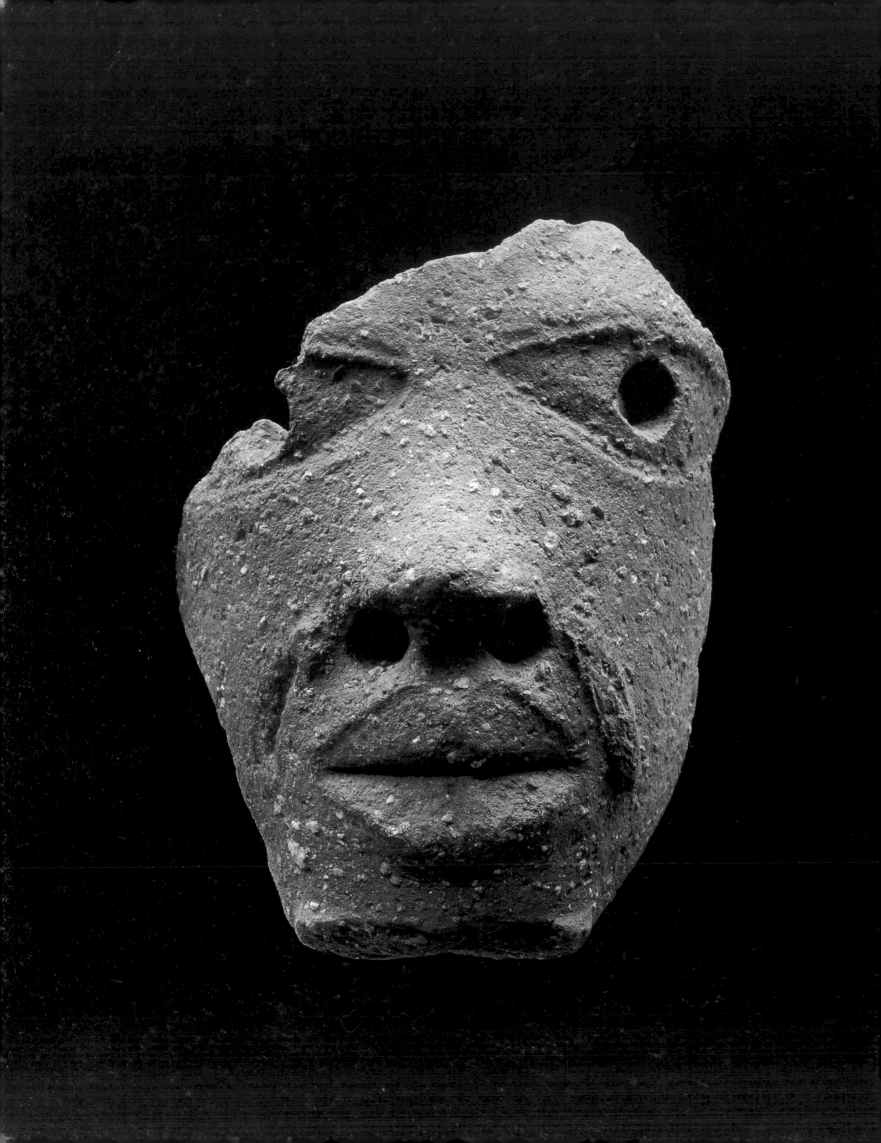

Terracotta,
a survivor from
the hidden past

Africa's earliest history is written in terracotta: the oldest known figurines were modelled in clay. Their great age - up to two thousand years in some cases - is the result of the material's lack of importance; metals stirred the greed of metal-casters who melted down metal objects for use in fresh castings, and wood was prey to termites. Terracotta, with its negligible value, was rarely re-used.

It had the further great advantage that it could be moulded with bare hands and without tools. Firing bene-fited from the age-old skill of making utilitarian pottery. Certain pieces were dried in the sun, others baked in the ashes of an open hearth at about 300° Centigrade, while still others were subjected to even higher temperatures to produce a stronger material.

Discoveries at Nok

As far as we know at the present time, the clay figurines discovered near the village of Nok in central Nigeria can be dated between approximately 500 BC and 500 AD by thermoluminescent testing.

They were discovered by chance in a tin mine in 1943. An employee at work found a clay head (fig.1), which he

15

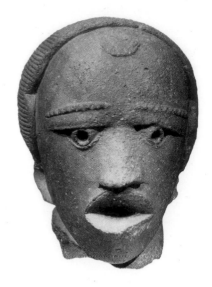

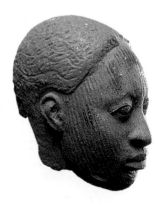

took home to make a scarecrow, a role which it played to perfection for a year, in a field of yams! However, it was noticed by the manager of the mine who bought it and took it to the town of Jos. He showed it to a trainee civil administrator, Bernard Fagg who was also an archaeologist. He immediately appreciated its significance and asked all the miners to inform him of any fresh discoveries, thereby acquiring more than 150 items. The subsequent diggings directed by Bernard and Angela Fagg proved particularly fruitful because the discoveries, spread over a very large area, extended significantly beyond the initial site, but since archaeologists tend to name a style after the site where the first important object is found, these works are still described as "Nok style".

The craftsmen working in and around Nok used the same material for their modelled figurines as for their utilitarian pottery, a coarse-grained clay. Some statues are as tall as 1.20m, indicating excellent mastery of modelling techniques and open-air firing. Because many statues are hollow, the sculptor has taken care to maintain a uniform thickness for the whole piece, and to avoid parts which might burst during firing.

Such technical competence, like the stylistic mastery shown in these works, indicates that Nok art may be the end-point of an already well established artistic tradition. There are no traces of fumbling or trials; the style's characteristics are already precise. The size of the eyes is the first element to attract attention, sometimes formed as a section of a circle and sometimes as a triangle below the arc of the eyebrow counterbalancing the curve of the lower eyelid. The pupil of the eye is deeply incised, as are the nostrils, the ears and, where appropriate, the mouth which has large thick lips, the upper lip sometimes reaching almost to the base of the nose (fig.2). The ears may sometimes be placed very far back. The overall expression is extremely vivid, enhanced by the very detailed hairstyle which frequently consists of thick locks, each designed to hold a feather (the fixing holes are still visible).

There is no doubting the Nok residents' love of personal adornment and one statuette shows a small figure (fig.3) literally crushed beneath its necklaces and bracelets.

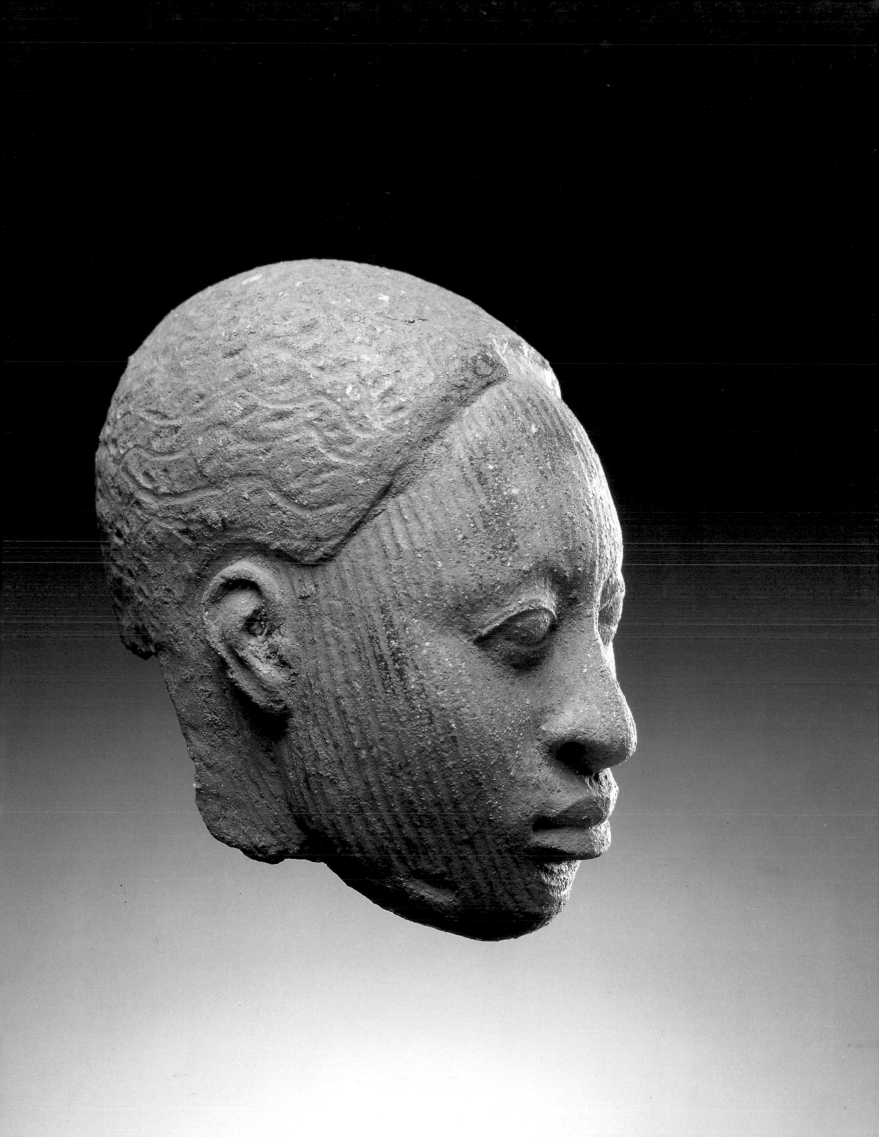

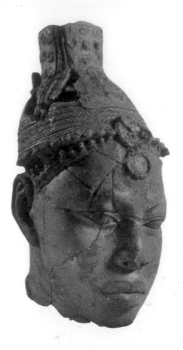

7 Commemorative effigy.
Nigeria. Ife. Terracotta. 13th century, property of the Oni of Ife.
This work shows impressive skill even more remarkable for the fact that the firing was done in ashes, at 300°C.

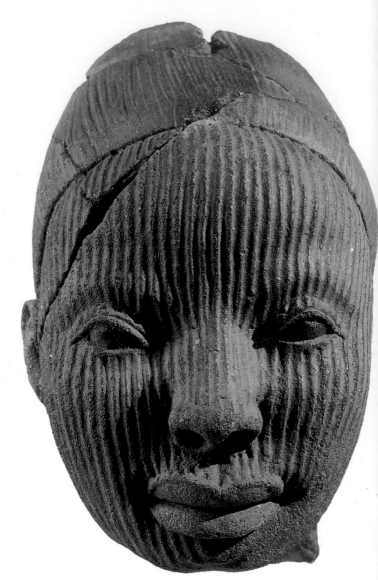

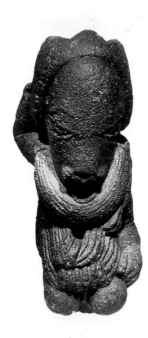

3 Kneeling man covered in jewellery.
Nigeria. Nok culture. Terracotta. 500 BC-200 AD. National Museum, Lagos. (Photo: Dominique Genet.)

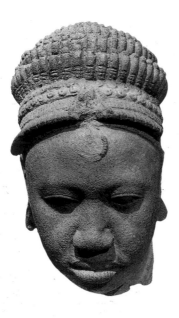

4 Queen's head.
Nigeria. Found at Ita Yemoo. Ife. Terracotta. 12th-13th century. H: 25 cm. Museum of Ife Antiquities. (Photo: Dominique Genet.) This head is not a complete figure: it was part of a full-length statue, and the crown included a crest which has disappeared. However, it remains one of the most delicate terracotta heads found at Ife. The five layers of beads on the crown indicate that the figure represented a queen.

9 Head.
Nigeria. Discovered at Igbo Laja, Owo. Terracotta. 15th century (approx.). H: 17.4 cm. National Museum, Lagos. (Photo: Dominique Genet.)
The serenity of this head points to the Ife tradition, but it was probably made at Owo. It has many characteristics of Ife art: parallel grooves on the face, the upper eyelid covering the lower eyelid, a slight indent in the upper eyelid, the corners of the mouth slightly hollowed out and the contours of the lips in light relief.

18

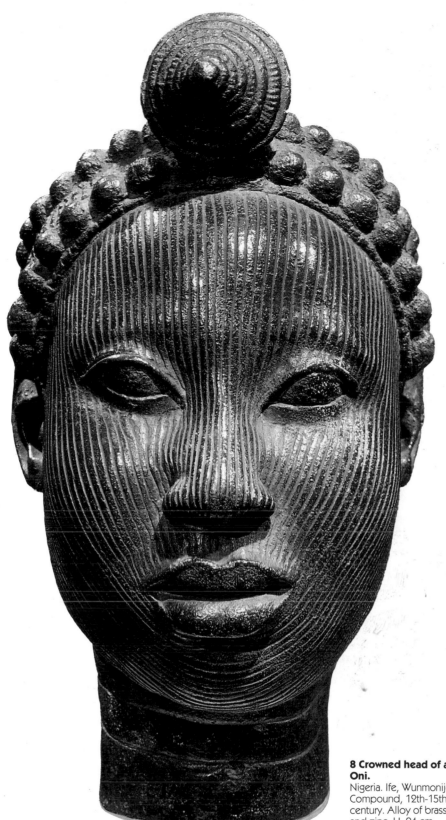

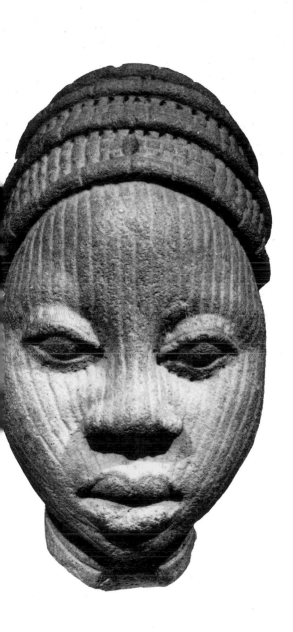

5 Head with beaded cap.
Nigeria. Ife. Terracotta, 12th-15th century. H: 16 cm. National Museum, Lagos. (Photo: Dominique Genet.) A hole in the beaded cap may indicate that it once held a crest or an egret plume.

8 Crowned head of an Oni.
Nigeria. Ife, Wunmonije Compound, 12th-15th century. Alloy of brass and zinc. H: 24 cm. Museum of Ife Antiquities. (Photo: Dominique Genet.) This "bronze" head marks the magnificent final stage of Ife art. The delicate modelling of the features is emphasised by the lines running up the face. The rosette above the face proves that this was an Oni, possibly a female Oni. The top of the crown is broken.

19

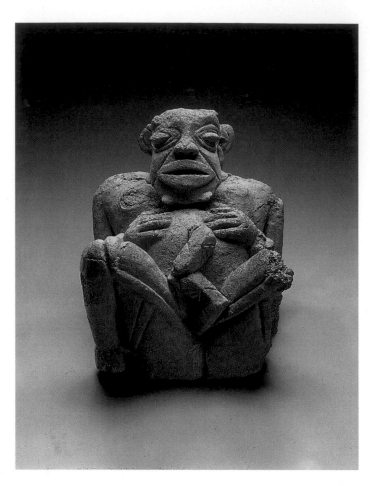

11 Female statuette.
Mali. Jenne region.
Terracotta. H: 39 cm.
Musée Barbier-
Mueller, Geneva.
This pregnant woman
with her hands on her
stomach appears to be
giving birth to a snake. A
snake cult in the kingdom
of Ghana was described
by the Arab writer Al
Bakri in the 11th century.

Hundreds of quartz pearls have been found, together with the tools with which they were made.

Although many heads look very lifelike in form - as does the head which attracted Bernard Fagg's attention - others in contrast appear to have a strict geometric design, based on spheres, cylinders or cones. The reason for such stylistic developments is unknown, although there can be no question of lack of ability because the animal heads found in Nok reveal that in this area the sculptors were capable of producing perfectly realistic and lifelike works. Religious constraints have been suggested. Frank Willett, former Director of Glasgow's Hunterian Museum and a great connoisseur of African art, attributes these differences in style to the fact that certain sculptors feared accusations of sorcery if they created fully realistic human heads. We may also agree with Mz Ekpo Eyo, former Director of Antiquities in Nigeria, who suggests that certain animals were represented with care because they had religious connotations for the people of their day. Further discoveries may perhaps offer a solution.

Did the Nok artists work with wood? Probably, but none has survived. There may be a distant echo of such works in certain modern Yoruba creations, the Yoruba of Nigeria being particularly artistically gifted. Their wood carvings, especially certain Gelede masks, have eyes with hollowed-out pupils, the same eyes which give such immediacy to Nok heads.

The decline of Nok art can be seen in less accomplished terracotta figures from the 1st millennium AD. They are of interest, none the less, because they show the continuation of a tradition whose legacy can be seen in Ife art which produced some of Black Africa's finest creations.

The great art of Ife

Apart from a very limited discovery by the German ethnologist Frobenius, in 1910, it was in 1938 that important works were properly discovered. These chance discoveries, made during house-building work, were followed by systematic digging between 1949 and 1963, the date when the Oni (king) of Ife, aware of the cult nature of the

objects being unearthed, ordered work to cease "so as not to disturb the bones of his ancestors". In the meantime, however, several sites had been explored in the city of Ife, around the existing palace.

According to the Yoruba people's myth of the origins of Ife, their holy city, it was the place where the gods descended from the skies to populate the world. The children of the first great god, Odudua, created their own kingdoms, and the kings of Ife are still considered semi-divine by their subjects.

Examination by carbon-14 dating and thermoluminescence makes it possible to place the "classic" peak of Ife art between the 11th or 12th centuries AD and the 15th century, while other works, of the 16th and 17th centuries, are designated "post-classic". Of the classic creations, it was above all the royal heads which were retrieved from the Ife soil. Made of terracotta, the majority appear to represent the origins of this art. Others, some thirty in number, are made of brass or copper castings, marking the final stage of this tradition. In most cases the terracotta heads are independent works, but some formed part of life-size statues. They still bear a few traces of the paint which originally covered them.

Given the physical beauty of the individuals represented, and the delicacy of their features, it is often difficult to distinguish between male and female. Very often parallel lines cover the whole face, running from the chin up towards the forehead and creating an exceptional effect of harmony and serenity. Could these be royal portrait pieces? Probably - but they are ceremonial portraits, idealised and removed from the grip of everyday concerns (figs.4 and 5).

Since clay is easily modelled it can be used to give the faces a skin-like texture, animating the thick lips and almost making the nostrils flare. Unlike the Nok heads, here the pupil is not deeply marked; the gaze appears to focus on the infinite, between lifelike and delicate eyelids (fig.6). Where hair is represented, it is always well cared for and serves to complement the facial proportions (fig.7).

The same characteristics can be seen in the bronze heads (fig.8) which are the peak of this tradition. Holes around the neck show that they were designed to be fixed

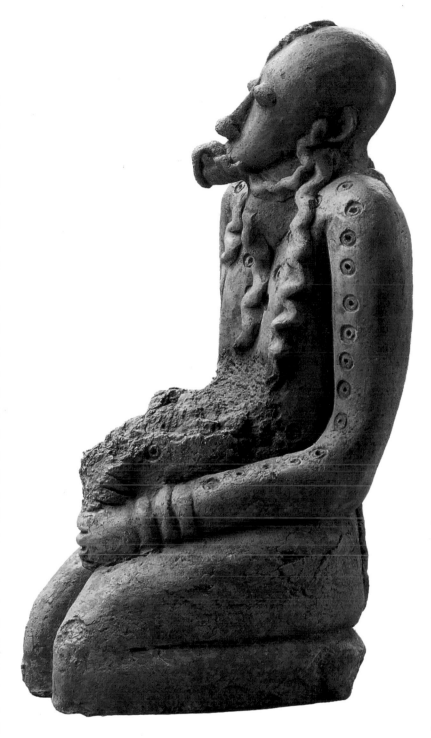

10 Statuette.
Mali. Jenne region.
Terracotta. H: 42.5 cm
Musée Barbier-Mueller,
Geneva.
Several snakes are coiled over the body of this man, who may be a reliquary figure linked with the snake cult in the Jenne region. The meaning of the circles on the arms is unknown. The characteristic protruding eyeballs hint at a state of hallucination.

onto wooden bodies to take part in the secondary funeral ceremonies of the Oni. They embodied the intangible permanence of royalty beyond the grave.

In addition to these portrait heads some highly abstract human figurines were found at Ife, showing the face as a cylinder pierced with two holes and a slit for the mouth. This style, whose purpose is unclear, was contemporaneous with the princely images. There were also numerous realistic animal representations.

In the 16th century Ife experienced a decline in bronze art, due to a shortage of metal as conquered vassal kingdoms claimed their independence and refused to pay tribute. Locally available terracotta posed no such problems, but the style lost its earlier elegance.

Many characteristics of Ife art can be found at Owo, another Yoruba city half way between Ife and Benin, which appears to have taken over from Ife in the art of terracotta during the 15th century. Apart from human heads of great quality (fig.9), many representations of animals were found at Owo, together with macabre themes, such as a basket full of severed human heads, which distanced it from the Ife spirit. Owo may have played an important part in the 16th century in transmitting certain elements of Ife art to Benin.

The perfection of the Ife creations, comparable to the greatest achievements of Greece or Italy, inevitably suggested to art historians a non-African origin for this civilisation. The Mediterranean? Egypt? Frobenius considered these as possibilities, but such hypotheses have been rejected in the absence of persuasive arguments, leaving Ife as the apogee, the purest form, of a truly African culture.

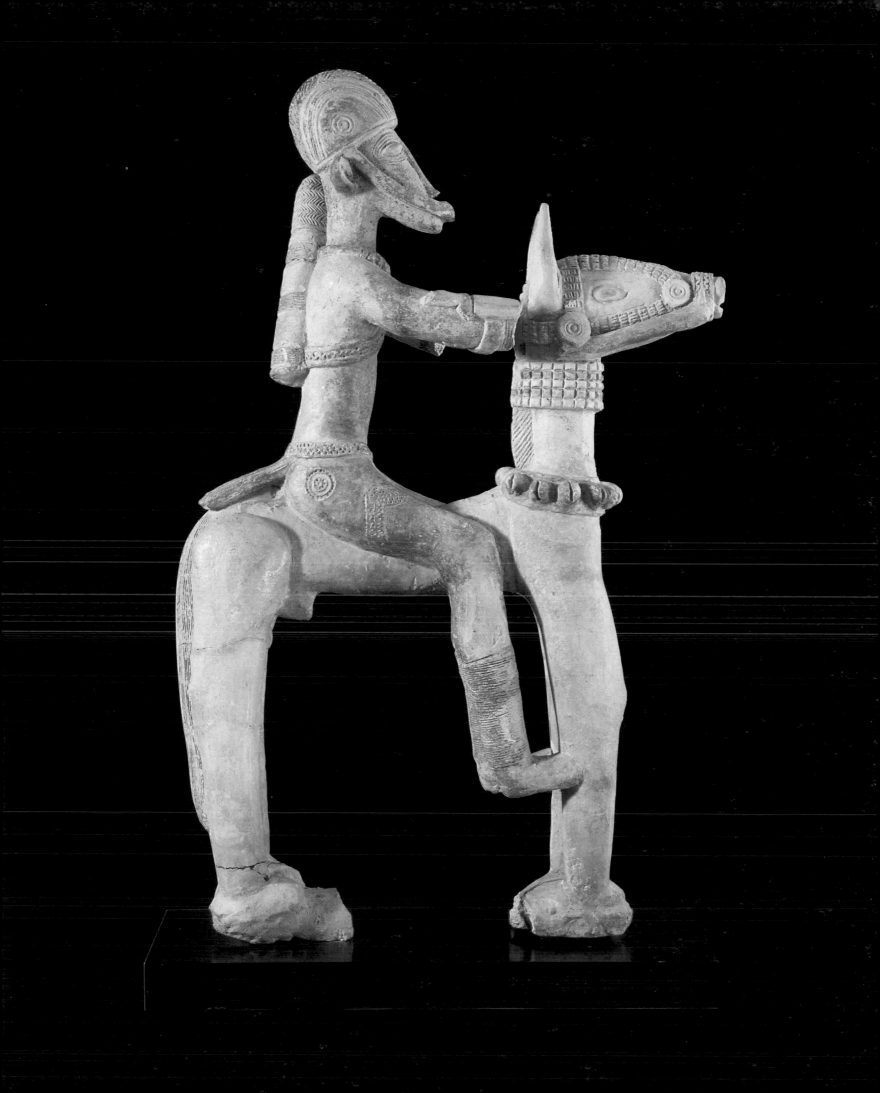

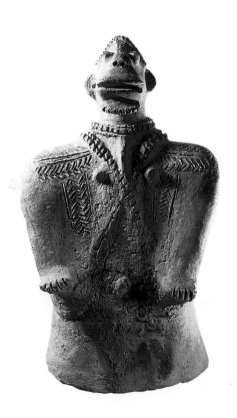

14 Ancestor figure.
Chad. Sao. Terracotta.
H:20 cm. Musée de
l'Homme, Paris.

Mysteries of the Niger Inland Delta

Statues reaching the art market since 1970 have astonished collectors and researchers, who are currently trying to enlarge their knowledge of these powerful and austere works (fig.10). They were discovered in the Niger Inland Delta, that vast terrain subject to inundation lying between the cities of Segou and Timbuktu in Mali. They are often grouped together under the general description of Jenne style, but this is not always accurate, since some were found a long way from the town of Jenne. Only a small proportion of these works come from official digs which lifted them from the alluvial soil in which they were buried. The remainder come from digs operated by people living beside the River Niger, without any scientific supervision.

Thermoluminescent analysis places these statues in periods ranging from the 11th-12th centuries for the earliest up to the 18th century for the most recent. The majority probably date from the 14th and 15th centuries. These statues portray individuals in crouching positions, above all kneeling with their hands on their knees. The body is sometimes covered with little balls of earth, evoking pustules or the lesions of filariosis. There are snakes everywhere, climbing up their backs or appearing out of their orifices, noses and ears, and there is even one woman apparently giving birth to a snake (fig.11).

The frequent presence of these reptiles seems to indicate the very ancient existence of an important snake cult in the local population. The statues, whose link with the snakes is difficult to specify, may represent royal ancestors of the village who were subsequently deified. They were hung on walls or set in niches in special sanctuaries with their own guard and a ritual sacrificial dignitary. The blood of the animal or human victim was poured over the statue while the faithful, kneeling in the same position as the god whom they venerated, identified themselves with the deity. The importance of the wide and bulging eyes, perhaps indicating a state of trance induced by hallucinatory drugs, is notable in these statues.

A certain proportion of equestrian statues has been discovered among the productions of the Niger Inland

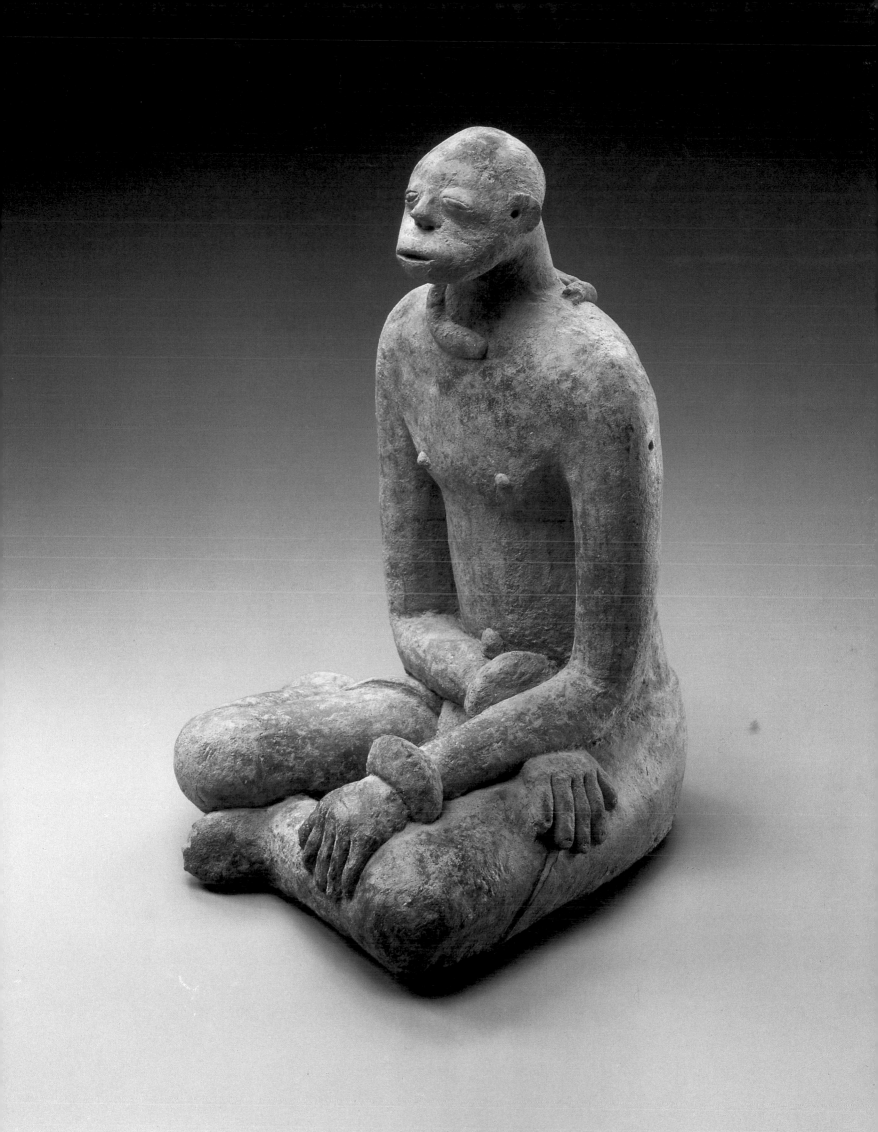

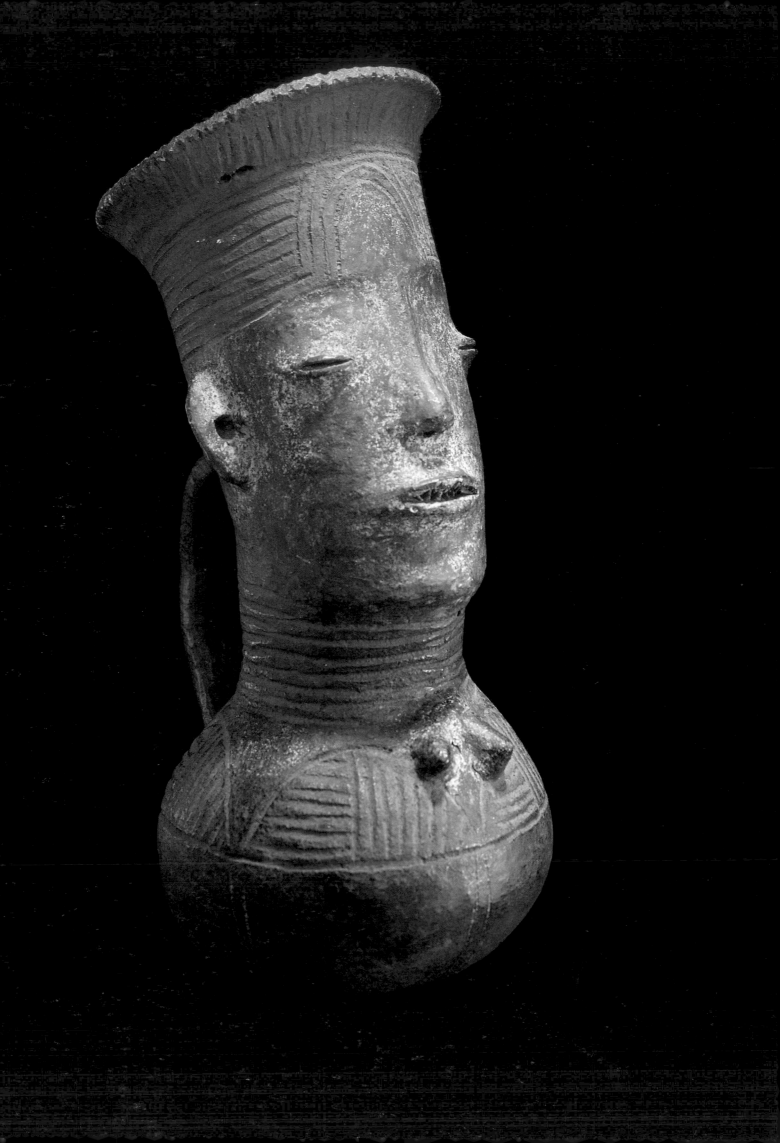

Above and left

**17 Anthropomorphic
pot.**
Zaire. Medje region.
Mangbetu. Terracotta. H:
27.4 cm. American
Museum of Natural
History, New York.

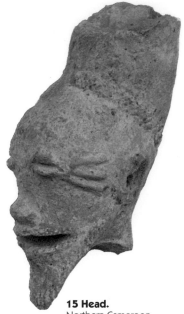

15 Head.
Northern Cameroon.
Afadé. Sao. Terracotta.
H:20.3 cm. Muséum
d'Histoire Naturelle, La
Rochelle.

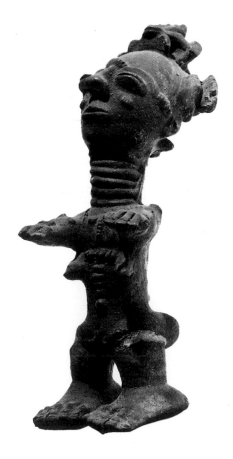

**16 Commemorative
portrait of a dead
queen.**
Ivory Coast. Anyi.
Terracotta. Musée de
l'Homme, Paris.

Delta. The horse, introduced into Africa during the second millenium BC, was a rare creature of great prestige in the 15th century AD, a mark of particular luxury. Imbued with very powerful symbolism, it indicated the pre-eminence of an individual - a king, a warrior or a founding ancestor (fig.12).

Traces of sacrifices and ritual burials of horses have been discovered in digs in the Niger Inland Delta. Such ceremonies, which may date from the Soninke empire around the year 1000 AD, also appear in oral tradition, through myth and legend, with mentions of sacrifices of virgins, horses and pregnant mares, to seek the help of the gods.

Other works of an entirely different style known as Bankoni (fig.13), probably of the same period, found further south in the Segou region, are linked with the Jenne style statues of the Niger Inland Delta. They exhibit a surprisingly smooth skin effect, contrasting with the rough and heavily worked surface of the Jenne creations. The modelling is supple and lightly defined, aiming at a realistic effect.

Elsewhere, from Chad to Zaire

Beyond these great areas of terracotta work, many other regions of Black Africa have proved rich in high-quality works down the centuries, with figurines frequently created for ancestor-worship. Only the most remarkable are mentioned here.

In Chad the Sao people have left traces of a culture which developed between the 10th and 16th centuries AD - unless they are archaeological remains. They buried their dead in coffin-jars set vertically into the ground and covered with inverted pottery. Their ancestor figurines (figs. 14 and 15), are lifelike despite their small size, and the heads, with enormous lips, are animated with rare power. Clothing is represented with care, and zigzag decoration plays a large part.

The terracotta work discovered in Komaland in the 1980s should probably also be ascribed to the 15th and 16th centuries. As yet, very little is known about them, but

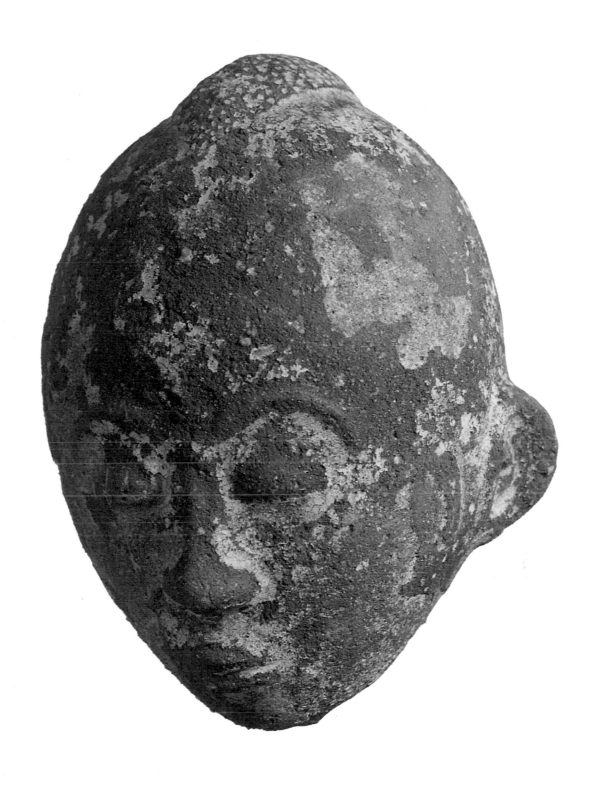

19 Head.
Ghana. Akan. Ashanti.
17th century. Terracotta.
H: 16 cm. Private
collection.

the power of their shaping cannot be ignored (fig.163, page 174).

Among the Anyi of the southern Ivory Coast, figurines of ancestors or dead rulers, moulded by old women who were professional mourners, display great expressive quality, concentrated in a large head set on a neck embellished with rings (fig.16). Clothed and bejewelled, such figures were placed on a platform over the tomb and protected by a straw roof.

The terracotta creations of the Mangbetu of Zaire are on the dividing line between pottery and carved figurine, but their great elegance demands attention. The lower part consists of a spherical vase decorated with spirals or geometric motifs, with the neck shaped into a female head with hair flared out to a fan shape, a style from the beginning of this century (figs. 17 and 18). There is no break in the shape. The marriage of a vessel and a female representation appears entirely natural and harmonious and the only surprising feature of these anthropomorphic vases is their apparent uselessness. No ritual purpose has yet been ascribed to them with certainty, and they were not suitable for any practical purpose such as cooking or drinking. They may rather be a symbol of power restricted to dignitaries.

Created during a relatively short period in the late 19th or early 20th century, these unusual Mangbetu works mark one of the final stages in the very long tradition of Black Africa's terracotta.

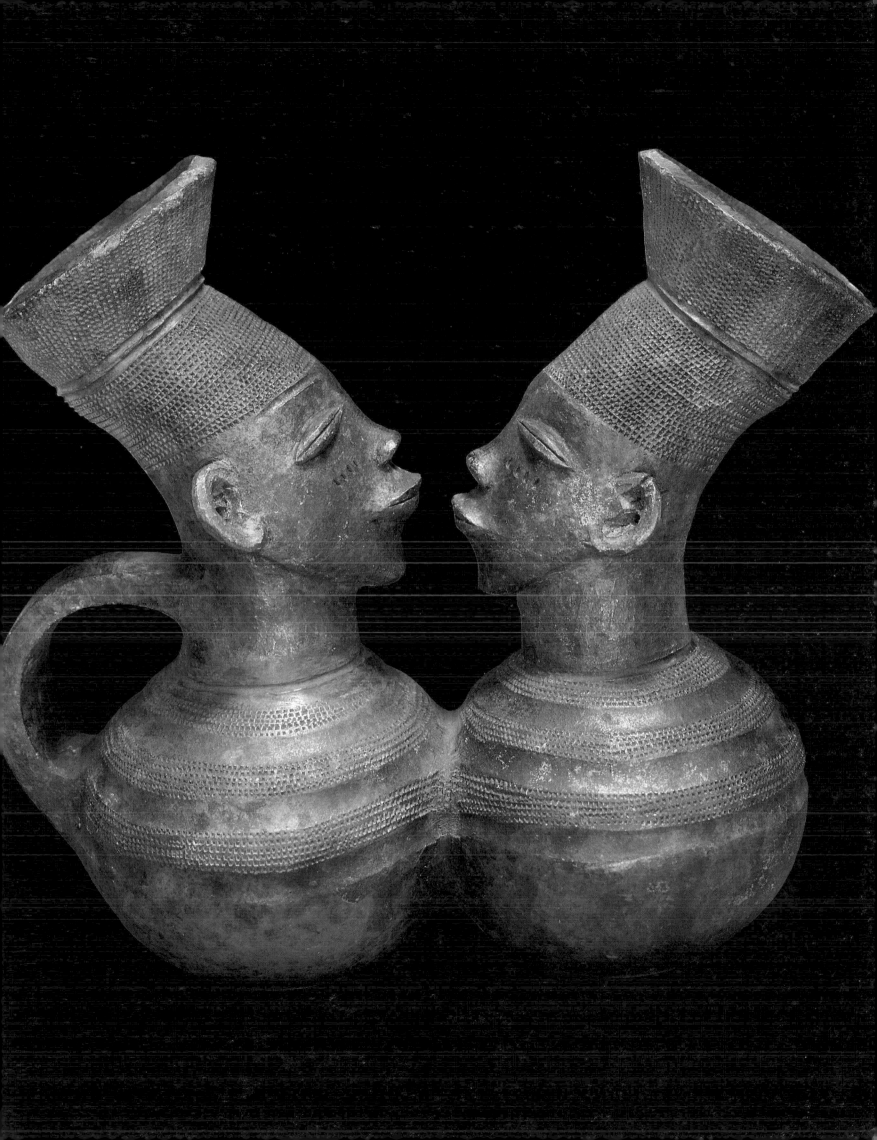

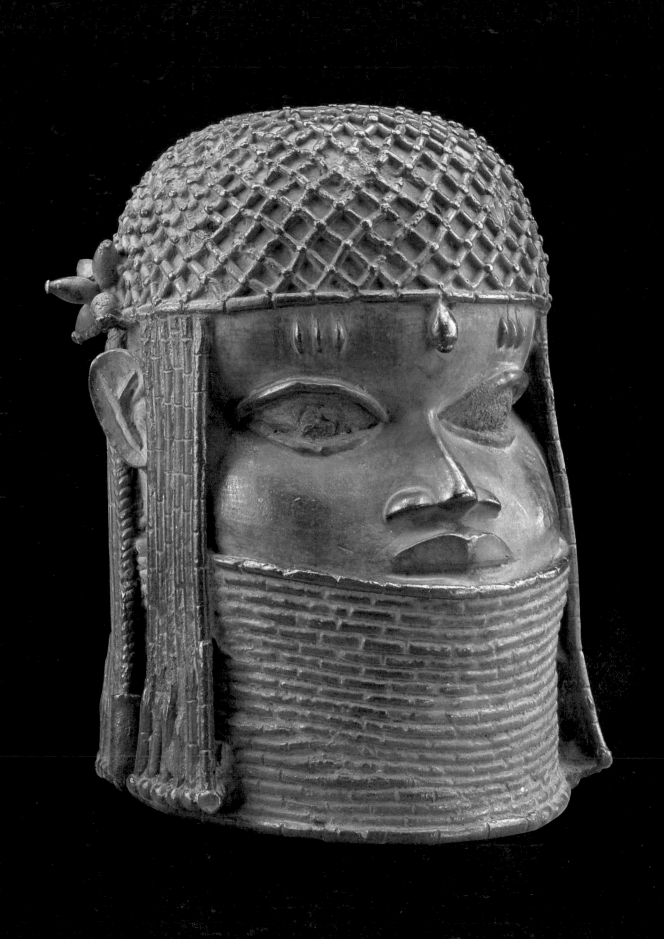

Bronze and ivory, proud possessions of great kings

1897 marked the end of both the great African kingdom of Benin and the sumptuous art first developed around the 15th century which was already decadent by the 19th century. Based on bronze and ivory, it was designed to give the king, the Oba (fig.20), a setting to enhance his prestige.

A lack of understanding, a clash of attitudes, and, finally, several misunderstandings contributed to the catastrophe. The British had settled on the Benin coast in the second half of the 19th century, seeking to profit from the palm-oil trade; but the Oba avoided all their proposals, always finding a way to delay signing any treaty. To put an end to such evasions, the young British assistant consul general James R. Phillips decided that, despite everything, he would arrive unarmed at the Oba's palace, escorted by nine fellow Britons and two hundred black porters. The Oba agreed to let them in but was disobeyed by his tribal chiefs, who sent their own people to massacre the little expedition. The Oba then realised that war was inevitable. As a last resort he ordered multiple human sacrifices to his ancestors in the palace, but this did not prevent the arrival of a 1500-strong British expedition. The city was captured on 18 February 1897.

On entering the town the Europeans discovered a terrible spectacle: the Oba had fled and the city was full of

Left

20 Commemorative head of an Oba. Nigeria. Benin. Brass. H: 26.5 cm, D: 16 cm. Late 16th century. Museum für Völkerkunde, Vienna. (Photo: Musée Dapper, Paris.)

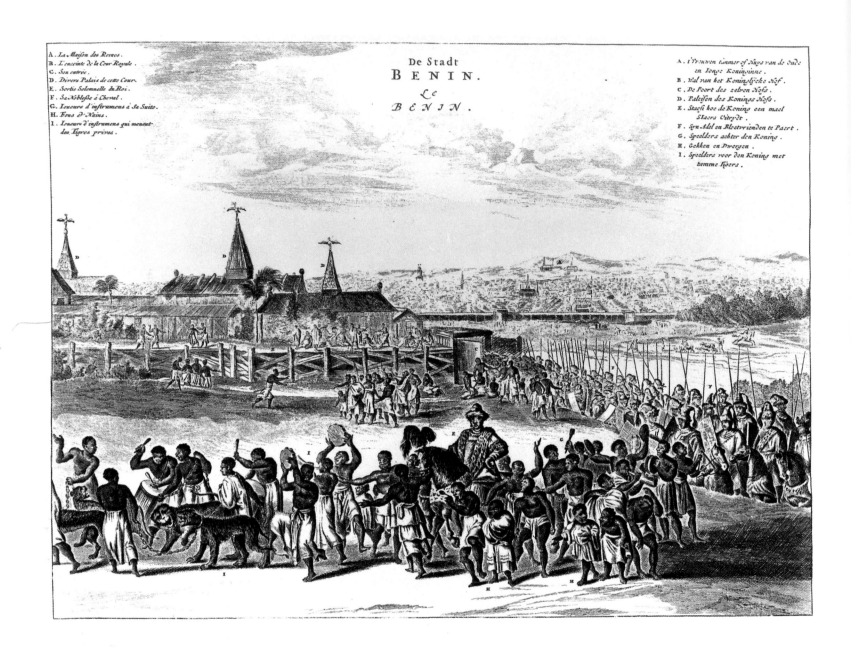

22 View (restored) of the city of Benin.
Illustrates Olfert Dapper's Description de l'Afrique (1686), Musée Dapper Archives, Paris.

mutilated sacrificial corpses. Two days later a fire consumed the final remains.

The Oba returned on 5 August, however, and publicly showed his submission by rubbing his brow three times on the ground. After a final attempt to flee he died in exile sixteen years later in Calabar. Since 1914 his descendants have recovered a semblance of power, but despite undeniable technical skill, bronze art lost its former royal inspiration and turned to a foreign clientele.

Not wishing to see its image tarnished in the eyes of the world, the British government published a report in 1897 which set out the problems: *Papers relating to the*

Massacre of British Officials near Benin and the consequent Punitive Expedition. As well as historical facts, it contains a list of royal treasures discovered in the palace: in bronze, numerous heads and statues, several hundred figured plaques, and some seats. In ivory, a large number of carved tusks, bracelets, and above all two leopard statues.

At first the British were disappointed by the lack of precious metals and puzzled by the style of the objects they found. They appreciated their beauty without being able to pinpoint their origin. At random, they suggested Egypt or China.

These treasures, some 2400 objects, were dispersed throughout the world and bought by the great museums of Europe and the United States.

If the British had been familiar with the history of Benin during preceding centuries they would have understood better the meaning of their discoveries. Benin is in fact one of the rare African countries whose past has been recorded in travellers' accounts, and it is known that Portuguese explorers and traders arrived there in 1485. Trade soon flourished in three areas: slavery, ivory and pepper.

In the 15th and 16th centuries, the period of the warrior kings, the Benin sovereigns sought to reinforce their spiritual powers. They tried to give royalty sacred origins, combining the concept of divine right with absolute power, all emphasised by impressive ceremonies and court etiquette.

Olfert Dapper, a 17th-century Dutch doctor, left a famous picture of the city of Benin in his 1668 work *Description of Africa*. This is not an eye-witness account, for he was merely an armchair traveller, but he brought together many valuable personal accounts and produced the first reference work on 17th-century Africa.

The book caused surprise with its description of the size of this African city, perhaps 5 leagues in circumference, and above all the queen's palace, about 3 leagues round the outside. The outside wall was 10 feet high, with several gates 8 or 9 feet high and 5 feet wide (fig.21). Next, Dapper was the first European to mention the wide galleries inside the immense palace, resting on wooden pillars with brass plaques showing scenes from contemporary military life.

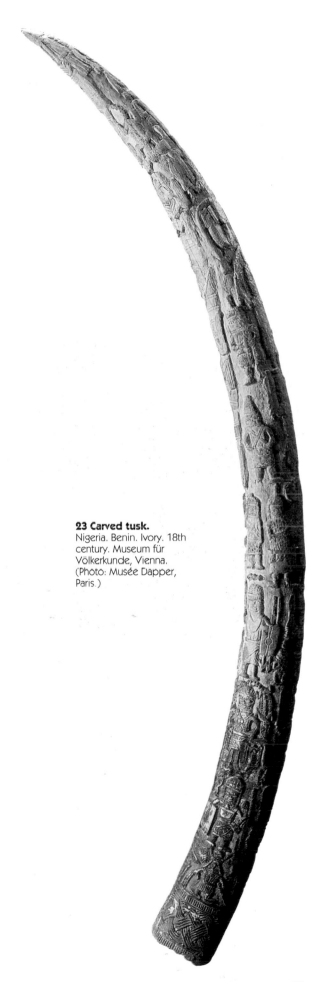

23 Carved tusk.
Nigeria. Benin. Ivory. 18th century. Museum für Völkerkunde, Vienna. (Photo: Musée Dapper, Paris.)

Dapper also mentions the pomp surrounding the Oba's appearances: "This prince appears once every year in public, on horseback, covered with royal ornaments, with a suite of three or four hundred gentlemen [. . .] and a troupe of musicians [. . .]. Tame leopards are led on chains, with numerous dwarfs and deaf people who are present to entertain the king" (fig.22). This parade was not the only public ceremony, however. "And there is another day when anyone may see the royal treasures made of jasper, coral and other rare materials."

In 1699 another Dutch traveller, David van Nyendael, finally gave an eye-witness account. The city was much smaller by then and, as he was no longer the head of the army, the Oba's powers were diminished. Inside the palace van Nyendael saw the altar of an ancestor with eleven heads cast in brass and surmounted with decorated elephant tusks.

A final burst of energy in the 18th century allowed the Oba Akenzua I to retrieve the situation and to instigate a last artistic revival, but a decline was under way which was to end in the massacre and collapse of 1897.

"Bronze" heads on ancestors' altars

The objects found in the palace match the travellers' descriptions exactly. First and foremost were the brass Oba heads (fig.20), although they are generally described as "bronze" (see chapter note). Originally placed on ancestors' altars as centrepieces for ceremonies and commemorative sacrifices, they should be considered not as portraits but as ritual items.

The surface of the faces, smooth and stretched and their spare form reduced to a few significant elements, gives an impression of harmonious spirit and youthful energy - young but confident, the eyes fixed on the future with all the self-assurance of power and all the dignity of royalty. The king wears a high collar of coral beads and a flat head-cover woven like a net of coral and enhanced by agates set in relief. Symbols of sovereignty, these beads were reserved for the Oba, the queen mother and a few important dignitaries. They represented other beads

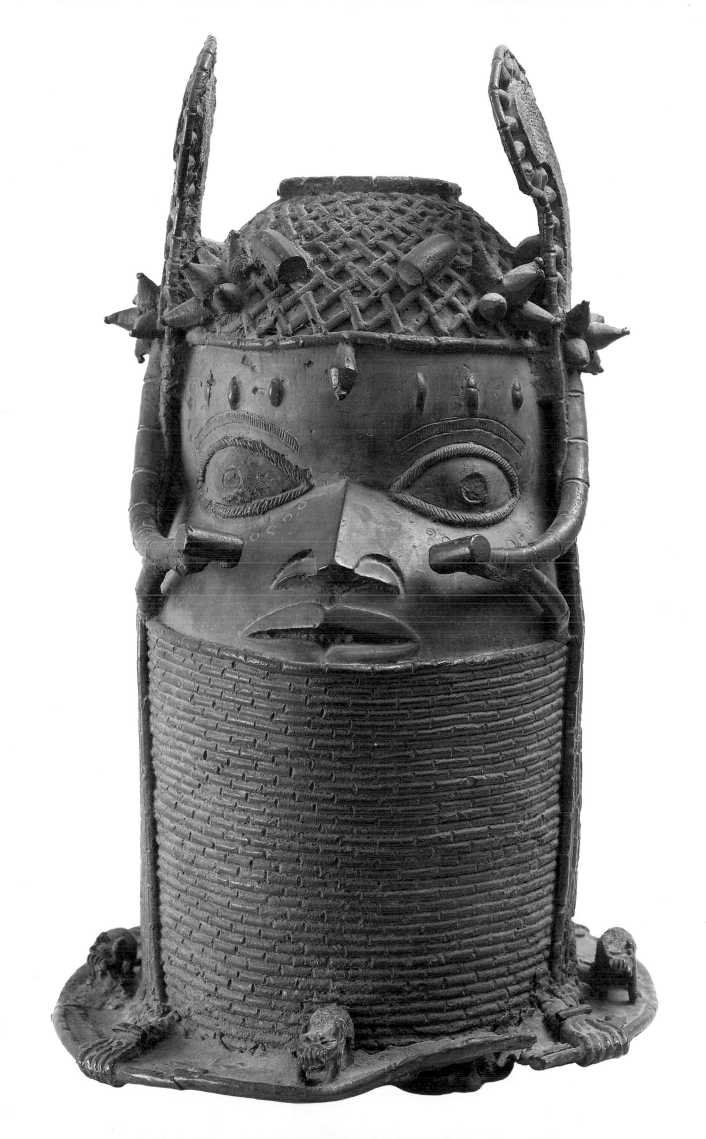

21 Entrance to the Royal Palace, Benin. Nigeria. Benin. Brass. British Museum, London. A python is visible on the turret above the gate. The pillars on each side of the gate are covered with bronze plates representing people set vertically above each other.

which, according to legend, had been stolen from the palace of Olokun, the god of water. Every year they were endowed with fresh vital energy through the blood of sacrificial victims.

In the 17th century the heads were made with thicker bronze. The metal was used less sparingly because the Oba sold great numbers of slaves and received in exchange "manillas" of brass brought in by Europeans. The base of the heads was edged with a broad border sometimes overlaid with small animals to provide a better balance and a long elephant tusk, covered with carving representing mythological themes and episodes of oral tradition, was set on top of each head. Only a small circle of initiates understood its meaning (fig.23).

In the middle of the 19th century the quality of the bronze work declined. Lifeless features were set in mechanical reproductions of the models while secondary decorative elements proliferated, particularly curving "wings" placed on either side of the face on the orders of Oba Osemwede (1816-1848). (See fig.24.)

Queen mothers' heads (fig.162, page 172) followed a similar pattern. Like the Oba they had the right to a network of beads, but their head-dress was conical, a "chicken's beak". Moreover, it was very frequently a bronze cock (fig.25) which stood on their altars, where it figured both as a protective spirit and as a spy on dynastic plotting.

The Oba court revived

When the Benin creations became known in Europe, it was possible to relate them to Dapper's descriptions and perceive the exact relationship between object and description. A whole culture is thus preserved and visibly brought to life.

Dapper mentioned "dwarfs". They have been rediscovered, and authors such as the German von Luschan, and above all William Fagg, former curator of the British Museum's Department of Ethnology, placed these statues among Benin's most remarkable antiquities, both in their naturalistic spirit and in their perfect casting, producing a

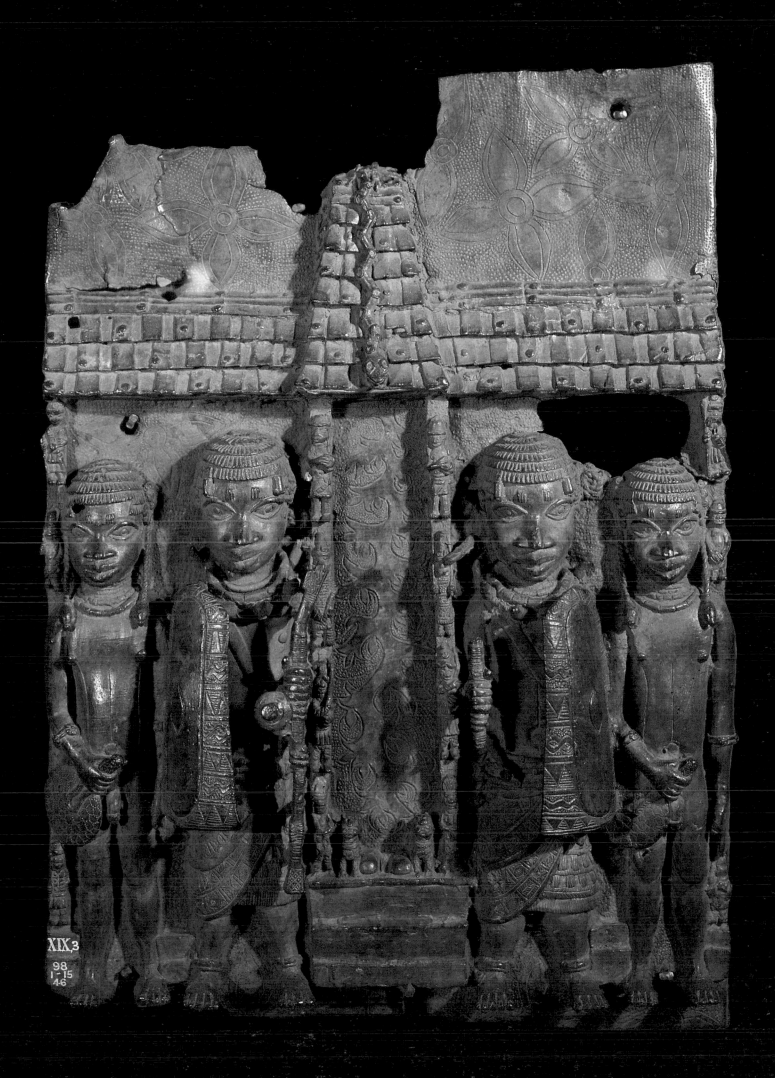

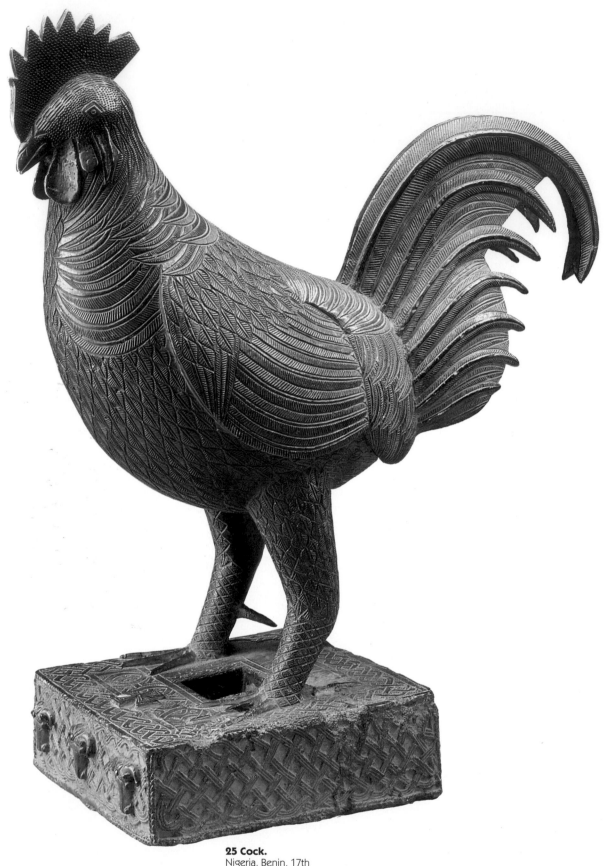

25 Cock.
Nigeria. Benin, 17th
century. Brass. H: 53 cm.
Museum für Völkerkunde,
Vienna. (Photo, Musée
Dapper.) Simultaneously
realistic and stylised, this
highly expressive cock
was set on the
commemorative altar of a
queen mother.

smooth and plump surface similar to the best Oba heads. What of the origin and date of such perfection? Ife or Benin? Doubt persists, but the realistic style is certainly the same as that of Benin.

The whole psychological world of these dwarfs can be seen in their appearance. One (fig.26) seems appointed to cheer up the Prince, for jokes must surely sparkle from this sarcastic face, while the very slightly lifted heel indicates an imminent pirouette. The other dwarf (fig.27), with its intelligent expression, is immobile and looks philosophical. Each one is in character.

Also established in their role, these *Messengers* (fig. 28 and page 11) are fully conscious of their importance and richly dressed to represent their sovereign with due dignity. The man probably held an L-shaped bar of iron in his hand, which would identify him as a messenger of the king of Ife. The significance of the "cat's whiskers" scarification is not clear: it may refer to the fur of certain felines, or be the mark of a secret society.

The whole court, finally, appears on the thousand carved plaques covering the palace walls in Dapper's time. Aids to the collective memory, designed as reminders of the military campaigns and the conquests of these important people, they could sometimes be "read" in sequence. Cast in the 16th and 17th centuries, when large quantities of brass were available, they were taken down after the fire in the royal palace at the end of the 17th century and never replaced. The British found them "buried beneath the dust of centuries", according to the official account.

And yet, what a marvellous strip cartoon! Everything is there. First the Oba, full length (fig.29), standing a head taller than the dignitaries on his right and left and who often support his arm symbolically. Clothes and weapons are carefully detailed, and particularly the ceremonial sword, the symbol of power. Smaller figures, of musicians, complete the sovereign's retinue, playing bells, castanets or horns.

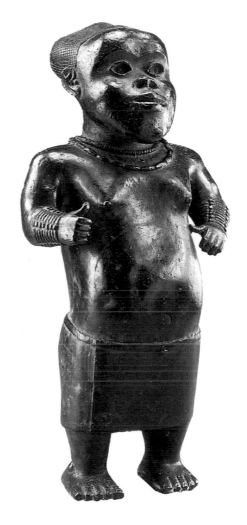

26 Statue of a court dwarf.
Nigeria. Benin. Late 14th/early 15th century. Brass. H: 59.5 cm. Museum für Völkerkunde, Vienna. (Photo: Musée Dapper.)

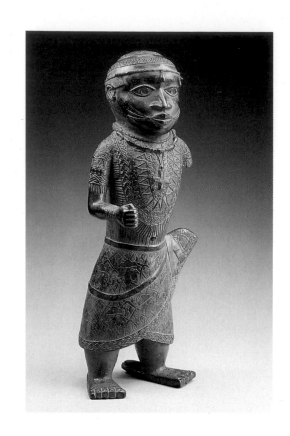

Above

**28 Statue of a
messenger.**
Nigeria. Benin. Late
16th/early 17th century.
Brass. H: 60 cm. Museum
für Völkerkunde, Vienna.
(Photo, Musée Dapper.)

Right

**27 Statue of a court
dwarf.**
Nigeria. Benin. 13th/15th
century. Brass. H: 59 cm.
Museum für Völkerkunde,
Vienna. (Photo, Musée
Dapper.)

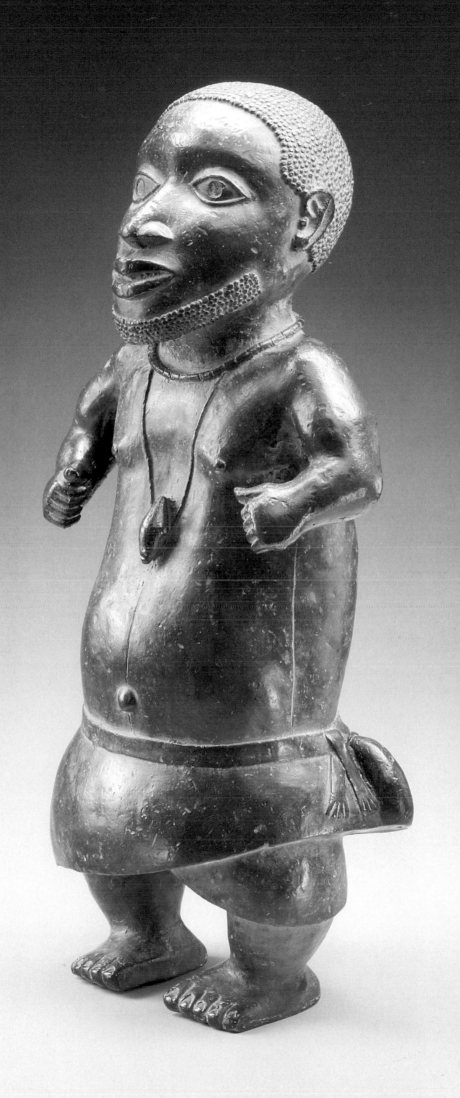

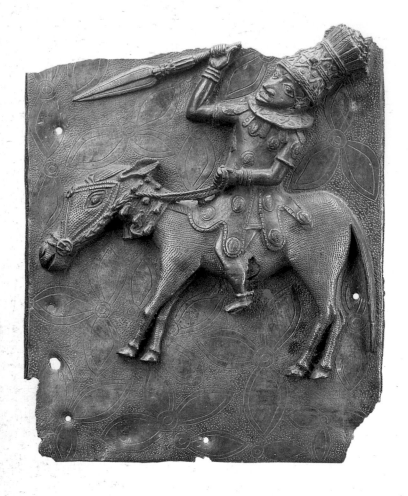

Above

31 Plaque showing a horseman.
Nigeria. Benin. 17th century. Brass. H: 35 cm. L: 29 cm. Museum für Völkerkunde, Vienna. (Photo: Musée Dapper.) This mysterious horseman is unusual in its asymmetric style.

Right

29 Plaque showing an Oba with dignitaries and musicians.
Nigeria. Benin. H: 38.5 cm. L: 39 cm. 17th century. Museum für Völkerkunde, Vienna. (Photo: Musée Dapper.)

Elsewhere the *Bull sacrifice* marking the funeral of an Oba shows the priest and his aides carrying out their duties (fig.30).

There is a surprising plaque showing a *Horseman* (fig.31) in unusual clothing with a particularly interesting head-dress. He has been described successively as the king of a friendly neighbouring people, or even Oranmyan of Ife, a mythical Yoruba ancestor who introduced horses to Benin, but the mystery remains unsolved. The plaque representing a *European trader* (fig.32) is happily easier to interpret; his smooth beard and hair are unmistakeable, like the brass manillas which the man brings to exchange for the cargoes he will take away.

The very numererous images of dignitaries were not portraits, but they certainly reminded contemporary viewers of specific individuals whom, sadly, we cannot identify. They have become simple archetypes.

Independently of their subjects, these plaques can be seen to represent many diverse styles. There are stylised frontal images *(The Oba with his officials)* but the embarrassment of the bronze-caster can sometimes be felt, when faced with a problem he cannot resolve *(Sacrifice of the bull)*. In such cases the craftsman juxtaposes contradictory points of view, as a modern artist would do. Sometimes a search for movement and volume is apparent *(Portrait of a horseman)*, involving assymetry and depth. Some influences may be European, derived from the small devotional objects and pious images brought into Benin by missionaries.

The background of the plaques is always covered with scattered crosses set within circles or four-leaf clovers, emblems which may refer to the creation of the world. Similarly the rosettes placed in the corner of the plaques may refer to the sun and to Olokun, the water god who absorbs the light in the evening. This mythic element defined by A. Duchateau, chief curator of the Black Africa department of the Museum für Völkerkunde, eliminates any consideration of motifs as simple space-filling and relates them to the theme of the deification of the Oba as an intermediary between his people and the forces of the supernatural, of which he was seen as the earthly personification.

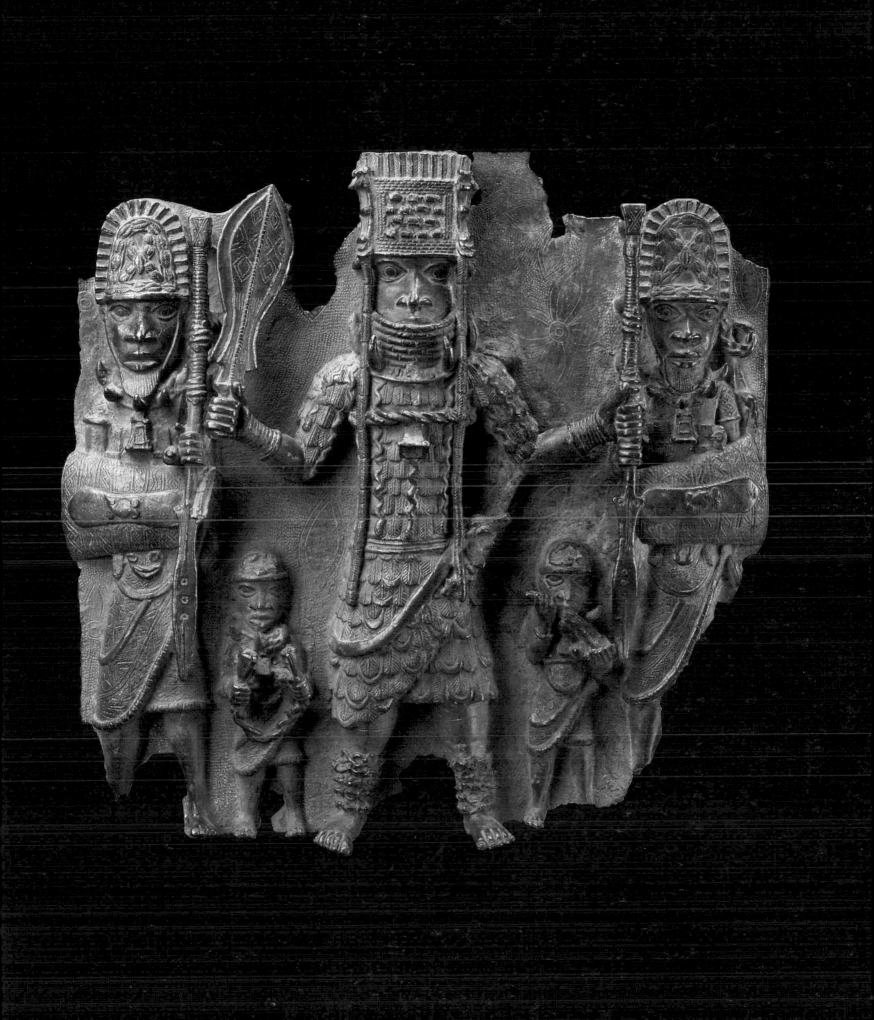

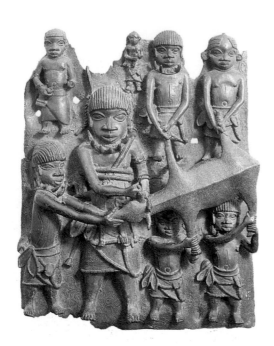

**30 Plaque showing a
bull sacrifice.**
Nigeria. Benin. Brass. H:
51 cm. British Museum,
London.

Animals of great significance

This emphasis on symbolism and repeated reference to
myths is also apparent in the numerous animal images on
all kinds of object. From their earliest days the people of
Black Africa remained very close to nature and created a
network of significant relationships with the animal world
which united myth, proverb and popular wisdom. These
animals were all part of the symbolism of the Oba's power
as he reigned on earth and interceded with Olokun. Semi-
aquatic creatures are prominent, with crocodiles appea-
ring as guardians of law and order. Snakes are every-
where: as Olokun's messenger and games-companion, the
snake appears on weapons and armour as well as vases
and even the tops of palace gates. The fish is the symbol
of peace and fertility. The sovereign is frequently repre-
sented with catfish legs, perhaps because an Oba of
ancient times, whose legs were paralysed from the age of
25, disguised his disability by creating a myth that, on
pain of the most terrible fate, the Oba's legs should never
touch the ground. The union of the earth (the Oba) and
water (Olokun) is also personified by the frog which
embellishes a splendid pendant (fig.33).

As early as the Dapper period, birds appeared to watch
over the royal palace. They symbolised the opposition
between day and night, good and evil. One particular bird,
a priestly Ibis, continues his watch on a plaque (fig.34).

But the *Leopard* (fig.35) is, without doubt, the sculp-
tor's greatest and most frequently copied achievement.
In bronze or ivory, he appears everywhere; powerful, fier-
ce, sharp-toothed, with curving crouch, velvet paws and
rich dappled coat, he symbolises the Oba wisely restrai-
ning his limitless powers. Only the king or his hunters were
entitled to kill leopards, and strictly for sacrificial purposes.
Other leopards, captive and tamed, paraded every year in
the Oba's retinue, each one a proof of the ruler's power,
even over these lords of the forest.

Mysterious origins

In their very perfection all these works - human or animal silhouettes, in bronze or ivory - raise questions as to the origins of this art. The finest creations date from the earliest periods, the 16th and 17th centuries, while the 18th and particularly the 19th centuries show relative degeneration.

The surviving 16th-century works appear to have reached a state of perfection and a total mastery of technique. Where was the apprenticeship stage? Where are the earlier attempts?

The existence of "lead bronzes" on the African continent is very ancient. There are references from the 6th century in Senegal and the 8th-9th centuries in Mauritania. But above all there are the many objects in bronze cast by the lost wax process found in the village of Igbo-Ukwu. Different specialists give dates between the 10th and 15th centuries. They are strikingly complex and delicately decorated, but their style is profoundly different from that of Benin - in fact it resembles no other art, so the Igbo-Ukwu finds are not generally regarded as precursors of Benin art.

This is in contrast to the city of Ife some 200 kilometres away, where distinguished art developed between the 12th and 15th centuries. In 1968 the black chief Jacob Egharevba published the result of his research into Benin's myths and traditions, concluding that the Benin dynasty originated in Ife around the 14th century. He states that dynastic difficulties resulted in the Benin inhabitants (known as the Edo) begging the king of Ife to send a prince to rule over Benin. In order to overcome local resistance and gain popular acceptance, the prince married an Edo wife. Through his mother, the son of this first prince thus had the right to govern the Edo despite his connections with Ife. Subsequently all queen mothers were to enjoy a position of privilege in Benin.

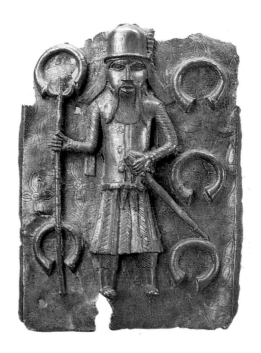

32 Plaque showing a European surrounded by manillas.
Nigeria. Benin. Brass. H: 46 cm. W: 34 cm. Late 16th century. Museum für Völkerkunde, Vienna. (Photo: Musée Dapper.) The manillas were used for bartering in the slave trade.

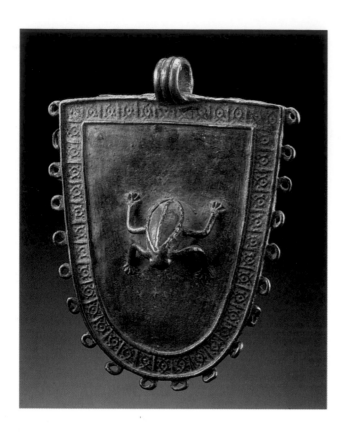

33 Pendant with frog in relief.
Nigeria. Benin. Late 17th century. Brass. H: 12.5 cm. W:10.5 cm. Museum für Völkerkunde, Vienna. (Photo: Musée Dapper.)

Right

34 Plaque showing a mythological long-beaked bird.
Brass. H: 41 cm. W: 17 cm. 17th century. Museum für Völkerkunde, Vienna. (Photo: Musée Dapper.)

According to tradition, when the first Oba died his head was sent to Ife for burial, with Ife sending back a bronze head for the ancestors' altar. Towards the end of the 14th century the king of Benin demanded from the king of Ife a craftsman who could teach the art of bronze work to his people. The Ife artist, Ighe-Igha or Ighea, found himself in Benin among artists who were already well trained. Since the 13th century they had known how to produce brass and to work it by hammering or incising but had difficulties with the technique of casting. They also knew how to make heads in wood or clay for the ancestral altars of their noble families. From then on they were to transfer their own ideas and aesthetics to bronze work. A bronze *Head* dating from the 15th century, preserved in the Lagos national museum and probably representing an Oba, is clearly very similar to a terracotta *Head* of the same period (also in the Lagos museum), discovered on Ighea's commemorative altar and therefore not representing an Oba. This latter head is typical of Benin art and although made of terracotta could not have any connection with Ife.

Tradition again has it that there was a custom in Benin of decapitating vanquished kings and offering their heads to the Oba, who would have replicas cast by his foundry craftsmen. It might happen that the son of a rebel king would none the less ascend the throne; to remind the son of the risks of insubordination and of his father's fate, the Oba would send him the bronze portrait of his father. The trophy heads from the early 16th century may therefore represent records of the kings' victories over their enemies.

The very beautiful and rare *Head* in the Barbier-Mueller collection in Geneva (fig.36) dates from the first period of the Benin kingdom, before 1550. It may either be the head of a dead king destined for a commemorative altar - it is only 21 cm. high - or the head of a vanquished king. In either case it shows the perfection of the technical casting attained by the Benin craftsmen and the elegant stylisation which raised their works far above the level of a simple realistic copy.

Craftsmen in bronze and ivory

The casting technique which Ighea passed on to the Benin craftsmen is said to be that of lost wax (see chapter note). Despite its difficulty it made possible the creation of very delicate bronze works which were sometimes only 1 mm. thick - for in the 16th century it was imperative to be sparing with this extremely rare metal. Subsequently, the large quantities of alloy needed by the bronze founders were supplied partly from tribute exacted from conquered races and partly through trade with Europe.

Another body of remarkable craftsmen worked for the Oba. These were the ivory workers, who often came from the neighbouring city of Owo. They created the king's ceremonial regalia, which were masterpieces of refinement and technical skill, such as the *Armband* (fig.37) made of two cylinders carved from a single tusk yet capable of being turned separately. Then there was the *Mask*, profoundly imbued with humanism (fig.38), which was an attribute of the Oba at the height of his power. In 1897 the British discovered a chest full of these ornaments in the king's chamber.

The symbolic significance of leopards has already been noted, and they were represented by bronze and ivory workers alike.

These two groups of skilled craftsmen were subject to strict regulation. Bronze was reserved exclusively for the Oba and his family, while ivory craftsmen worked primarily but not exclusively for the king, for rich nobles were allowed to commission their work. Whenever hunters killed an elephant the Oba automatically received one tusk and had first refusal to buy the other. Guilds of bronze and ivory craftsmen were required to live in a particular part of the city where they could be more easily supervised by palace officials.

In Benin, bronze and ivory work has always been a royal art - royal in its destination and royal in the great prestige of its creations.

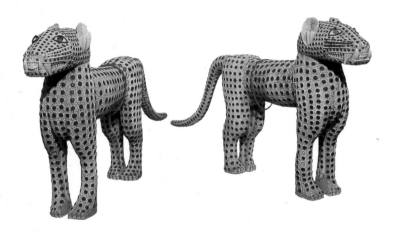

Above and right

35 Leopards.
Nigeria. Benin. 19th-
century copies of earlier
models.
Ivory. H: 81.5 cm. British
Museum, London. Lent by
H.M. The Queen.
These leopards were
placed beside the Oba
for public state
appearances. Each animal
is made from five tusks,
the eyes are made of
mirror and the spots are
copper discs.

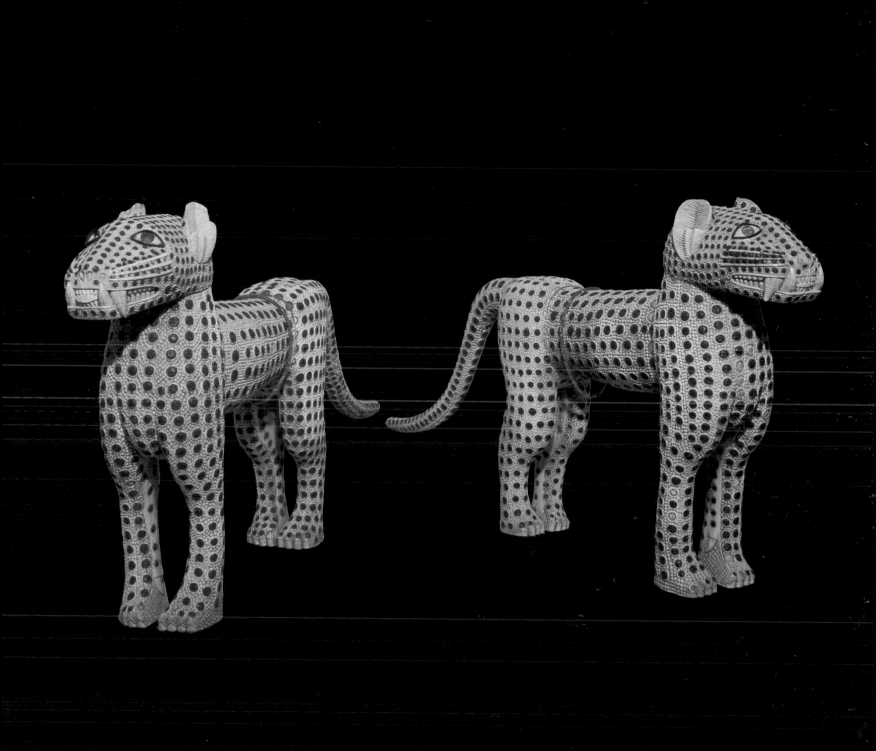

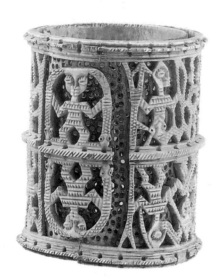

37 Armband with double cylinders carved with stylised figures.
Nigeria. Benin. 18th century. Ivory. H: 11.3 cm. D: 9.5 cm. Museum für Völkerkunde, Vienna. (Photo: Musée Dapper.)

Right

36 Head of a dead king or conquered ruler.
Nigeria. Benin. Brass. H: 21 cm. First period, pre-1550. Musée Barbier-Mueller, Geneva.

The technique of lost wax casting

Lost wax casting can be used for bronze or brass just as easily as for gold.

1. For a small object, or a jewel, the craftsman prepares a wax model of his work.

1b For a large hollow item the caster prepares a central core from a mixture of clay and charcoal in the desired shape and then applies wax over this core and carves the surface in great detail.

2. The artist adds a wax extension to conduct the molten metal.

3. The wax core is then covered with fine clay, powdered and dampened, taking care to follow the shapes of the surface design.

4. Using coarser clay mixed with kapok, the caster creates a mould of the whole work of art.

5. The mould is heated; the wax melts, and is replaced by molten metal which fills the empty space.

6. Once cool, the mould is broken to remove the work of art. It can therefore only be used once.

Bronze or brass?

The alloy used for these castings was approximately 75 per cent copper, 20 per cent zinc, 1.5-2.0 per cent lead and 0.80 per cent tin. Strictly speaking it was thus not bronze but brass, but the name Benin "bronzes" is customarily used.

Geographical note

The modern state of Benin is not the same as old Benin, which lay in what is now Nigeria.

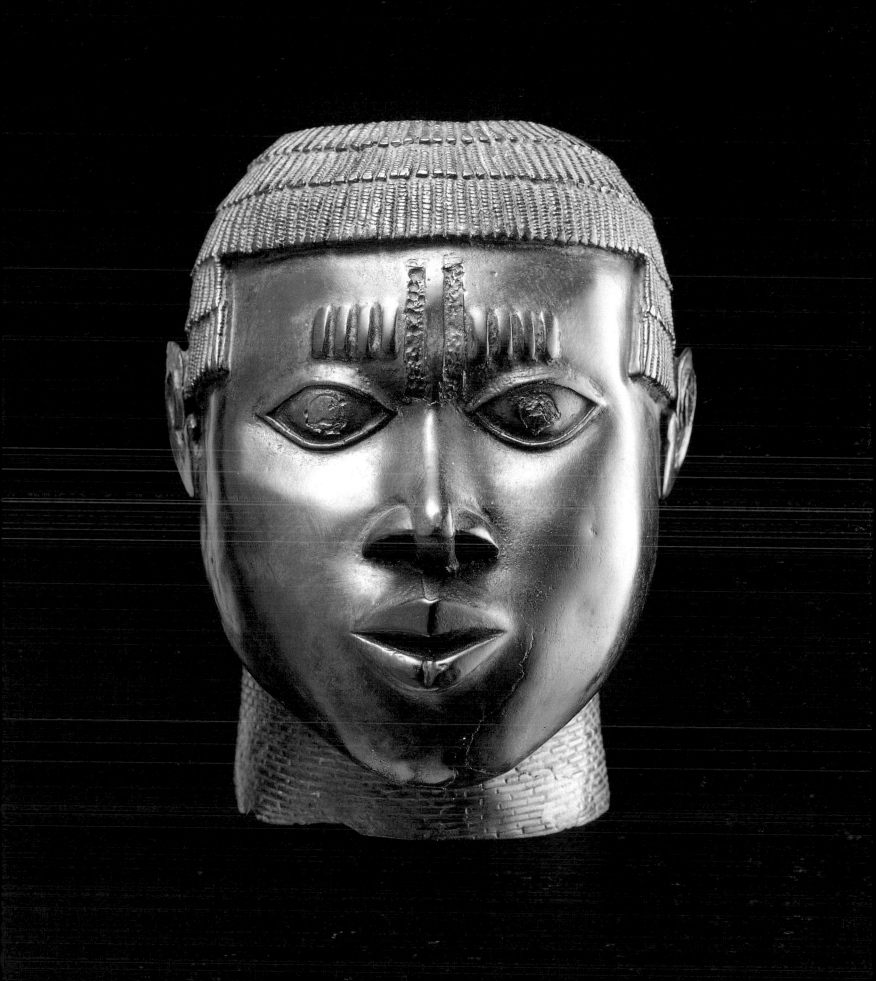

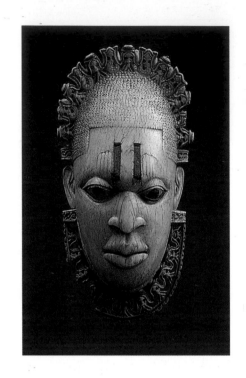

Above and right

38 Mask.
Nigeria. Benin. Ivory. The
Metropolitan museum of
Art, New York.
The Oba probably wore
this ivory mask hanging at
his side for a ceremony
honouring his dead
mother, but the identity
of this portrait is
unknown. It is thought to
be a woman because in
Benin the number of
marks over the eyes is
three for men and four for
women. The crown of the
head is set with
Portuguese heads, which
suggest that it may
represent Idia, mother of
king Esigie, whose reign
covered the arrival of the
Portuguese in Benin.

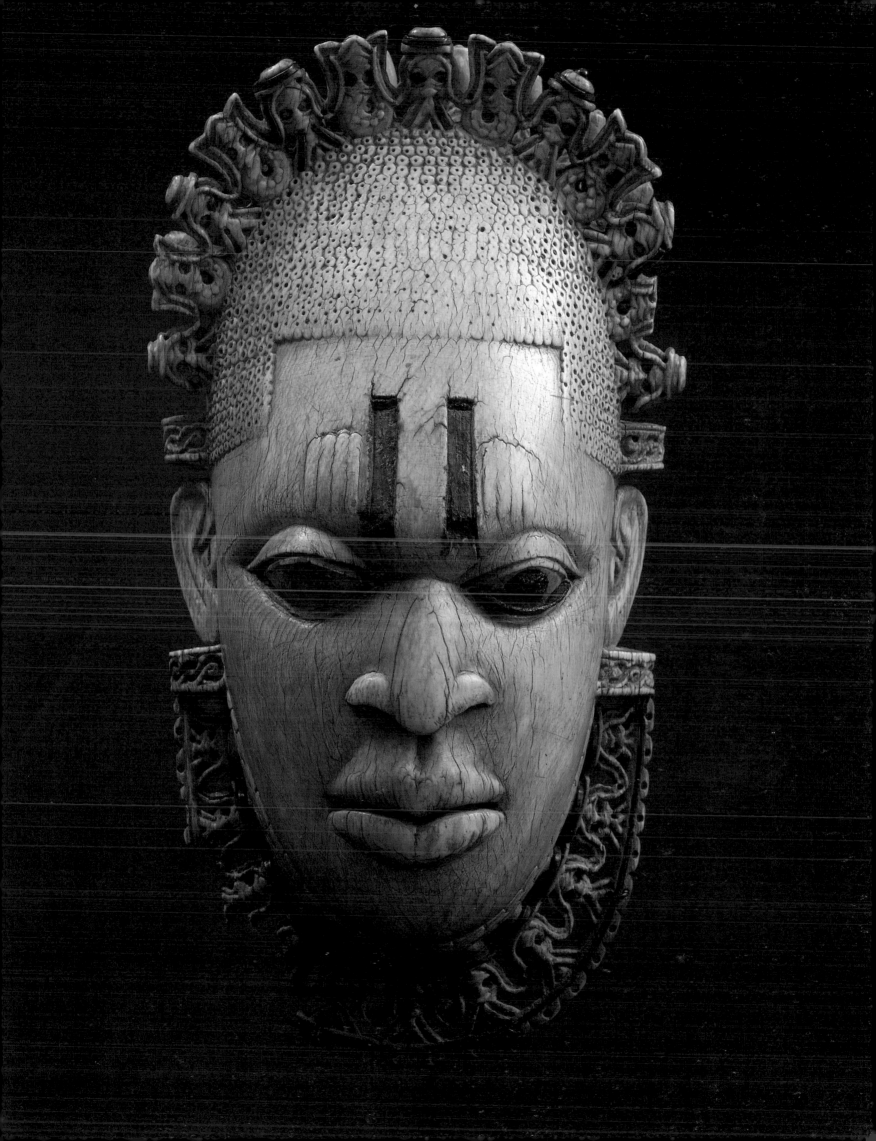

Art from
the Royal Courts
of Cameroon

Political power in Cameroon was divided into units of varying size. Beside powerful kingdoms like those of the Bamoum and the Tikar, in the north-west of the country, called the Grassland, there were numerous smaller chieftainries.

The very complex artistic styles did not necessarily coincide with ethnological boundaries. Among the latter the large Bamileke group, with its many subdivisions, was pushed back onto the high plateaux of central Cameroon by the rapidly expanding Bamoum at the turn of the century. All, however, developed a richly varied artistic production.

The chieftainries are like small nation-states whose institutions are clearly defined but vary from one chieftainry to another. In general the chief, aided by his counsellors, governs the nation and has his orders carried out by various secret societies or brotherhoods (the Bangwa people's Brotherhood of the Night is an example). These involve princes, nobility, officials and palace guards. Each brotherhood has its own masks and musical instruments.

Society everywhere is intensely hierarchical and subject to powerful stratification, and art in the king's palace differs from village art. In the Grassland chieftainries the chief, or king, known as the "Fon", lives with his court in

39 Detail of a hut post.
Chieftainry of Bamali, Ndop plain, north-west Cameroon. Carved wood. (Photo: Louis Perrois.) The characters are set vertically above each other. Note the individualistic style of carving with its elongated forms, as if drawn from the solidity of the base.

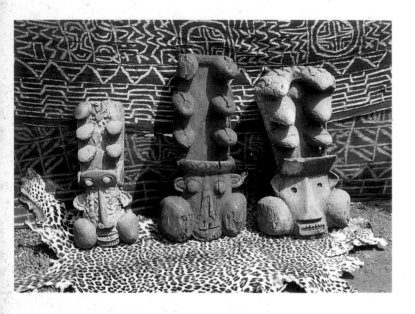

41 Bafandji funeral masks used for Fon funerals.
(Photo: Louis Perrois.)

Right

40 Royal statue.
Cameroon. Bangwa. H: 102 cm. The Metropolitan museum of Art, New York.
Some traditional royal attributes can be seen on this statue - the royal necklace, the pipe in the left hand and the gourd in the right hand.

the capital which is thus a religious and cultural centre. The compartment holding the skulls of the Fon's ancestors is inside the palace; possession of these skulls is essential to legitimise his power, and periodically he worships them. In Cameroon - as indeed elsewhere in Black Africa - the cult of the dead plays an important role as the basis of traditional religion. Even outside the palace the skulls of the famous dead are preserved and receive propitiatory offerings. The palace also has a compartment containing the chieftainry's treasure, which consists of statues of earlier kings, thrones, masks, and sacred musical instruments.

The Fon in each chieftainry has reached the peak of the hierarchy of all the brotherhoods and with the magical powers ascribed to him he is supposed to transform himself into a panther, a buffalo, a python or an elephant. His power is also based on military strength which enables him on occasion to annex a weaker neighbouring chieftainry and to gain payment of a tribute which will help to maintain the wealth of the court.

Art radiates out from the focal point of the royal palace, although it must be remembered that Cameroon has hundreds of chieftainries. Therefore, there is a wide difference between the small principalities and the vast contemporary kingdoms such as Dahomey or Benin with their greatly superior financial means. Despite such subdivisions Cameroon has long been a particularly fertile artistic breeding-ground, one of Black Africa's great centres of creativity.

Work in wood, metal or pottery was in the hands of professionals who passed down trade secrets from father to son and enjoyed general prestige. Sometimes the Fon and the princes themselves deigned to take part in artistic creativity, such as the Fon of Babanki's wood carving or the Bamoum king Njoya's invention of decorative fabric motifs.

Wood-working was often on a monumental scale, giving scope for creating architectural elements, carved window-frames or door-frames for the dwellings of chiefs or secret societies (fig.39); among the Bamileke such carved embellishments were marks of prestige reserved for the nobility and the chief's wife can often be seen among

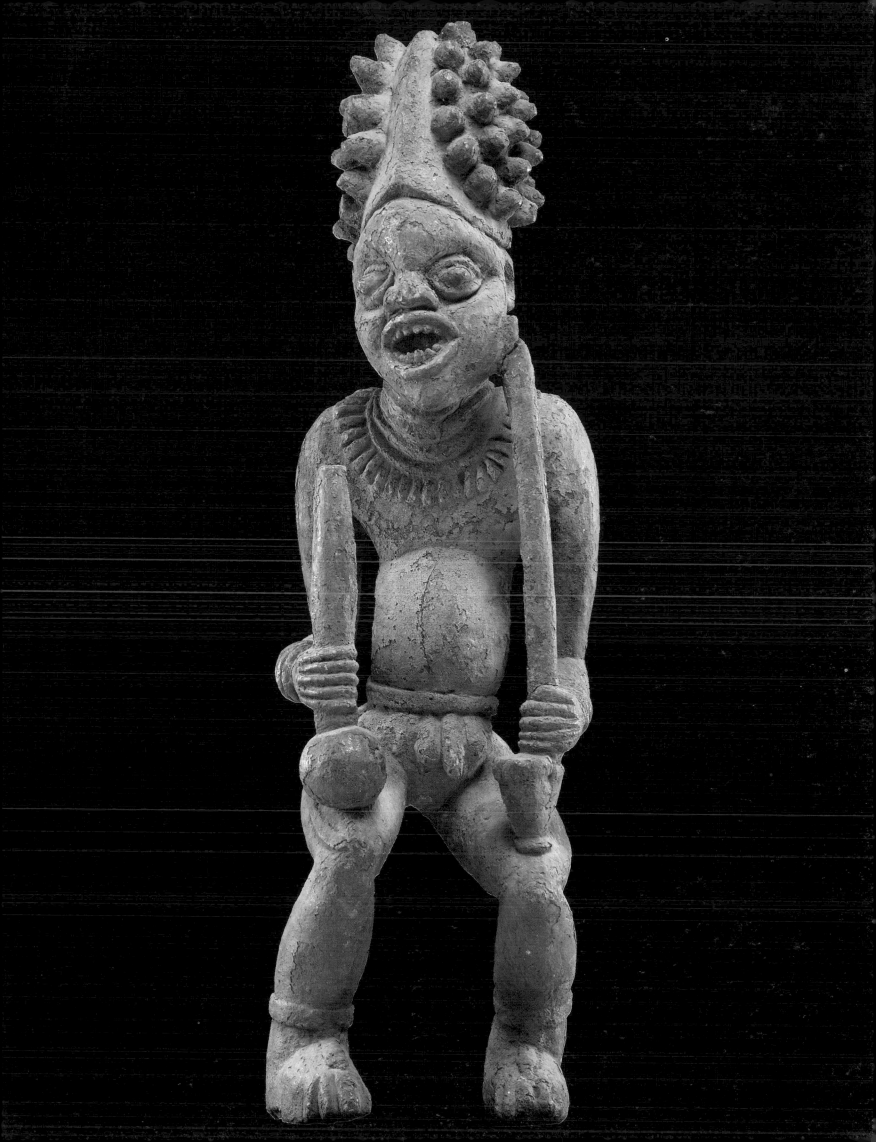

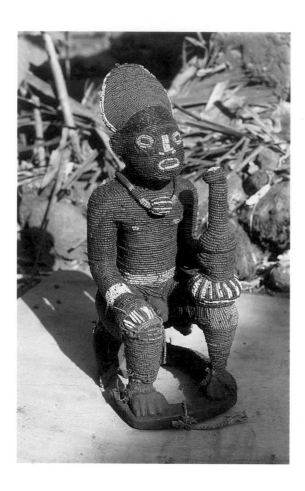

42 Statue from the chieftainry of Mandankwe.
(Photo: Louis Perrois.)

these creations, full-face among mythically significant animals. The tortoise is involved in ordeals; the spider is essential to divining rituals; water creatures, caymans and snakes are symbols of fertility; and above all the panther is the royal beast. Humans and animals are juxtaposed as they stand in horizontal or vertical rows.

Work on actual statues leant more towards the court, and its desire for decoration and representation, than towards religious rites. On his accession each Fon commissioned a statue of himself as well as one of the wife who had given him his first child, statues designed not for ancestor worship but as commemorative portraits (fig.40). Standing, or seated on a carved stool, the kings hold various accessories such as a pipe or drinking horn, and brandish a cutlass or an enemy skull. The forms are generous, the realism dynamic, the figure solidly balanced with legs apart. The queens, sometimes showing signs of pregnancy, stand upright and carry a wine gourd or a bamboo flute.

The surface of statues and wooden objects is often covered with glass beads or cowrie shells stitched onto fabric fitted over the whole statue. This technique reflects the Cameroon people's great love of polychrome effects.

Treasures of the Fons

Each important Fon possessed a treasure which often constituted a very fine collection and Louis Perrois, Director of Research at ORSTOM (the French overseas scientific and technical research Office), has visited the area with his team to carry out an inventory of these unknown treasures.

In the Grassland of the north, the Fon of Bafandji owned one of the most important treasures in terms of beauty and antiquity, including in particular the *Masks* (fig.41) which were used for the Fon's funeral ceremonies. Their tendency towards abstract detail indicated their originality and, as Louis Perrois comments, "The facial elements are taken separately and reassembled in a symbolic manner as a reminder that the Fon belongs to the Council of nine nobles". The protuberances above the face refer to the royal hat seen on some statues.

The Fon of Mandankwé reigned over a small chieftainry near the city of Bamenda. In his treasure a *Royal beaded statue* (figs.42 and 43) represents a seated man whose ceremonial head-dress and ritual vase, held in his right hand, may indicate that he is a Fon.

The treasure of the Fon of Babungo, in the north-west of the country, has thousands of items. This "collection", the most substantial in quantity, constitutes a true "traditional folklore museum", containing beaded thrones with anthropomorphic seat-backs, masks, architectural elements and containers, all designed to create a prestigious setting round the Fon.

The Fon of Kom (fig.44) could be proud of possessing in his palace at Laikom the most famous and beautiful of Cameroon's royal statues, the finest flowering of a remarkable collection of objects of all kinds, from statues to pipes. The three great statues at Laikom, representing the Afo-a-Kom and two women, are doubly regal: created in the reign of the 7th Fon of Kom (between 1865 and 1912), these figures may be the work of the Fon himself and of two princes. The male *Statue* (figs.45 and 46) is thought to be the portait of the Fon Nkwain Nindu, who ruled between 1825 and 1840. Originally the statues of a queen mother (fig.47) and the Fon's wife were complemented by three more figures representing a child and two servants.

Almost life size, these statues are in fact seat-backs depicting the human form, traditional in Cameroon. They symbolised the chieftainry's prosperity and power, and were presented to the people at the great annual dance and at royal funerals. The Cameroon people's love and veneration for these works was intense, and was particularly evident when the three statues, stolen in 1966, were discovered in the United States and returned in triumph to Laikom.

Full of dignity and ethereal serenity, these figures are idealised portraits, well suited to endure down the centuries as expressions of the highest peak of humanity. They are among the masterpieces of Black African art.

Near Laikom the chieftainry of Oku produced the Ngon *Masks* (fig.48) representing heads of princesses similar to those of the Afo-a-Kom statues. Their surface is covered with sheets of brass instead of beading.

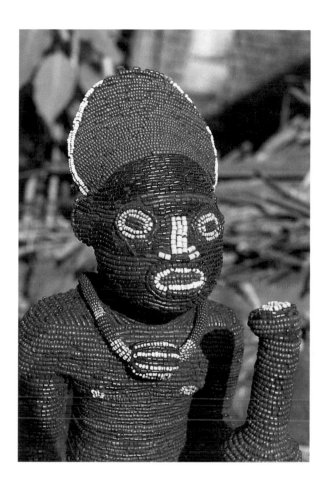

43 Detail of the Mandankwe statue.
(Photo: Louis Perrois.)

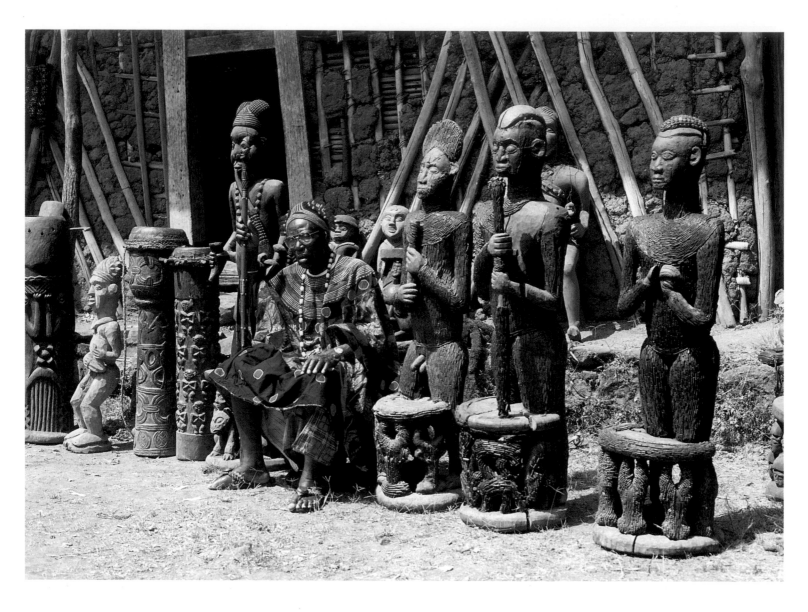

44 The Fon of the Kom chieftainry.
(Photo: Louis Perrois.)
The seated Fon is surrounded by his chieftainry's royal treasure. On the right of the photo are the three famous statues representing the Afo-a-Kom and two women. On the left are other statues of earlier kings and sacred musical instruments (bells and gongs).

The Bamoum and King Njoya

The Bamoum, a dynamic race who conquered their way from the north two or three centuries ago, pushed the Bamileke back into the mountains to the west and settled in the high plains. From their capital Foumban they organised a strong and unified kingdom, even occasionally conquering others. Bamoum art tends towards dramatisation, power and sumptuous luxury and although it lacks the refinement of the best Bamileke works, it inspired some very fine creations.

The Bamoum were fortunate to be led by King Njoya, a man of exceptional intelligence and a great lover of art. His long reign - from 1886 to 1933 - fostered a great spread of creativity.

In his contacts with cultures other than his own, Njoya benefited from the best that they could offer without losing his Bamoum identity. Having converted first to Islam, he became a Christian in 1902, during the German colonial occupation; in 1915, with the departure of the Germans, he became a Moslem once more, reverting again to Christianity under the influence of French Protestant missionaries. These shifts resulted in the creation of a new religion, founded by Njoya on the basis of his own synthesis of the Bible and the Koran.

Having understood the importance of writing, he commissioned his scribes to develop a script suitable for a transcription of the tonally based Bamoum language. Finally, he founded the first truly African museum, the Foumban Museum, which contains statues and objects from the royal collection as well as other items assembled on his orders: statues, masks, weapons, war trophies, sacred symbols of power and the insignia of secret societies. Now fully catalogued, the Foumban Museum helps to perpetuate the tradition of Bamoum art.

Although there is unfortunately no statue of Njoya to accompany the Afo-a-Kom figurines, German photographers who were in Foumban before 1915 collected a substantial body of material on the royal family which is now preserved in the Museum of African art in Washington. The sophisticated life of a large court early in the 20th century can be seen and appreciated here, with its combination of ancestral traditions and the best of European influences.

Washington is also now the home of a beaded statue, almost certainly the commemorative *Effigy* of a member of the court (fig.49), which dates from around 1908. According to the latest research, it was created on the orders of King Njoya to commemorate the death of Captain Glauning, a German colonial officer who died in battle against the Tiv in 1908. By using elongated blue beads the artist skilfully emphasised the blue linear pattern on a white background. The stylised face is very expressive.

Another small Bamoum *Beaded statue* in the Musée de l'Homme in Paris (fig.50) is unfortunately less well documented.

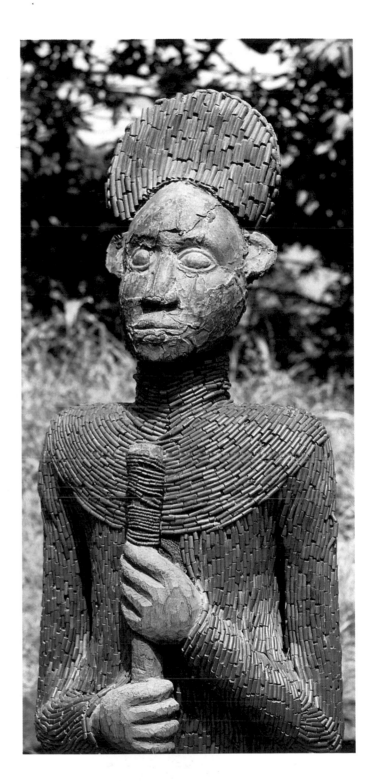

45 Statue of the Afo-a-Kom of Laikom.
(Photo: Louis Perrois.)
This wooden statue, almost completely covered with beads, is a throne-figure.

47 Detail of female figure, possibly a queen mother. Part of the Laikom chief's treasure (Afo-a-Kom). (Photo: Louis Perrois.)

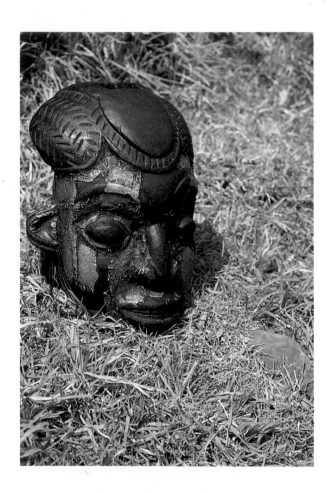

48 Ngon mask From the chieftainry on the slopes of Mount Oku. Head of a princess in wood, plated with old brass. (Photo: Louis Perrois.)

Pipes and state seats

Among the Bamileke, as with the Bamoum, the official seat is a symbol of power and social rank and the throne was made on the accession of a new chief, at the same time as the royal statue. The seat is placed on a figure, which may be an animal or a woman, and the back is made up of statues of one or two figures.

King Njoya's throne, which is preserved in the Museum für Völkerkunde in Berlin, was presented to Germany by the king himself. It is completely covered with beads, predominantly in tones of blue, brown and black, enhanced with white cowries. Several two-headed snakes, symbols of royal power, help to support the seat.

The king also had his *Travelling throne* (fig.51), without a back. A series of figures of servants act as caryatids for this stool, holding each other's shoulders in a sequence which matches that on the step of the great throne; their faces, covered with sheets of copper, are similar to the *njah* masks which were used for certain festivities. Around the cowrie-encrusted seat, the edging with its triangle decoration is a reference to the royal leopard with its spotted fur.

In the court, the members of the royal family, officials, and the grand initiates of the brotherhoods each had the right to a seat indicating their social rank. Despite its luxurious appearance, a great *Seat with back* (fig.52) does not appear to have been destined for King Njoya but for the queen mother, the second most important person in the state. The royal symbol of the two-headed snake appears on the base of the seat as well as on its back.

Pipes existed in endless variety (figs.53 and 54). Very fine brass pipes were often made by the Tikar, using the lost wax process - they were specialists in the arts of metal-working. The majority of the pipes were, however, made of clay at Bamessing, the chief centre for pottery. This art was reserved exclusively for men.

Both the size and the decoration of the pipe were regulated by a strict code, according to the fortunate owner's rank and wealth: a simple geometric motif for an ordinary citizen, a human feature for high officials or members of the royal family, and an animal motif if the

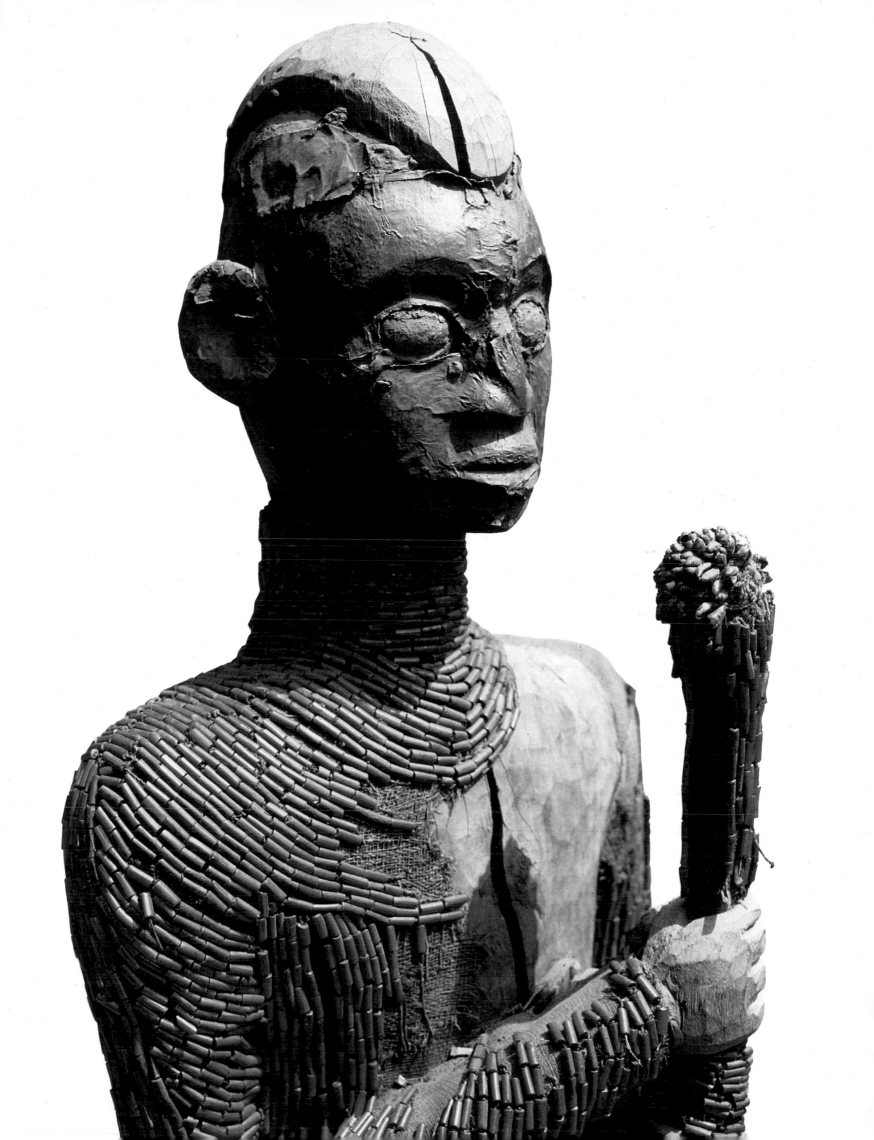

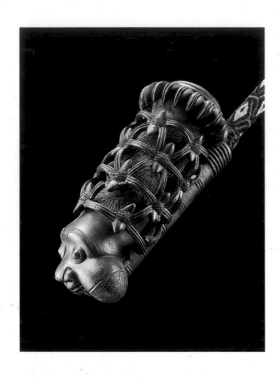

54 Chief's pipe.
Cameroon Grassland.
Bamoum. Clay, with
beaded pipe. Total
length: 110 cm. Museum
of Ethnography, Antwerp.

owner belonged to a secret society or had totemic links with the animal represented. Among the Bamoum, King Njoya often gave terracotta or brass pipes as wedding presents; the bowls had very complex decoration and the stems were encrusted with polychrome beads. The motif on the carved portion was most frequently a human head with puffed-out cheeks and rows of six-legged spiders, insects of mythic significance.

Some pipes were too large to use, and were therefore simply prestige objects. Only the other, smaller pipes, known as "travel pipes", were ever actually used.

To the seats and the pipes should be added a long list of luxury objects, such as fly-whisks and drinking-horns, which were designed to confirm the prestige of chiefs or kings. Preserved in chiefs' treasuries, in the Foumban museum or in the great museums of the United States and Europe, they all offer glimpses of the high level of artistic creativity in Cameroon in the past.

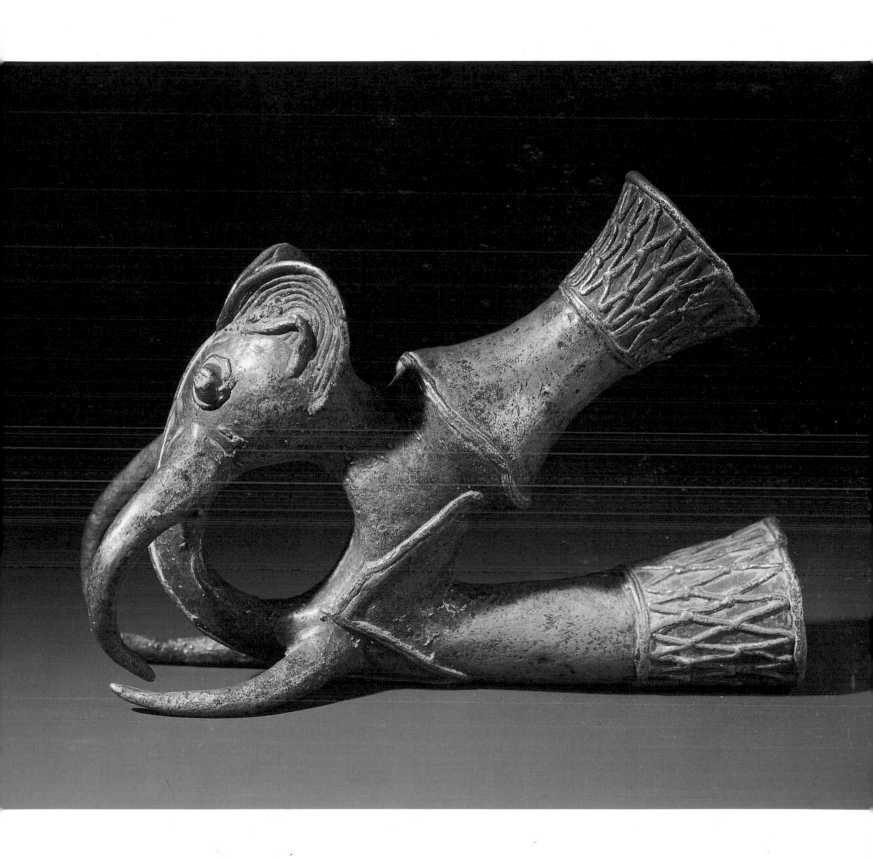

**53 Brass pipe with
elephant's head.**
Cameroon. Bamoum.
Museum Rietberg, Zurich.

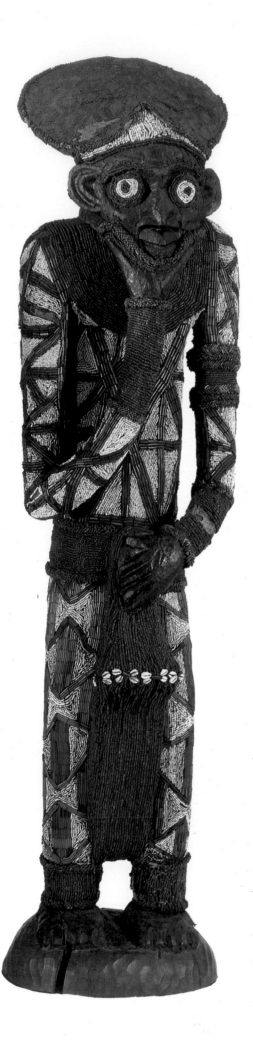

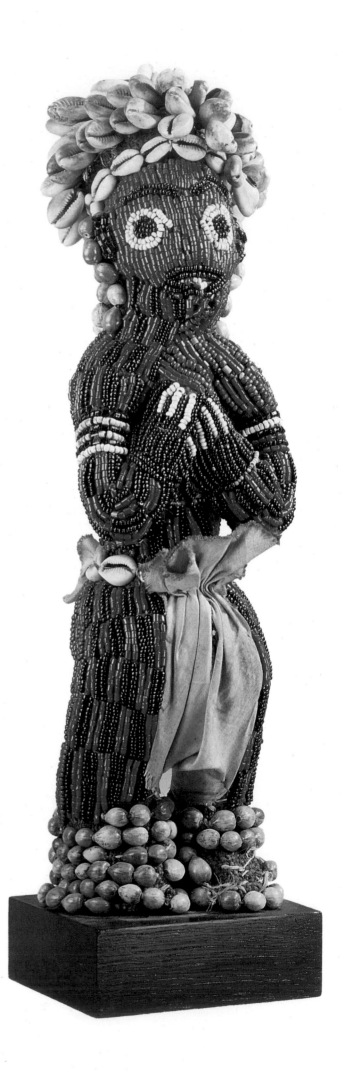

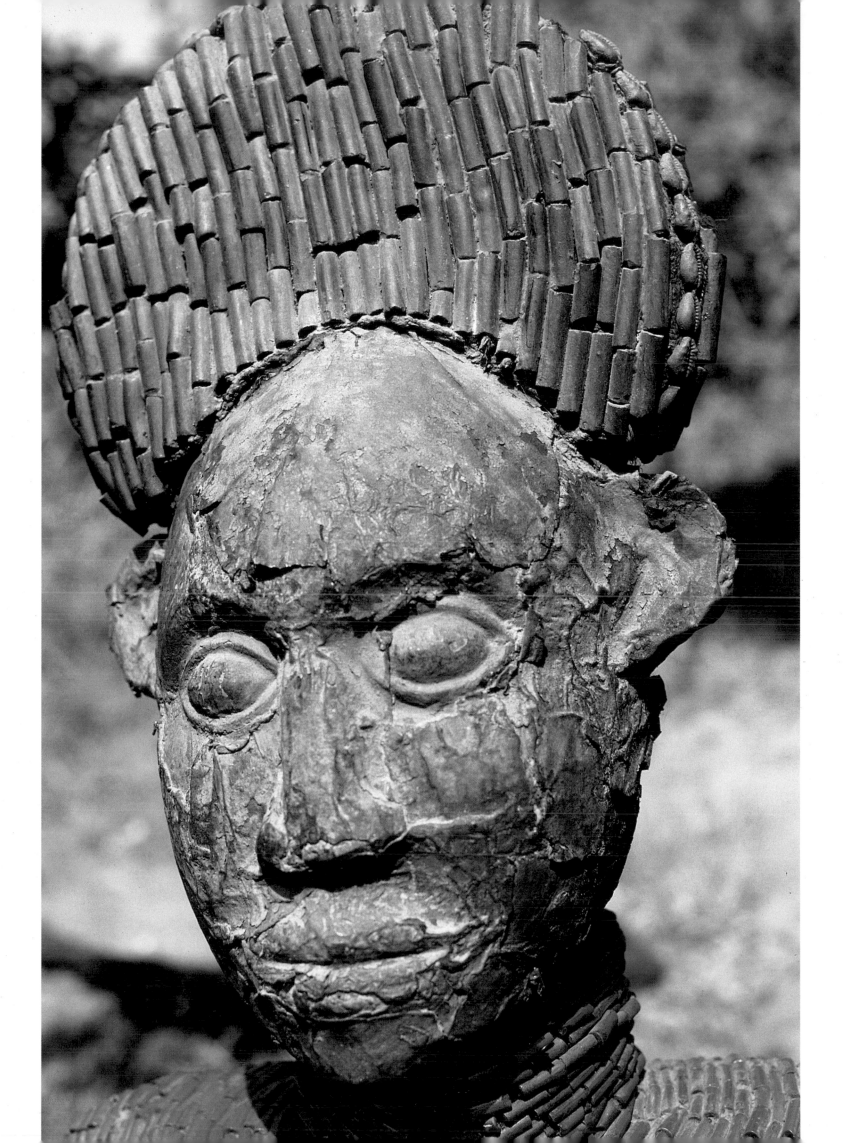

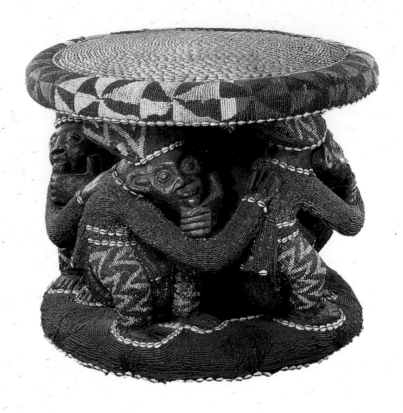

51 Large seat.
Cameroon. Bamoum.
Given by king Njoya to a
German officer, c.1905.
Wood, cowries, beads
and leaves of hammered
copper. H: 57 cm. Musée
Barbier-Mueller, Geneva.

Right

52 Seat with back.
Cameroon. Bamoum.
Wood, beads, cowries
and plates of hammered
copper. H: 120 cm.
Musée Barbier-Mueller,
Geneva.

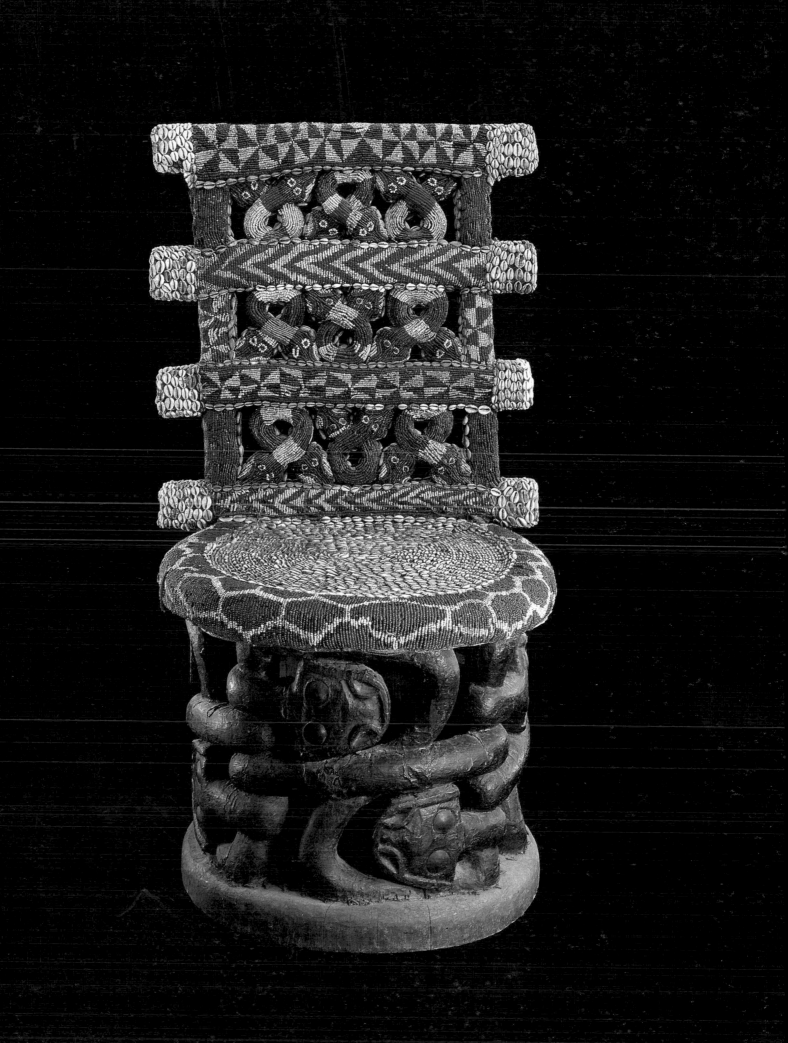

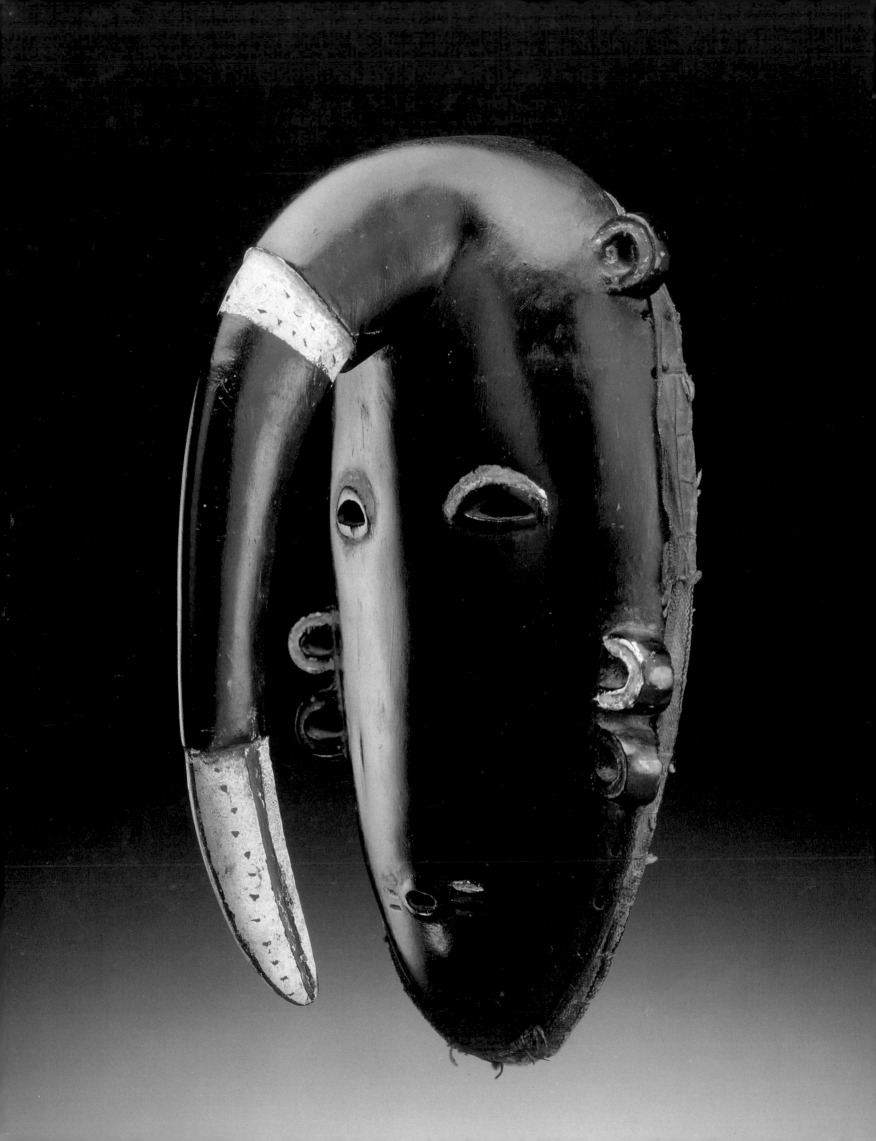

Masks and dances
bringing myths
to life

Imprisoned in a show-case or nailed to the wall like an owl over a barn door, the mask is a dead object. It was an essential basis for a fabric or raffia costume, inseparable from the music, rhythms, chanting, sacrifice and the full ritual which accompanied it and brought it to life. Immobile and solitary, deprived of the elements which frequently raised it to a different level of meaning, its significance is lost.

But what is its meaning? What is its aim? The world of the mask is as complex, widespread and convoluted as the equatorial forest, but a few guiding elements may be distinguished. With Marie-Noël Verger-Fèvre, research assistant in the Black Africa department of the Musée de l'Homme in Paris, we can look at the arrival of the Gbah (chimpanzee) mask in an Ivory Coast village: "He is brought in on a sort of litter [. . .]. He jumps off suddenly and performs a wild dance [. . .]. He throws himself roughly onto one of his acolytes, knocking him to the floor, and appears to disembowel him, puts a piece of fruit in his mouth and departs, leaving him for dead. Soon after, the man reawakens and performs a triumphal dance with his companions". Next comes the interpretation of the scene: "The mask mimed the scene which in the past saved the male villagers' ancestors who were about to be massacred

Left

56 Do mask.
Ivory Coast, Bondoukou region. Wood, blue and white oilpaint, thread and fabric. H: 28.8 cm. Musée Barbier-Mueller, Geneva. The masks of the Do secret society were used by Moslem worshippers for feasts marking the end of Ramadan and for dignitaries' funerals. This mask combines a calao bird's beak and a human face. The dancer performs alone at the end of the ceremony, with the community hoping that propitious impulses emanating from the calao will have a lasting effect.

57 Nimba mask.
Guinea. Baga. Hardwood, upholstery nails and small French coins. H: 135 cm. Musée Barbier-Mueller, Geneva.
This is the largest of the African masks. It was placed on the head of the dancer whose body was concealed beneath a fibre robe. Two holes cut between the breasts enabled him to see. An image of fertility, the Nimba appeared at the time of the rice harvest.

by their enemies [. ..]. After consuming the fruit left by the chimpanzee, they were plunged into hypnotic sleep and considered dead by their enemies. Since then this clan has not eaten any chimpanzees and does not kill them.".

Thus the mask perpetuates and regularly revives the historic tale which it portrays. History is often fixed by myth: the mask brings life to the tribe's founding myths, and to the myths of everyday life. It locates them within the real experience of the living.

More generally, it may be said that the mask is the personification of a spirit, of a supernatural creature intervening in village life. It stands at the junction of the sacred and the profane, making the next world visible and regulating individual existence, and in this setting everything becomes possible. Given visual expression by the mask, the spirit can defend an unwritten moral code, tracking down and punishing those who do not conform to accepted laws.

Such displays involving masks enable laws to be passed from generation to generation without being written down. These laws are personified, given redoubtable repressive powers and intensified through the transfiguring masks as they move into a supernatural world which endows them with an even greater constraining force. In addition, the laws are made attractive, integrated into the collective unconscious, and more readily accepted.

Whatever the form of the mask, it differs profoundly from the carved statuette. Even if an artist works in both fields at the same time, his style is different. The mask belongs to a separate world and does not always reflect the style of ethnic figurines and, although the sculptor was bound to conform with tradition for each category of mask, the mask frequently displays surprising combinations of form. Unlike statues, the mask very often unites human and animal elements to create a hybrid incorporating into the human elements not only an animal form but above all its vital force, so that the mask links the dancer to everything living in the world (figs.55, 56 and p.8)

Finally, as a creation independent of man, the mask rarely depicts humans: in fact it is deliberately different from them. It is this difference which constitutes its strength.

The intervention of masks marks all the significant

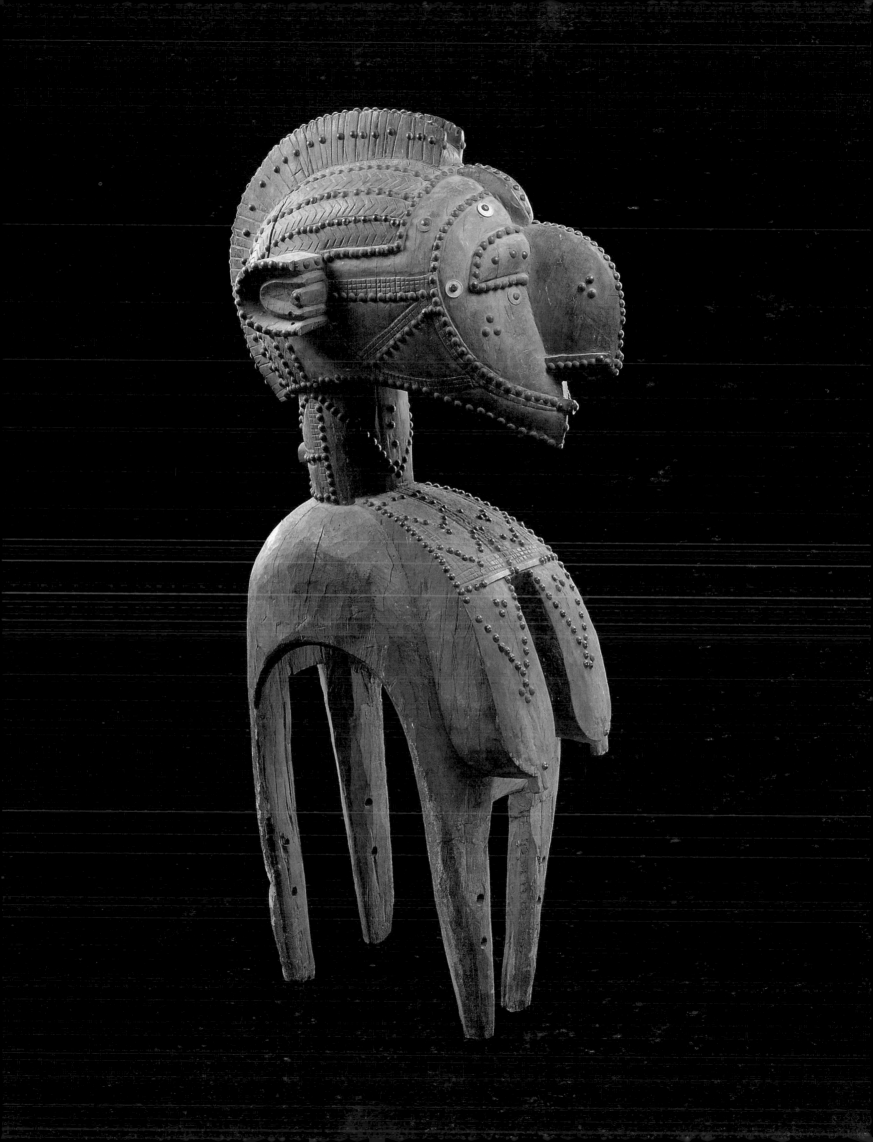

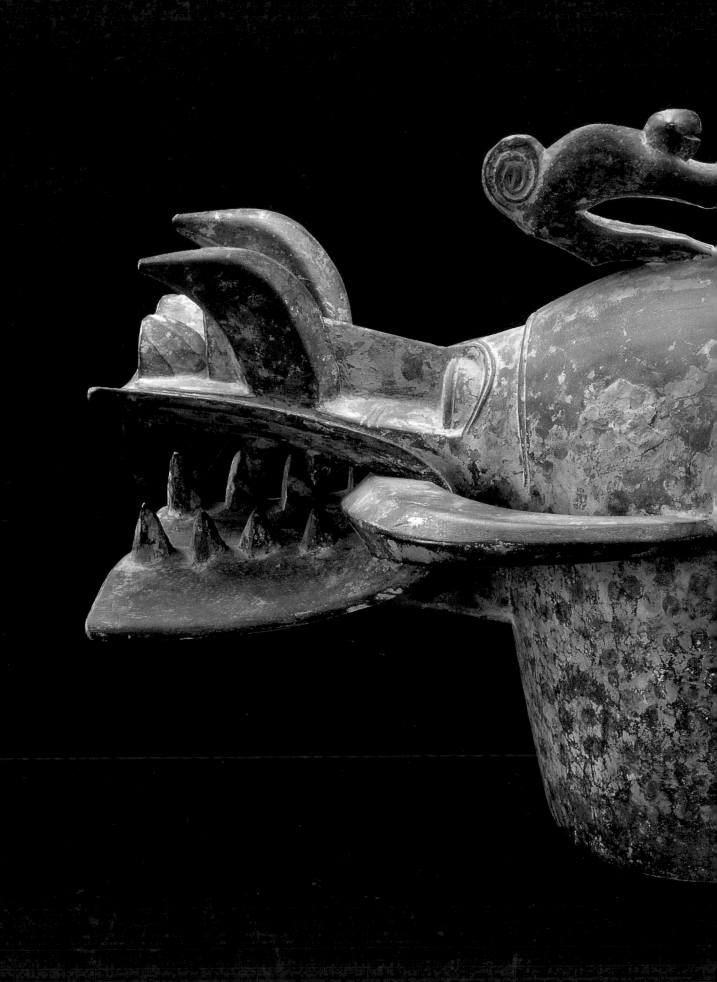

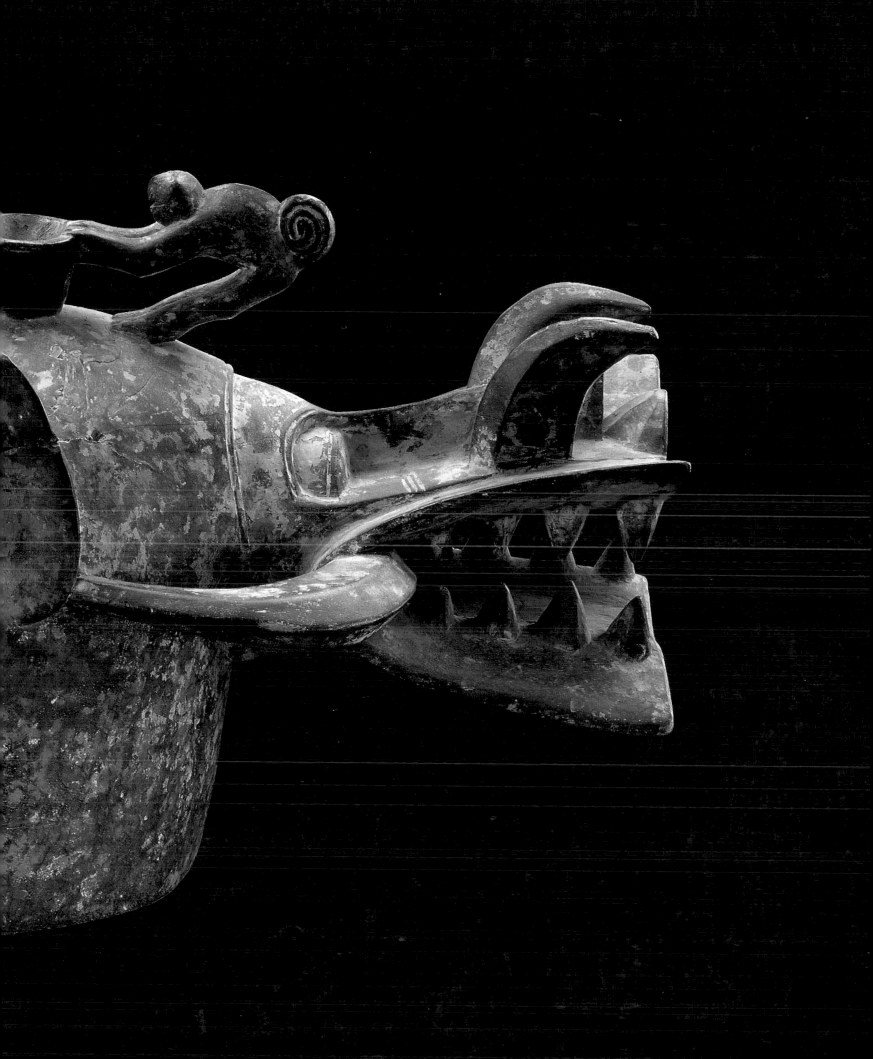

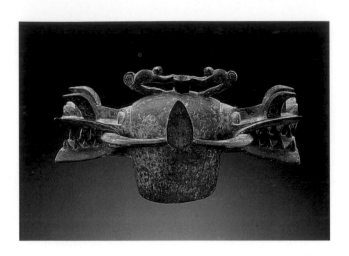

Above and previous page

55 Janus mask of Waniugo style.
Northern Ivory Coast. Senufo region. Musée Barbier-Mueller, Geneva. This double mask is entirely composed of threatening features: the jaws bristling with large teeth, the multiple horns and, above all for Africans, the small cup held by two chameleons on top of the head. Material alleged to give the mask strength and evil power was put into this cup. A magical object, it was used by small associations of men attached to the Poro. See p.8 for a Wambele mask dancing. Ivory Coast, Senufo. Barbier-Mueller Archives, Geneva.

moments in African life, and three stages in particular: fertility rites, initiation into adult life and funerals. This is not an exclusive list, however, and, depending on the customs of each ethnic group, masks may appear in the most varied situations.

Fertility rites

These masks tend to be found in regions sufficiently far from the Equator for the rhythm of the seasons to allow significant crop cultivation. Fertility rites belong to the end of the harvest, as in the cultures of, for example, Guinea, Mali, the Ivory Coast and the Cameroon Grassland. The participants ask the spirits and the gods concerned to grant them descendants, to help the crops and increase their livestock.

At harvest time the Baga, who live near the Guinea coast, take the great *Nimba mask* (fig.57) through their fields. The peasants see its fibre robes and heavy breasts appearing from among the crops and beg for its protection, even if elsewhere they proclaim themselves as Moslems.

In the Ivory Coast and Burkina Faso, in rites begging the god Do to grant rain to the farmers, numerous zoomorphic masks mingle human and animal features. The form of the butterfly (fig.58) is a reminder that these insects appear in great numbers immediately after the first rains.

Among the Bambara, who are also farmers, at the beginning of the rainy season young men wearing *Tyiwara crests* (figs.59 and 60) dance in the evening in the village square after their day's work in the fields. They glorify the spirit Tyiwara, guardian of the harvest and object of worship by the society that bears its name. The Tyiwara crests are always in pairs, male and female side by side, marvels of harmonious elegance.

In the north of Cameroon the *Ma'bu mask* (belonging to the Ngwarong secret society) is used in land and fertility rituals (fig.61). This very powerful mask also appears at funeral ceremonies. The face combines anthropomorphic and zoomorphic features, with its "visor" forehead and the puffed-out cheeks of the masks of western and northwestern Cameroon.

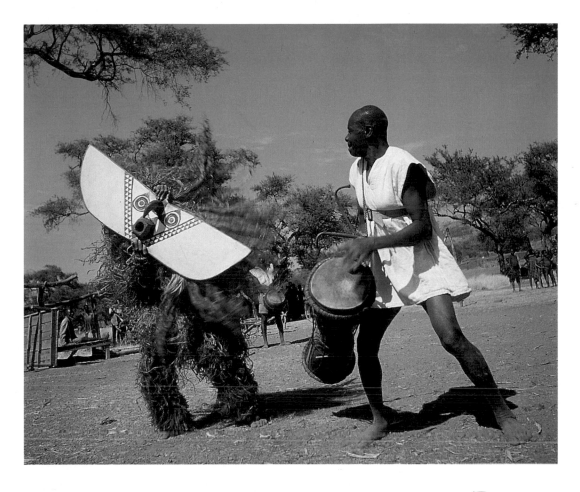

58 Do mask.
Burkina Faso. Bwa. (Photo: Hoa Qui.)
The god Do represents renewal. This butterfly-shaped mask appears during fertility rites and after harvests.

61 Ma'bu mask.
Cameroon. Nkambe region. (Photo: Louis Perrois.)
The mask is set horizontally on the head of the dancer, whose face is hidden by a sort of ventilated black fabric. Under the mask is a large cape of bird's feathers.

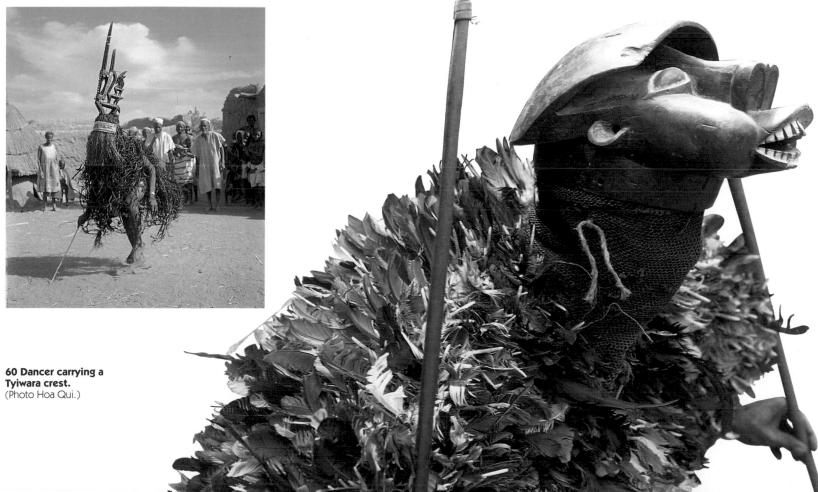

60 Dancer carrying a Tyiwara crest.
(Photo Hoa Qui.)

59 Tyiwara crest.
Mali. Bambara (Bamana) from the Beledougou region. Wood, vegetable fibres and iron nails. Musée Barbier-Mueller, Geneva.
The Tyiwara crests can have many widely varying shapes on the theme of the antelope, which is always very elegantly depicted.

Masks visible to all

The masks moulded the personalities of members of the tribe, an effect which developed progressively, by stages. Women and children had to hide, sometimes under pain of death, when the most feared masks paraded through the village, preceded by the sound of trumpets, but many spectacles using masks were (and still are) open to all as entertainment on festive occasions.

Such celebrations are particularly widespread in the Ivory Coast. Among the Dan, the *Comic mask* with its black polished human face mimics and ridicules certain personalities in the village, such as the careless woman who neglects her work. Frequently, too, the young men wearing the *Racing mask* hold sporting competitions amongst themselves, to see who will arrive first. So that they can see better, large round eyeholes are cut out of the smoothly curved surface of the face. Among the We, or Bete, the *Singing mask* (fig.62), laden with little bells and accompanied by drums, sings the praises of the feast's organisers and revives ancient tales and famous deeds of their ancestors, quoting proverbs familiar to all. Still with the We, the *Begging mask* which often accompanies the singer entertains the public with clowning as the wearer gathers up little gifts for himself.

Among the Dan, however, the feast is sometimes roughly interrupted by the sudden intervention of the *Brawling mask* (fig.63), with its coarse appearance, a sporting duplicate of the *War mask*. He throws wooden hooks around him and may set off a "joke war", which serves as another welcome point of interest during the rejoicing.

At any moment, not only at feasts, the *Gunyege mask* (fig.64) may burst in, playing the role of a frowning policeman. Woe to the woman who has carelessly lit her cooking fire too close to the grass of the plain on a windy day! The Mask overturns and confiscates the cooking pot, which will only be returned to the guilty woman's husband on payment of a heavy fine.

Mention should also be made of the *Gelede masks* (fig. 65) of the present-day Yoruba in Nigeria, named after the brotherhood of the same name, for which the sculptors give full rein to their imagination and which appear on a variety of occasions.

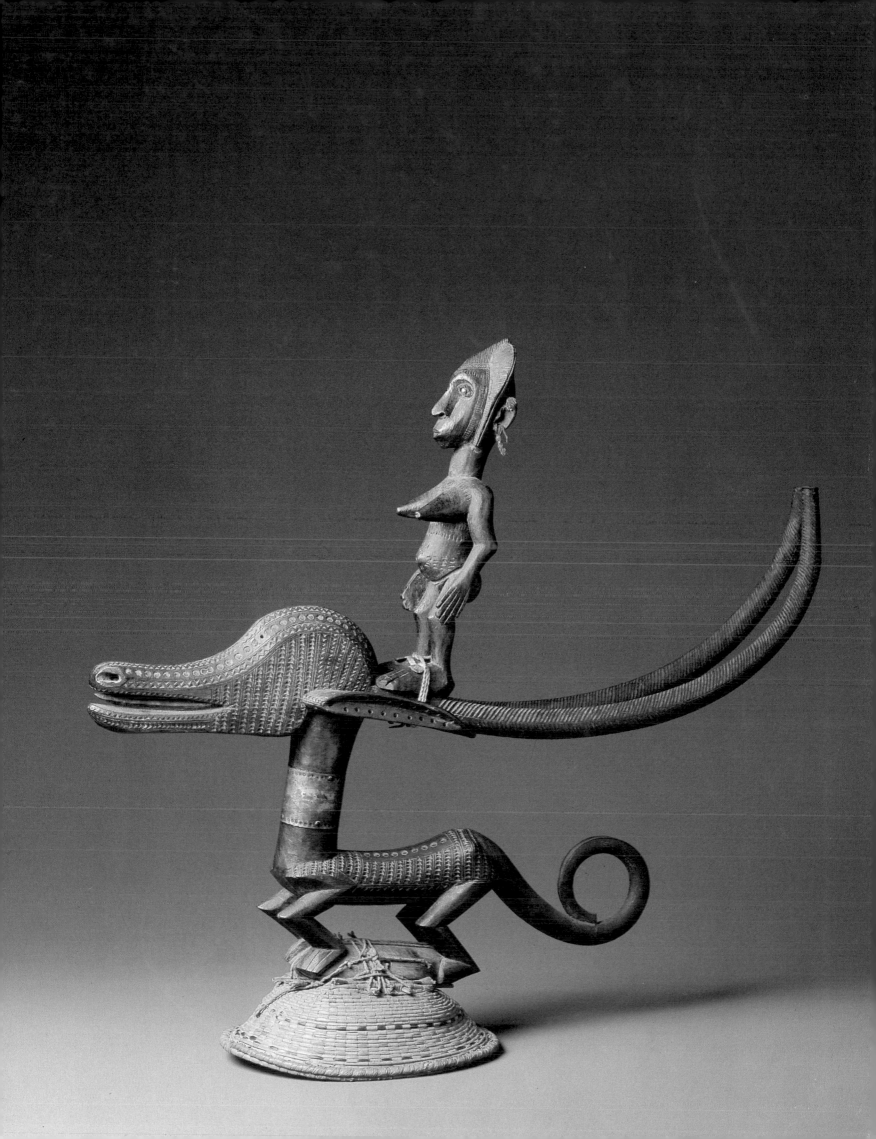

62 Singer mask.
Ivory Coast. We or Bete.
Wood, iron and brass
nails, fabric, cowries,
human hair and four small
brass bells. Size: 26 x 20
x 11 cm. Musée des
Beaux-Arts, Angoulême.
Considered feminine and
elegant, this mask
enlivened festivities.

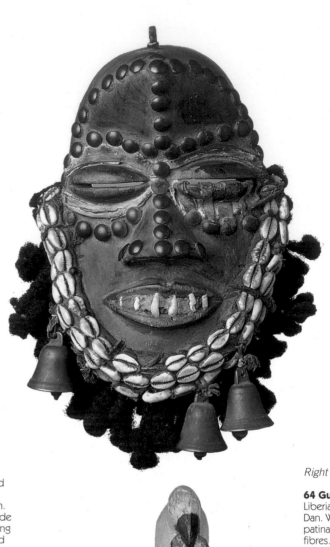

63 Brawler mask.
Ivory Coast. Dan. Wood
and vegetable fibres.
Size: 21 x 14.5 x 11 cm.
Musée de l'Afrique et de
l'Océanie, Paris. Brawling
and brutality expressed
with a minimum of
means.

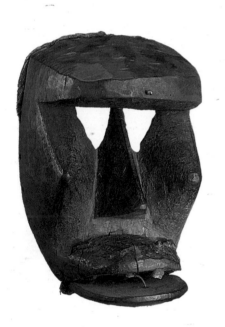

Right

64 Gunyege-type mask.
Liberia and Ivory Coast.
Dan. Wood with deep
patina and cap of plaited
fibres. H: 36 cm. Musée
Barbier-Mueller, Geneva.

**65 Mask of the Gelede
brotherhood.**
Benin (formerly
Dahomey). Yoruba.
Polychrome wood, traces
of red, yellow, black and
blue. Size: 47 x 33 x 40
cm. Musée de l'Afrique et
de l'Océanie, Paris.
These masks for
entertainment were
always very diverse in
style. This example has
the face of a bearded
man wearing a turban, no
doubt representing a
Moslem dignitary with,
above, geometrical forms,
an upturned crescent
and, finally, two birds
modelled in the round.
This mask was worn
across the top of the
head.

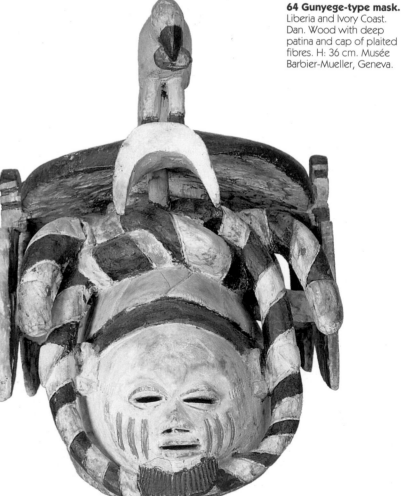

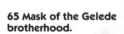

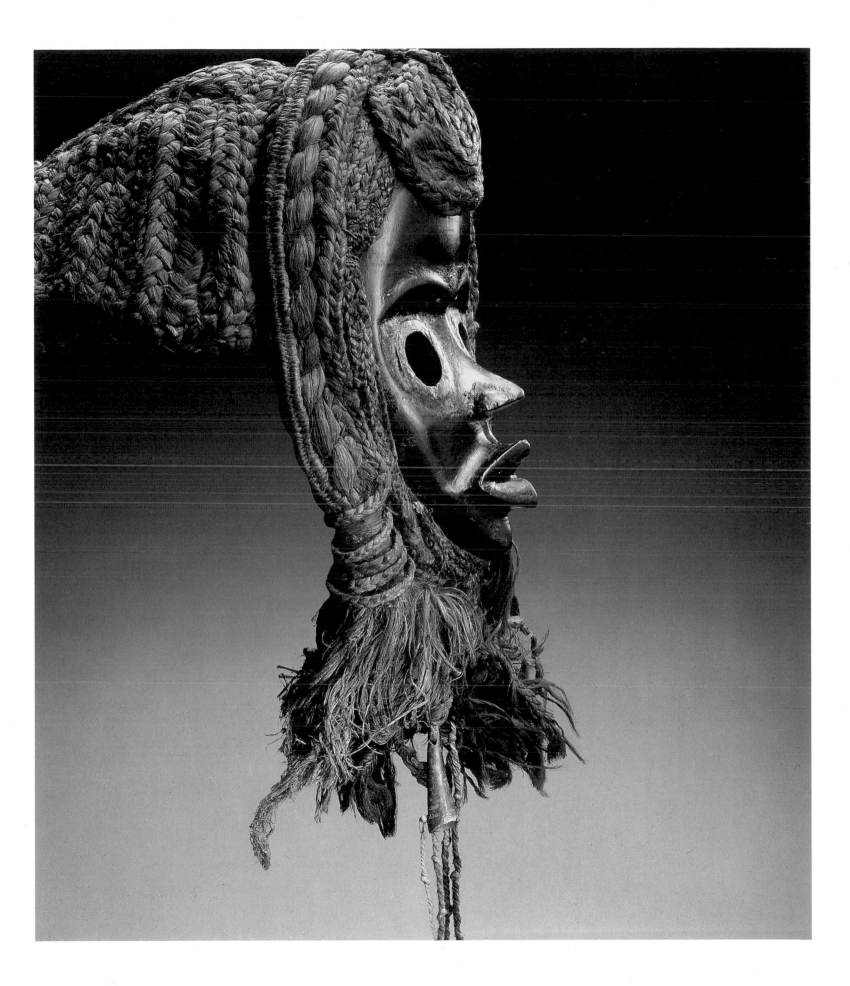

66 Cikunza mask.
Zaire and Angola. Jokwe.
Branches, resin, beaten
bark and fibres. H: 162
cm. Musée
d'Ethnographie,
Neuchatel.
The mask imposed the
authority of the man
directing circumcision
rites.

Impressive masks for initiation rites

The period of initiation was crucial for all adolescents. Some tribes had rites of passage for boys, others for girls and still others for both sexes. These were rites to render them adults with rights, but conscious of their responsibilities. Initiation was practised among most tribes but not all and included in each case a period of seclusion away from the village. However, initiation varied greatly in form from one culture to another - there was no one overall style.

Take for example the Jokwe in Angola, who have been studied in depth by Marie-Louise Bastin, professor at Brussels University. Boys would spend several months in the bush school where circumcision was carried out and masked men taught them adult behaviour and led them through a sequence of often very demanding trials. Masks shaped out of bark, twigs, branches, resins and fabrics and painted with symbolic motifs, evoked the cosmos. The spirit dominating these rites was the *mukishi*, a disembodied being, believed to be dead but bursting from the earth completely clothed in fabric, a supernatural being to be both feared and worshipped. The man directing the ceremonial rites of passage wore the pointed *Cikunza mask* (fig.66), made up of mixed anthropomorphic and zoomorphic elements. The great *Kalelwa Mask* (fig.67), which might be related to celestial waters, intervened when the novices were short of food.

An impressive mask (fig.68), which might be found among the Yaka people, neighbours of the Jokwe, was also linked to initiatory rites and the dances performed when the young circumcised men returned to the village. Among the Baga Fore in Guinea, other initiation festivities were the occasion for a dance of wooden beams in the form of pythons (fig.69), which were perhaps a phallic symbol. These beams are not masks but accessories to the dance.

Most of the masks involved in initiations belonged to secret brotherhoods, so their appearances were not restricted to the initiation of adolescents. They might take place on other occasions, often still little known, for initiations allowing officials to attain higher ranks within the brotherhood, or at funeral ceremonies. This was the case

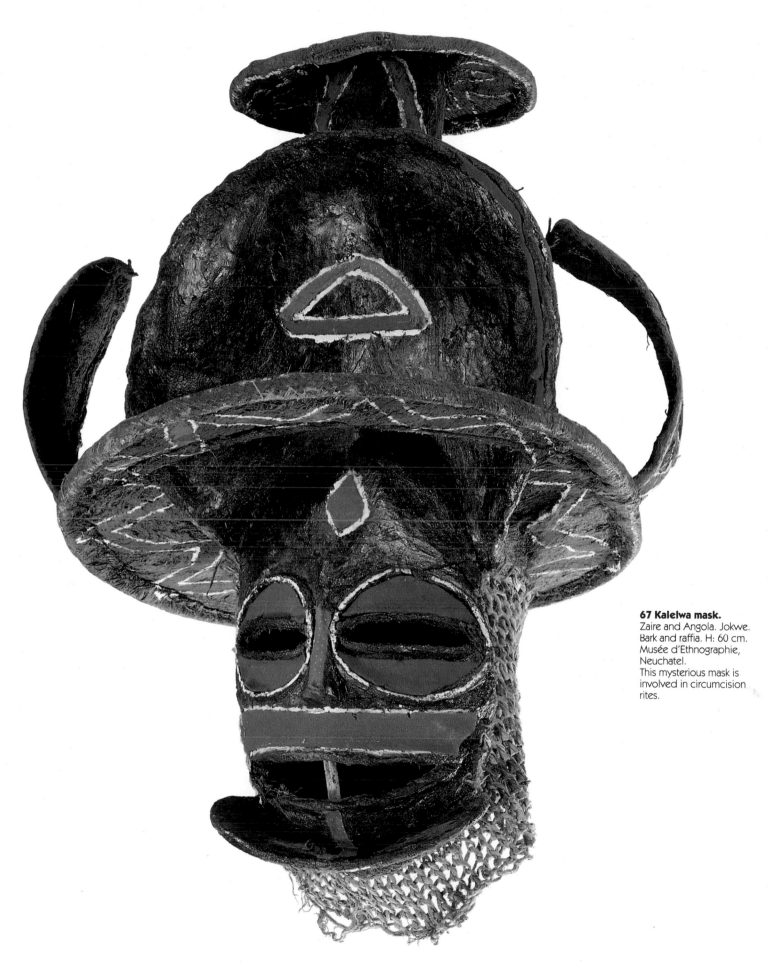

67 Kalelwa mask.
Zaire and Angola. Jokwe.
Bark and raffia. H: 60 cm.
Musée d'Ethnographie,
Neuchatel.
This mysterious mask is
involved in circumcision
rites.

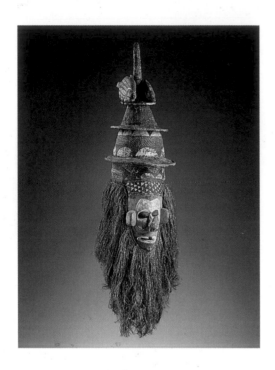

68 Initiation mask.
Zaire. Yaka. Wood, raffia
and fibre. Various
colours. H: 71.5 cm.
Musée Ethnographique,
Antwerp.
New initiates danced
with these masks, whose
white-painted faces were
reminders of death.
Figurative elements - here,
fish - may vary, but are
derived from a
mythological cycle.

in Zaire with the Lwalwa's *Nkaki masks* (fig.70), among the Salampasu (fig.71) and finally with the mysterious Mbagani masks (fig.72).

According to Frobenius, in Zaire the Songye people's *Kifwebe mask* (fig.73) was worn by the chief or the witch-doctor in serious cases such as epidemics, the death of the king, or war. More recently, it was used in the initiation rituals of male societies.

The masks of the Makonde (fig.74) in Mozambique, off the east coast of Africa, also appeared at initiation ceremonies and funerals.

Masks as the basis of social life

Although African societies vary very widely in their styles, the secret brotherhoods and their masks play a central role everywhere in asserting authority, assuring social control and repressing deviant behaviour.

For ceremonies designed to legitimise the authority of certain families, the Temne people of Sierra Leone have a mask (fig.75) which represents the spirit responsible for protecting the reigning dynasty of each chieftainry. This legitimises the religious power of the new chief. The mask is only seen in public for the enthroning ceremony of a chief, in which it plays a central role and is worn not by the chief himself but by the dignitary presiding over the transmission of power from one chief to the other. The same dignitary also acts as mediator between the new chief and his people.

In the past masks disguising men had a part in all areas of society, until they were replaced by administrative or judicial systems.

The *War mask* (fig.76) of the Grebo people of Liberia spread fear all around with its fearsome expression. It was meant to terrify opponents in battle and, above all, to put the enemy's protective witchdoctors to flight.

Elsewhere it was a matter of easing the payment of taxes, which was the great achievement of the Jokwe's *Cihongo* (fig.77). Evoking the spirit of wealth and worn by a chief's son for tours lasting several months, in return for its dances it received substantial gifts equivalent to a

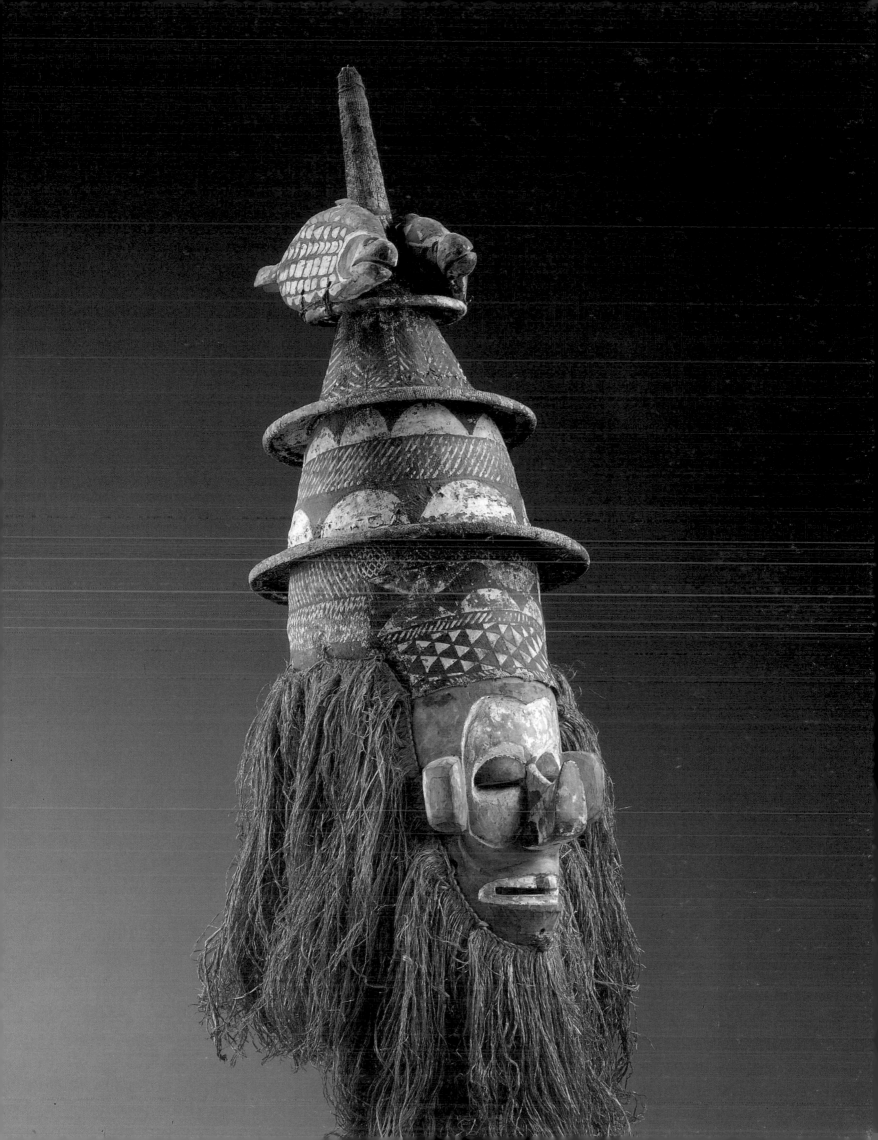

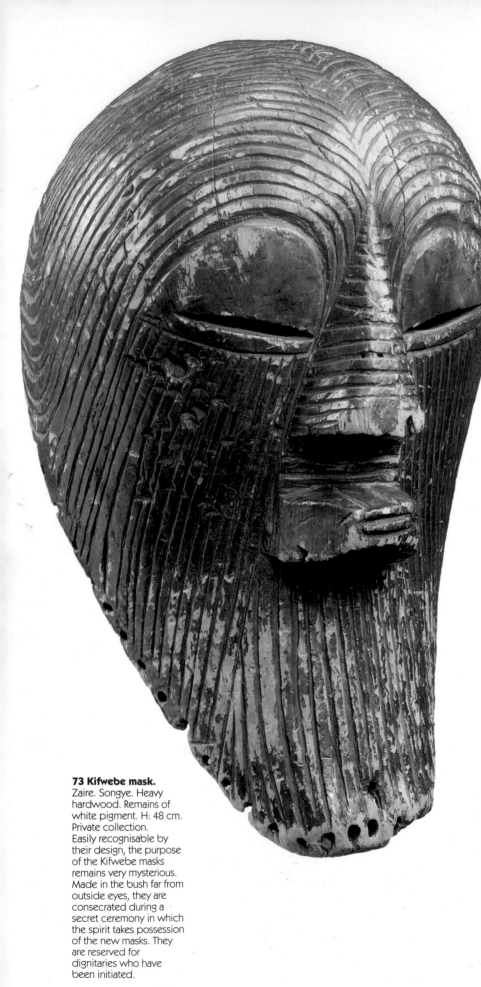

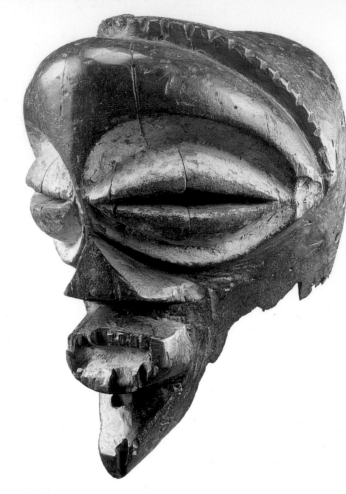

72 Circumcision mask.
Zaire. Mbagani. Wood. H: 31 cm. Private collection. These masks appeared during initiation ceremonies. Their enormous white eye-sockets overwhelm the thin face with its pointed chin, creating an impression of calm contemplation.

73 Kifwebe mask.
Zaire. Songye. Heavy hardwood. Remains of white pigment. H: 48 cm. Private collection. Easily recognisable by their design, the purpose of the Kifwebe masks remains very mysterious. Made in the bush far from outside eyes, they are consecrated during a secret ceremony in which the spirit takes possession of the new masks. They are reserved for dignitaries who have been initiated.

76 Facial mask.
Ivory Coast and Liberia. Grebo. 19th-20th centuries. Wood and pigment. H: 69.9 cm. The Metropolitan museum of Art, New York. Symbolising the implacable nature of battle, this war mask is designed primarily to terrify. Nothing interrupts or softens the rigorously straight line of the nose, the rectangular mouth with its menacing teeth, or the protruding eyes. These masks appeared during battles, in the dances beforehand, and at the funerals of members of the group of warriors of the same age.

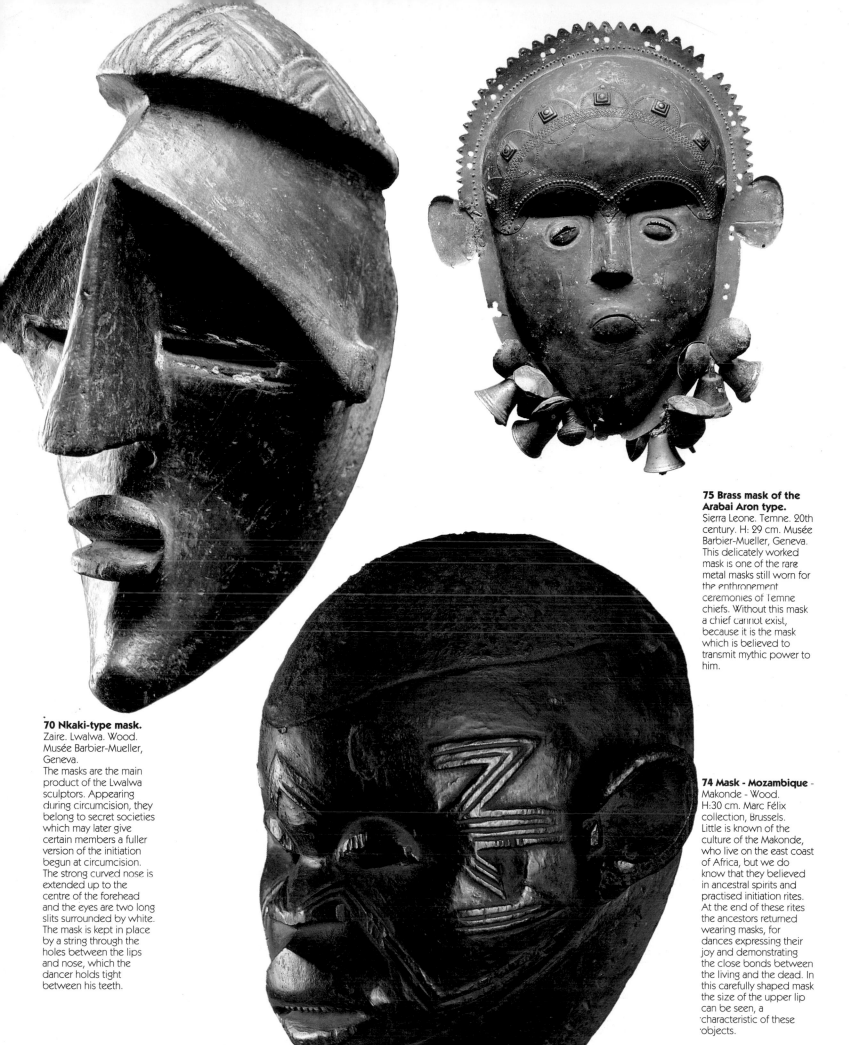

75 Brass mask of the Arabai Aron type.
Sierra Leone. Temne. 20th century. H: 29 cm. Musée Barbier-Mueller, Geneva. This delicately worked mask is one of the rare metal masks still worn for the enthronement ceremonies of Temne chiefs. Without this mask a chief cannot exist, because it is the mask which is believed to transmit mythic power to him.

70 Nkaki-type mask.
Zaire. Lwalwa. Wood. Musée Barbier-Mueller, Geneva.
The masks are the main product of the Lwalwa sculptors. Appearing during circumcision, they belong to secret societies which may later give certain members a fuller version of the initiation begun at circumcision. The strong curved nose is extended up to the centre of the forehead and the eyes are two long slits surrounded by white. The mask is kept in place by a string through the holes between the lips and nose, which the dancer holds tight between his teeth.

74 Mask - Mozambique - Makonde - Wood. H:30 cm. Marc Félix collection, Brussels. Little is known of the culture of the Makonde, who live on the east coast of Africa, but we do know that they believed in ancestral spirits and practised initiation rites. At the end of these rites the ancestors returned wearing masks, for dances expressing their joy and demonstrating the close bonds between the living and the dead. In this carefully shaped mask the size of the upper lip can be seen, a characteristic of these objects.

71 Arrival of masks.
Zaire. Salampasu. (Photo: Hoa Qui.)
These masks were probably used in circumcision and initiation ceremonies in male societies.

Right

69 Bansonyi.
Guinea. Baga Fore. Red, black and white hardwood and polychrome. Encrusted with European mirrors. H: 215 cm. Musée Barbier-Mueller, Geneva.
Linked to the python myth, these long sinuous beams came in pairs for the youths' initiation rite among the Baga Fore. Their dance is a duel between the aquatic world and the jungle, between east and west, between "husband" and "wife", the two halves of the village. The feast started when they appeared and, once it was under way, they disappeared back into the wood.

tribute. It could also administer justice by pointing out a guilty person in the crowd.

Still in Zaire, the king of the Kuba understood how much could be gained from this credulity among the population. A spirit called *Mwaash a Mbooy* was terrorising the Kuba; on the king's orders masks created to "resemble" this spirit, the *Mukyeem* or *Mwaash a Mbooy masks* (fig.78), were supposed to assess everyone's behaviour, and added their power to royal justice. Further, when they appeared before their subjects the chiefs wore the *Mwash a Mbooy* costume, for which the masks were made in the royal workshops.

It was not actually necessary to be king to become a judge. The members of many secret societies had numerous opportunities to turn themselves into judges, the best known being the Poro of the Senufo, in the Ivory Coast, who often exercised a reign of terror under the pretext of social regulation, the maintenance of order and the pursuit of criminals.

Similar to the Poro, but more humane, was a female society, the Bundu or Sande in Sierra Leone, which ruled the female world and presided over the initiation of young girls before marriage.

No matter how great the Poro's importance in pursuing criminals of all kinds, it was not alone in adopting this role. The Ogboni societies of the Western Yoruba, and above all the Ekoi societies in Nigeria, took on the same role and watched over the behaviour of members of the tribe through the eyes of masks covered in skin (fig.79).

Finally, in Cameroon, how could the inquisitorial gaze of the *Crest of the brotherhood of the Night* (fig.80) be avoided? Its most powerful members embodied a repressive power from which royalty judiciously distanced itself, and the *Ngil mask* (fig.81) in Gabon was hardly more reassuring. There are many more examples which could be quoted.

Sometimes, however, the simple village inhabitant could look to the masks for protection, as in the Ivory Coast and the masks of the Koma society, whose aim was to combat the misdeeds of witchcraft, which were both widespread and powerful.

Funerals, the final rite of passage

Death, the second great rite of passage, is of capital importance to animist Africans who believe that only the body dies while the spirit and the "soul" live on. They continue to surround the living, who are menaced by their jealousy aroused by their death, a vital force which must be seized and channelled through dancing for the benefit of those who remain on earth. This is not without danger, but the mask protects the dancer who wears it as a safeguard against attack by the dead man's spirit. These wandering souls must be prepared for their new existence and their entry into the kingdom of their ancestors must be eased.

With these fundamental concepts, common to different Black African peoples, as a starting-point, each culture has its own particular way of celebrating funerals: generalisation is impossible. Marcel Griaule has studied this ritual thoroughly among the Dogon of Mali, who may serve as an example. The death of a member of the tribe is announced with drums, bells and gunfire and the body is carried to the catacombs in a cliff where other villagers are already buried. The next day the men dance, mime battles and sing litanies. Finally, after a variable period of mourning, festivities involving dancing with various masks mark the end of the mourning. The great *Kanaga masks* are present, their superstructures resembling a cross of Lorraine. Marcel Griaule sees a link between these unexpected shapes and cave paintings which he discovered in the Dogon lands. Then the anthropomorphic *Walu masks* appear (fig.82), with their antelope horns and numerous zoomorphic masks - for example hares, lions or hyaenas. All these masks are sacred - charged with magic power, they represent dangers for the uninitiated. At the end of the dances the masks are considered to have played their part and can return to the cave where they are normally kept. The spirit of the dead man has reached the spirit world and definitively rejoined his ancestors.

Not far from the Dogon, among the Bwa people of Burkina Faso, the impressive *Board masks* (figs.83 and 84), some 3 or 4 metres tall, played a part in funerals and initiations.

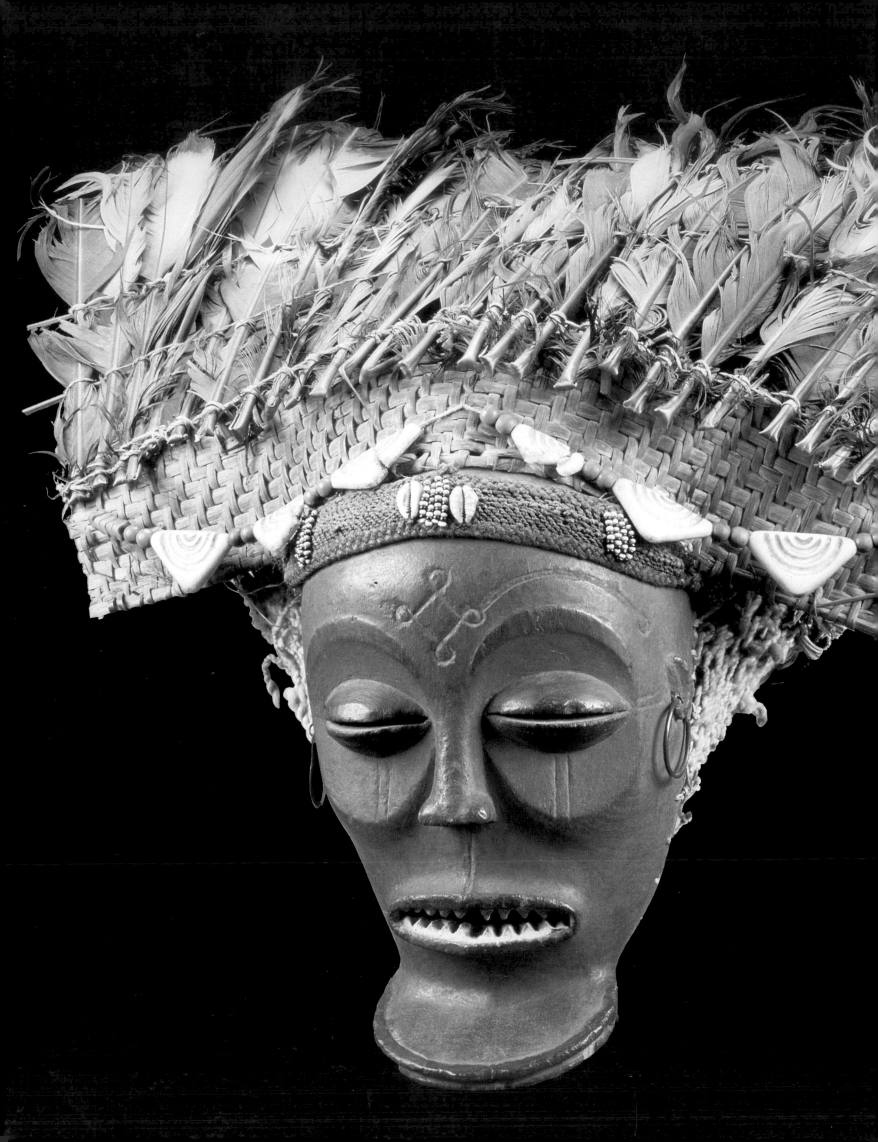

77 Cihongo mask.
Zaire Jokwe Wood,
brass, feathers and
plaited fibres. H: 24 cm.
(Photo: Hughes Dubois,
Brussels.)
A symbol of power and
wealth, this mask may
only be worn by a chief
or a chief's son, who is
allowed to collect
substantial gifts during the
dances.

"Grand funerals", ceremonies not for a single dead person but for several of the same age-group or who have died during a particular period, might be marked among the Senufo of the Ivory Coast by the appearance of the *Deguele masks* (fig.85). They were helmet masks topped with figures. This rare ritual of great pomp was part of the Poro ceremony.

Elsewhere, funeral ceremonies might have very different forms. In Gabon, for example, among the Tsangui of the south or the Kwele in the north-east, certain masks known as "white masks" were worn by men but represented the female ancestors of the dead man (figs.86 and 87). They are remarkable for their extraordinary beauty and the wealth of their psychological connotations.

Life and death of the masks

In African thinking, the mask was always the bearer of a fearsome magical energy for those who animated it as well as for those who saw it. To understand the origin of this "power", we must look at the creation of its material substance.

The shape of a mask is traditional and not specific to any one period. In the Ivory Coast, if a mask deteriorated or was destroyed, a small replica was made as a temporary refuge for the mask's spirit; this spirit should next show itself in a dream to its future dancer, who would find a sculptor to take the commission. Sometimes, too, among the Dogon in Mali or in Gabon, the masks were not supernatural powers but the temporary incarnation of a spirit, an ancestor or the vital energy of the dead, and were constructed by initiates. Required to conceal details of the initiation from outsiders, the neophytes disclosed nothing to those around them and retained their faith in the power of the masks on the religious level of the spirit world as well as on the social level.

Professional or not, the craftsman had to conform to existing models of masks: he did not have a free rein. He worked in great secrecy, for the mask was never considered to be human work - it was always attributed to supernatural origins: "It was found in the bush, or given by a spirit, a long time ago."

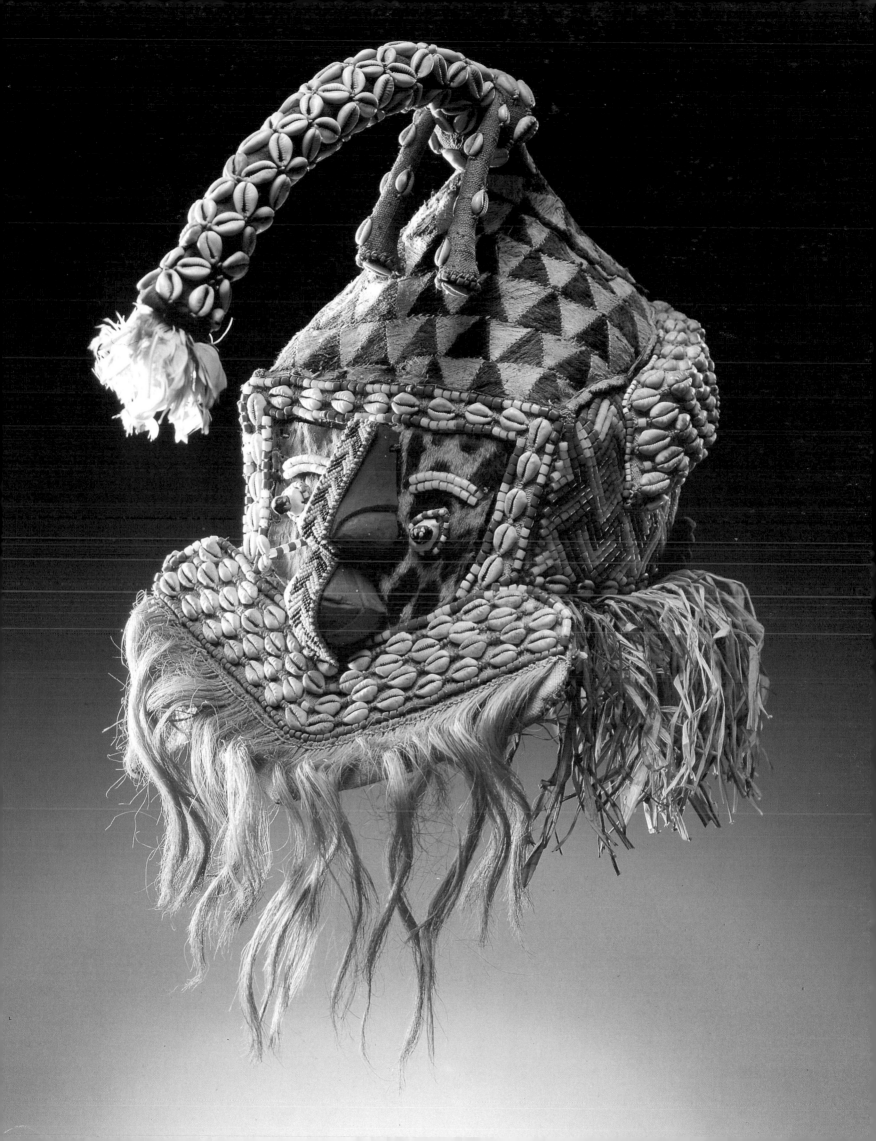

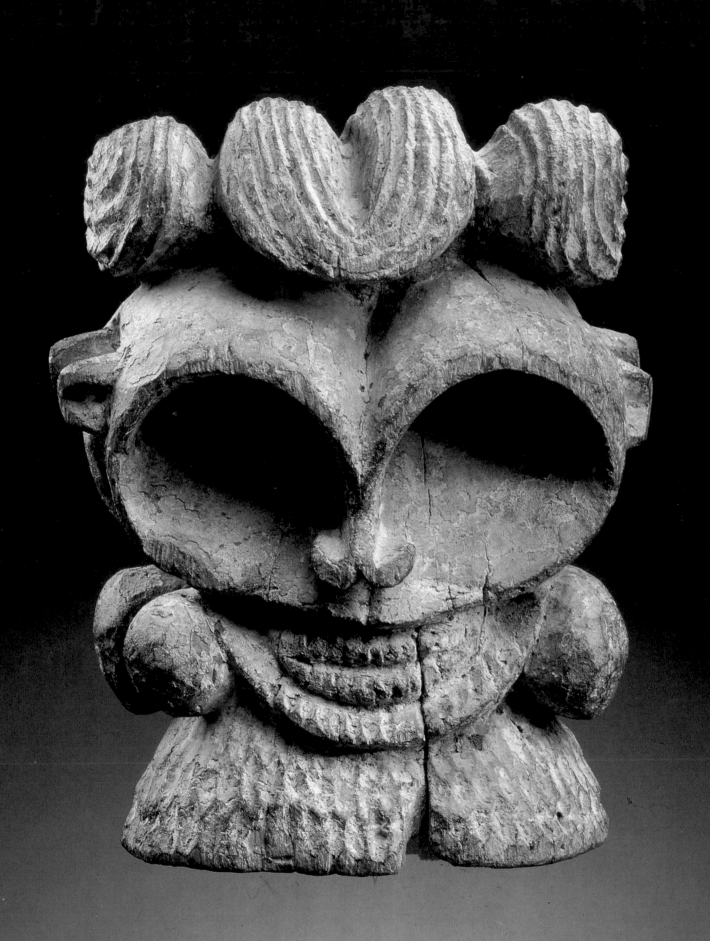

Above and right

**80 Crest of the
Brotherhood of the
Night.**
Cameroon. Bangwa.
Hardwood with traces of
kaolin. H: 41.5 cm. Musée
Barbier-Mueller, Geneva.
These masks were seen as
the visible manifestation
of a supernatural power,
dangerous for both the
initiated and the
uninitiated. Their role was
one of repression.

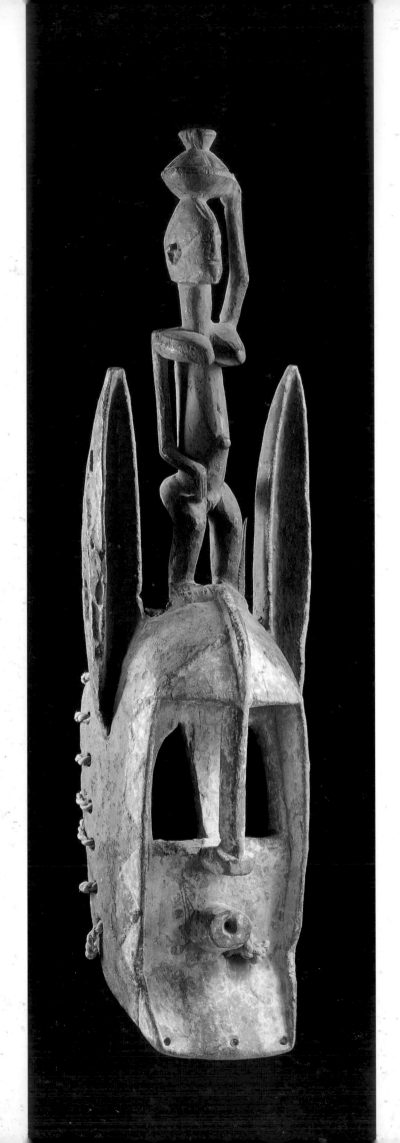

82 Walu mask of an oryx antelope.
Mali. Dogon. Wood, vegetable fibres and traces of white mineral pigment. H: 63 cm. Musée Barbier-Mueller, Geneva.

Right

81 Ngil dance mask.
Equatorial Guinea. Gabon. Fang. Semi-hard wood, face painted white. H: 44 cm. Musée Barbier-Mueller, Geneva. The Ngil masks played a part in the re-establishment of social order. These impassive elongated white faces were well designed to induce obedience to orders from the uncompromising mouth.

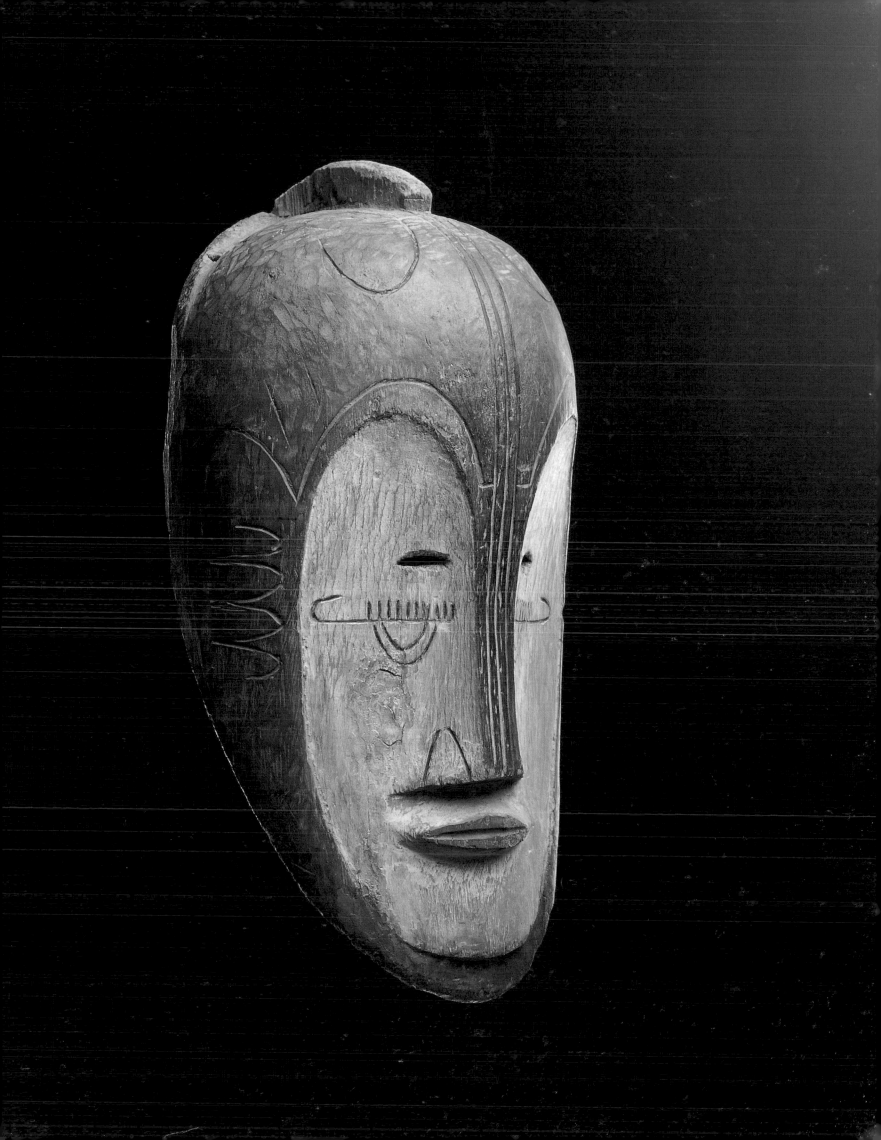

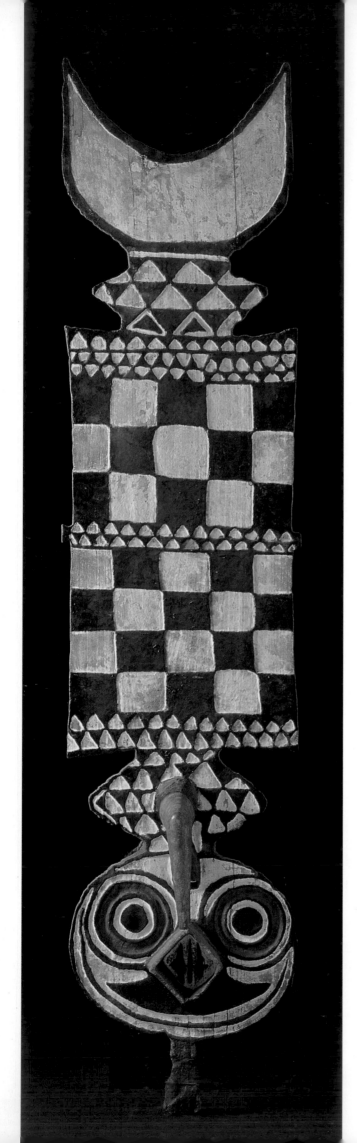

Before starting work the craftsman chose wood of a suitable quality, generally soft and light. To appease the spirit of the felled tree a diviner was occasionally called in to perform the appropriate ceremonies and in addition the sculptor himself had to be in a state of ritual purity.

The mask was generally made from a single piece of wood, although the Ivory Coast also produced masks with a jointed lower jaw. If the mask was to be polychrome the craftsman used kaolin for white, the symbolic colour of death, and charcoal for black, the colour of evil. Red ochre signified life. Later, yellow ochre or blue lye were sometimes used.

Other masks might be made of leaves and very swiftly destroyed; among the Ekoi of Nigeria masks of varnished antelope skin, substitutes for the previous use of human skin, were stretched on a cane frame. Beaten bark might also be used and certain masks were decorated with cowries or glass beads.

Despite the importance of such preparations, it was only on its first public appearance with the appropriate ritual that the mask acquired its sacred nature and until then there was no need for special precautions in handling it because it had not yet been charged with magic energy. In Gabon, Louis Perrois noted that between public appearances the masks were preserved well away from indiscreet eyes but without any particular precautions. Elsewhere, woe to any uninitiated who might try to take a look at certain masks, or who even glimpsed them by chance.

E. Leuzinger mentions more dramatic episodes in the life of the masks. "Among the Songye, in ancient times, a human sacrifice was necessary to call up the divine power and, in north-eastern Liberia, ritual required that a mask which had failed to fulfil its purpose in battle should be strengthened by the same means. But, later, by means of deception, a cow would be sacrificed instead of a human."

83 Blade masks.
Burkina Faso. Musée
Barbier-Mueller, Geneva.

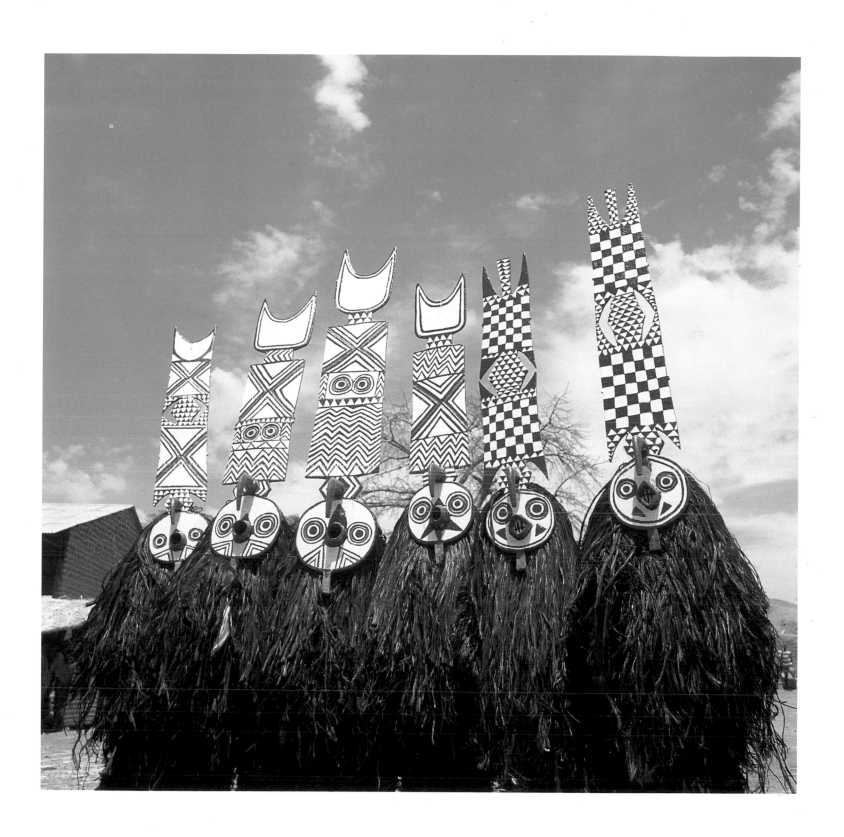

**84 Display of plank
masks.**
Bwa. (Photo: Hoa Qui.)
These masks take part in
family rituals and funerals,
or they mark the end of
mourning.

Right

85 Helmet-mask with female figure.
Ivory Coast. Senufo (village of Lataha). Hardwood with a deep grey patina. H: 102.5 cm. Musée Barbier-Mueller, Geneva.
These helmet masks were really statues carried on the head for a procession through the village. This might be on the occasion of "great funerals" designed to honour those who had just been "initiated" into the kingdom of the dead. They belonged to the Poro society and were kept in the sacred grove which they left only very rarely. Always without arms, they generally went in pairs, one female and one male. They are characterised by the ringed neck and body.

The mask generally had its own appointed dancer, an appointment which might span several decades. The mask would remain in the same line of descent as it was passed down from generation to generation, or would stay in the same secret society.

Finally, the life of the mask would come to an end. There were times when Jokwe masks of beaten bark or resin were burned at the end of ritual ceremonies, while wooden masks were preserved. In the past a mask was never generally thrown away without precautions being taken - its destruction was surrounded with rites destined to transfer its occult forces to another mask. Sometimes it was deposited in a cave or a special hut so that it could disintegrate with the effect of time and termites.

Among the Jokwe, specific rites were carried out for the *Pwo mask* (fig.88). The sculptor drew his inspiration from the features and hair of a woman he admired for her beauty and, as M. L. Bastin says, "before handing over the completed mask to the dancer, the sculptor received a brass ring as a "bride price". A sort of mystic marriage thus united the new mask with its owner. When he died, Pwo was often buried in a marsh with a metal bracelet, as repayment of the "bride price" to prevent the spirit coming to haunt a member of the family of the former dancer.".

In contrast to more realistic and static figures, the mask world thus offered Black Africa an escape into the supernatural, the unreal and the dynamic. It gave form to disembodied psychological forces, made more terrifying by their mystery, and catalysed immemorial fears in the face of nature. Confronted with the horror of death, its role in funeral ceremonies can be seen as psychotherapy - and, more generally, detaching its dancer from the contingencies of the world of the living, it could sometimes bring him to the heart of ecstasy and temporarily plunge all those in attendance into the atmosphere of a sacred world.

86 Dance mask.
Gabon. Tsangui.
Softwood painted white
with black and red
details. H: 30 cm. Musée
Barbier-Mueller, Geneva.
Particularly representing a
dead person's spirit, this
mask appeared during
mourning ceremonies, in
dances performed in the
pale light of dawn or
dusk. The dancer was on
stilts with the mask barely
visible, but the sculptor
obviously wished to
create an effect of
mysterious beauty.

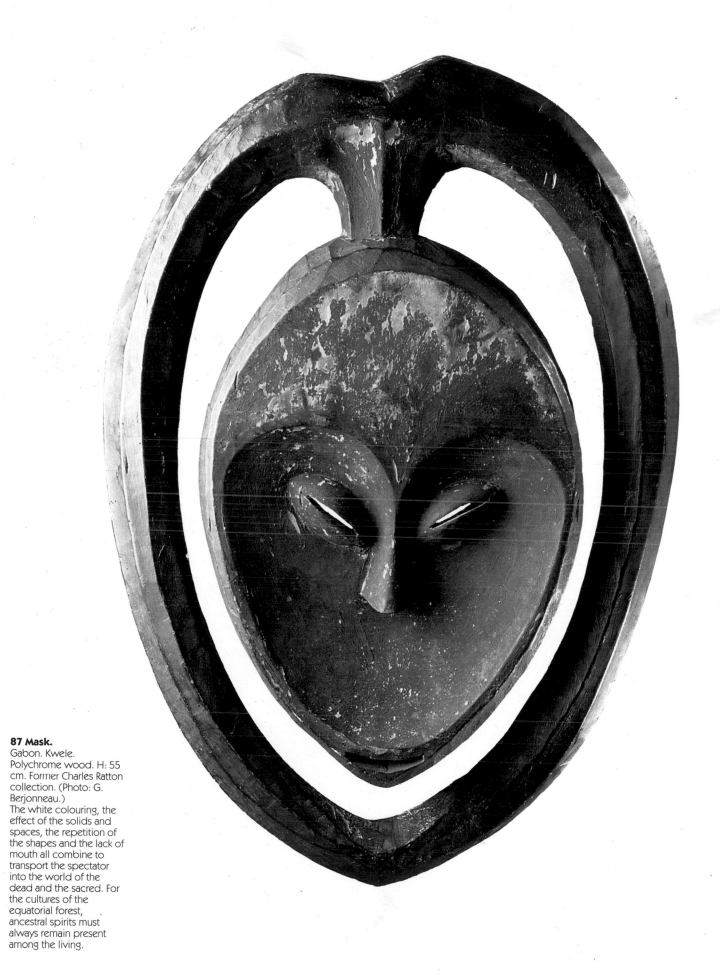

87 Mask.
Gabon. Kwele.
Polychrome wood. H: 55
cm. Former Charles Ratton
collection. (Photo: G.
Berjonneau.)
The white colouring, the
effect of the solids and
spaces, the repetition of
the shapes and the lack of
mouth all combine to
transport the spectator
into the world of the
dead and the sacred. For
the cultures of the
equatorial forest,
ancestral spirits must
always remain present
among the living.

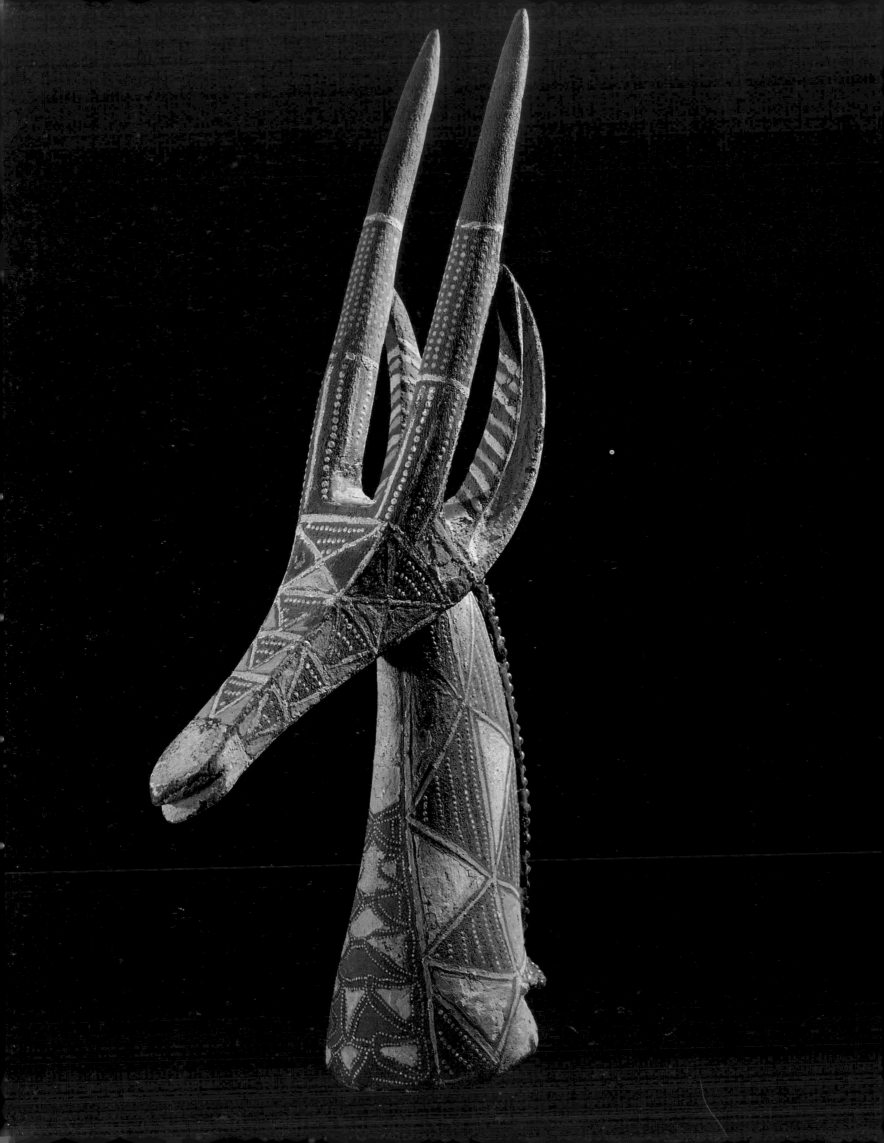

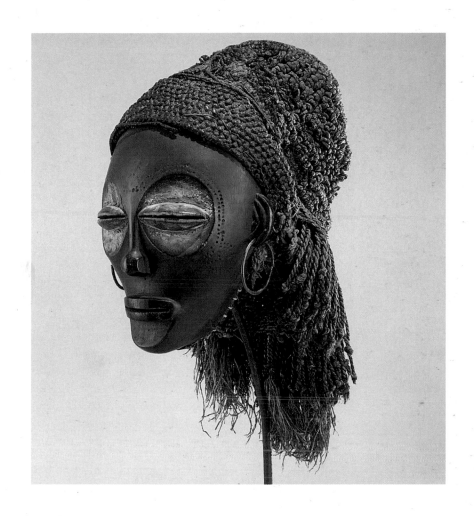

88 Female Pwo mask.
Zaire. Jokwe. Wood,
kaolin, metal and fibre. H:
28 cm. National Museum
of African art,
Washington.
The image of a woman
admired for her beauty
and linked to the sculptor
by a mystical bond.

Left

89 Antelope crest.
Burkina Faso. Kouroumba.
H: 70 cm. Musée de
l'Homme, Paris.
At the end of the
mourning period, the
souls must be expelled
from the villages.
Kouroumba dancers
appeared at this point,
wearing this elegant
sculpture with its
polychrome motifs on
their heads. A net held it
in place.

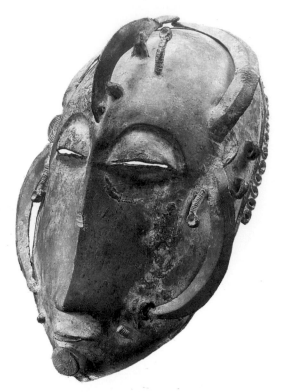

90 Mask.
Ivory Coast. Pre-Senufo.
Possibly 12th or 13th
century. Poor quality local
tin. Size: 23.5 x 16 cm.
Weight: 725 g. Musée
royal de l'Afrique
centrale, Tervuren.

Different mask forms

Very often the mask consists simply of a face and is carried in front of the wearer's face, the rest of the body being covered by an appropriate costume. Surface modelling varies from the completely smooth surface *(Tsaye mask)* to the most deeply sculpted features.

Helmet masks cover the dancer's head completely, like a hollow sculpture enveloping the head. They can be seen from all sides.

The Janus masks have two faces, set back-to-back with each other.

Double masks also have two faces, but in this case they are side by side.

Certain masks are not designed to enclose the head, but are worn across the top of the head; the *Gelede masks* are an example of this style.

Crests, such as the Bambara Tyiwara, consist of a figure, occasionally very tall, set on a wicker skull-cap.

Blade masks, surmounted by a tall wooden blade, are found among the Bwa.

Finally, there are some very small masks, often made of metal or ivory, designed not for dances but as charms; they are worn under clothing hanging from the waist.

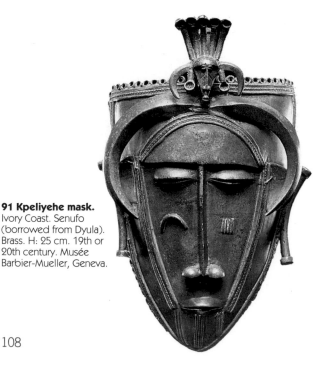

91 Kpeliyehe mask.
Ivory Coast. Senufo
(borrowed from Dyula).
Brass. H: 25 cm. 19th or
20th century. Musée
Barbier-Mueller, Geneva.

Masks in the past

The *Kpeliyehe Mask* (fig.91), visible by everyone, is female in character but is worn by men. It expresses feminine calm and balance. The lines surrounding the taut mouth indicate self-control and the crest set on top of the mask refers to revelations brought by jungle spirits in dreams, while the tiny human head is a reference to Dyula merchants. The horns are those of the buffalo, the powerful beast of the bush. Despite the great calmness of this face the dancers, young Poro initiates, wear brightly clashing colours and perform a wild dance.

The *Pre-Senufo mask* (fig.90) was discovered by chance in an ancient tomb in northern Ghana. This ancestral female face, with a chameleon on its brow and lateral decorations, resembles modern *Kpeliyehe masks*, and may be the archetypal original.

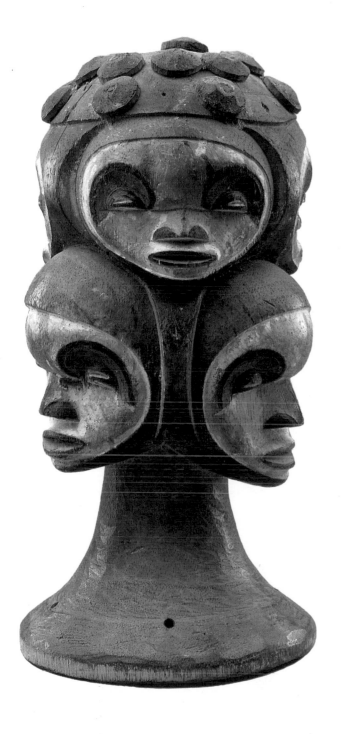

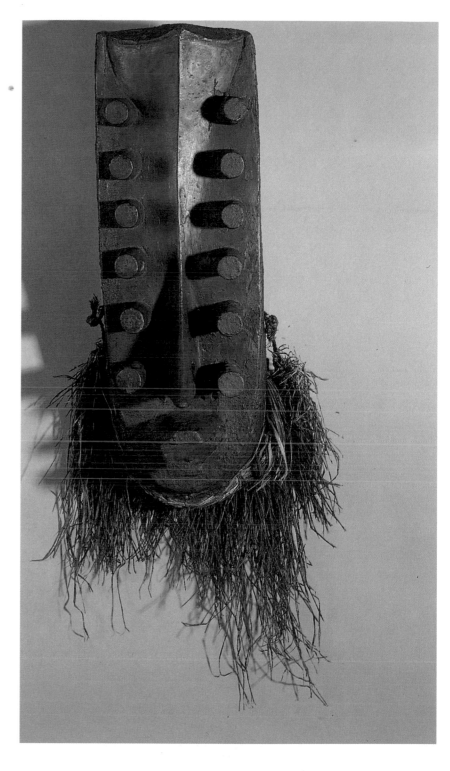

92 Idoma mask.
Nigeria. H: 29 cm. Musée
Barbier-Mueller, Geneva.

Hidden inside his mask and costume, the dancer cannot
be identified but appears to possess multiple vision, all the
better to track down and punish any who infringe traditio-
nal laws (figs. 92 and 93).

93 Oubi mask.
Ivory Coast. Grebo.
Blackened wood and
vegetable fibre. H: 42 cm,
W: 16 cm. Musée de
l'Afrique et de l'Océanie,
Paris.

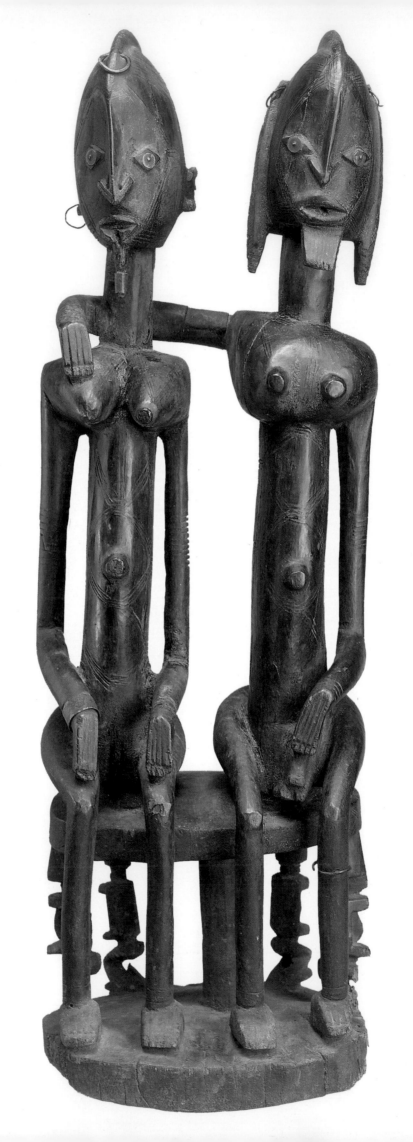

Ancestral statues
and representations
of spirits

Ethnological research over half a century into Black populations has led to a better understanding of the reasons for the immense quantity of wooden statues and statuettes produced by sculptors.

There is certainly one general rule: the prime function of these statues is not to please the eye. Their deepest purpose is religious, based on ancestral or mythic cults.

In the image which he gradually draws from the wood, the sculptor evokes a dead ancestor or an ethereal spirit. The patrons who commission statues already have ideas about these abstract entities, perceiving them in a particular way, and the sculptor must conform to these concepts. Within the framework of tradition he can, however, add his own personal note to the wood, the mark of his own artistic talent which, as is evident, often leads to the creation of works of high quality.

The majority of wooden African statues are male or female ancestor figures, or statues of dead chiefs. Others, however, correspond to anthropomorphic representations of spirits of nature or of secondary gods. As myths and animist cults vary from one culture to another, the works must be seen in the light of their place of origin.

Left

94 Seated couple.
Mali. Dogon. Wood and metal. H: 73 cm. The Metropolitan museum of Art, New York.

111

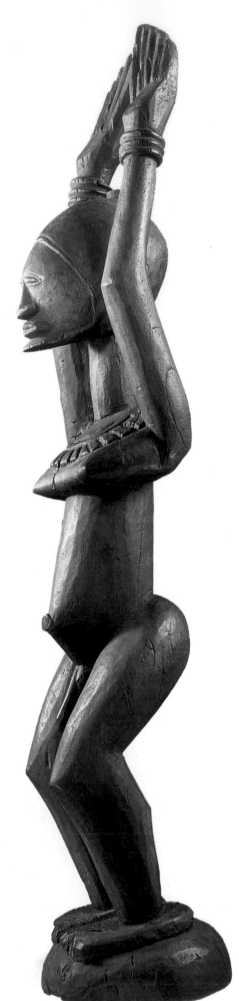

Among the Dogon

Living in an impressive, bare and austere landscape near the cliffs of Bandiagara in Mali, the Dogon are among the African cultures who have remained closest to their ancestral traditions. They may have replaced an older people, the Tellem, and also had links with the inhabitants of the Niger Inland Delta between the 12th and 13th centuries. The Dogon never attempt to represent historical characters, as happens in Ife or Benin; their art deals with the myths whose complex ensemble regulates the life of the individual.

The sculptures are preserved in innumerable sites of worship, personal or family altars, altars for rain, altars to protect hunters, in markets . . . In the Dogon pantheon Amma appears as the original creator of all the forces of the universe and of his descendant Lebe, the god of plant rebirth. Amma is also the creator of the ancestors of each clan, referred to as "those who are distant". Among the many other gods, Nommo, the water spirit, is often represented in conjunction with Amma. For these various cults the Hogon is both priest and political chief of the village.

In every case these statues, which are always static, display a solemn gravity and serene majesty well served by strict geometrical patterns.

The ancestral couple is often represented, charged with a particular creative energy which is honoured each year by sacrifices seeking health and fecundity for the living. The close union of masculine and feminine principles of equal importance is expressed by the balance of vertical and horizontal elements and, more concretely, by the man's arm on the woman's shoulders (fig.94).

Male or female statues with their arms raised belong to Dogon sculpture. This is probably a gesture of supplication to Amma to bring rain, so rare in this Sahel region decimated by drought. It is also tempting to establish a link between these effigies with their arms uplifted and the groups of vertical forms which characterise Mali architecture, but it is difficult to be precise about the nature of this link. Certain statues with raised arms have fluid lines and are relatively realistic, such as these two *Statues* in the

Barbier-Mueller museum (figs.95 and 96), but others may tend towards the abstract, such as the *Female statue with raised arms* in the Metropolitan museum (fig.97). This flat figure with fully carved head and breasts was probably placed against the wall of a small shrine. A "plank statue", it contrasts with other Dogon sculptures in the Metropolitan museum, which are equally abstract but treated as cylindrical volumes reducing the human form to its essential elements. Dogon statues are always designed with great deliberation.

The realistic representation of another *Male statue* (fig.98) gives an idea of the real-life Dogon man, in traditional costume. His beard shows him to be an elder of his clan and he wears what look like shorts and a cotton hat draped over the nape of his neck. The L-shaped instrument on his shoulder is both weapon, tool and ritual object, and a pendant hangs on his chest. The statuettes of the *Horseman* (fig.99) reflect the prestige attached to this animal by the plains-dwelling Dogon; the horseman has variously been identified as a Hogon (a Dogon priest), or as Nommo, principle of the order of the universe and god of rain. These various statues of ancestors or gods with their smooth appearance may have been simply shown to the faithful during funerals or cult worship in chapel.

A second type of more abstract works includes figures entirely covered with sacrificial material, blood and boiled millet, accumulated during ancestor worship and supposed to revitalise both the relevant ancestor and the person offering the sacrifice.

The Senufo

For these peaceful inhabitants of Mali, Burkina Faso and the Ivory Coast, the wood carvers - the Kulebele - created statues designed to sustain various cults linked with agricultural work. They appear in agricultural festivities and fertility cults, but may also be aimed at stimulating work under the supervision of very powerful secret societies regulating all aspects of life - the Poro, Sandogo or Lo. More than representations of ancestors, the statues

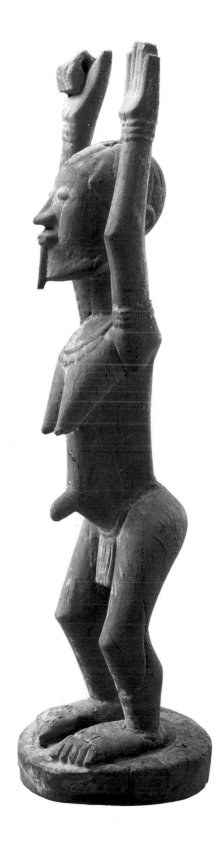

97 Statue with raised arms.
Mali. Dogon. H: 110.5 cm. Wood and colouring. The Metropolitan museum of Art, New York.

are mythic figures evoking the original man and woman. They could be used to explain the origins of life to young initiates.

Ritual statues of Deble style (fig.100) are large figures, although their lower parts are often missing because they were carried in procession during the initiation of novices and pounded on the ground in a slow rhythm to plead for fertility. Between ceremonies they were guarded in the sacred woods which were out of bounds for the uninitiated. The grave and thoughtful expression on the face generally surmounts the heavy breasts. The whole effect is one of sacred and monumental power.

In contrast to the Deble statues, many Senufo sculptures are small, such as those placed at the top of the "champions' batons" (fig.101). At the end of competitions organised between young land workers, this baton is given to the winner, the greatest honour that a young Senufo man can receive. In the example in the Barbier-Mueller museum the female figurine has elongated features in a stylised heart-shape face. Her long hanging breasts typical of the Senufo standard of beauty are emphasised by the sculptor with the same care shown for the hair and the details of the seat. Far from being an ancestor figure, this young woman evokes fertility and the future. She represents the desired bride.

Among the Guro and the Baule

To the south of the Senufo, in the centre of the Ivory Coast, the art of the Guro is related to that of the Senufo but distinguished by extreme refinement. Their *Weaving loom pulleys* (figs.201 and 202) are surmounted with heads, often female, of great elegance, embodying the protective spirit of labour. Among the rarer standing statues, the example in the Barbier-Mueller musuem is a representation of the soul of a *Female ancestor* (fig.102). Through her mediation, backed by the intervention of the soothsayer, she transmits news of the dead to the living and vice versa. Conceived as an image of beauty without being a portrait, she embodies the beloved wife of the man who commissioned the figure.

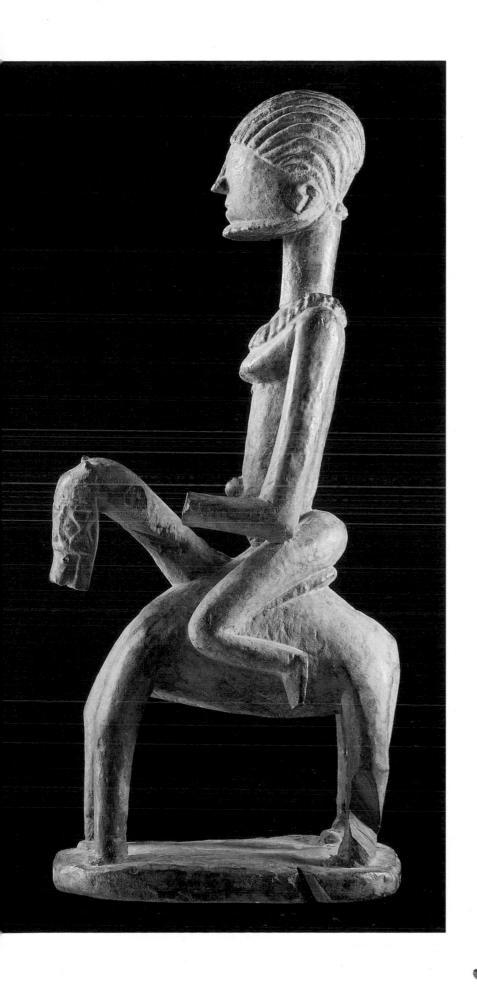

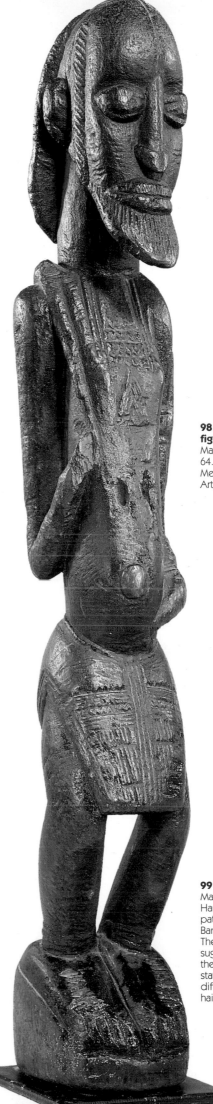

98 Standing male figure.
Mali. Dogon. Wood. H: 64.5 cm. The Metropolitan museum of Art, New York.

99 Horseman.
Mali. Tellem or Dogon. Hardwood with matt grey patina. H: 46 cm. Musée Barbier-Mueller, Geneva. The necklace of flat beads suggests a Tellem origin - the Dogon have similar statues, although with different jewellery and hairstyles.

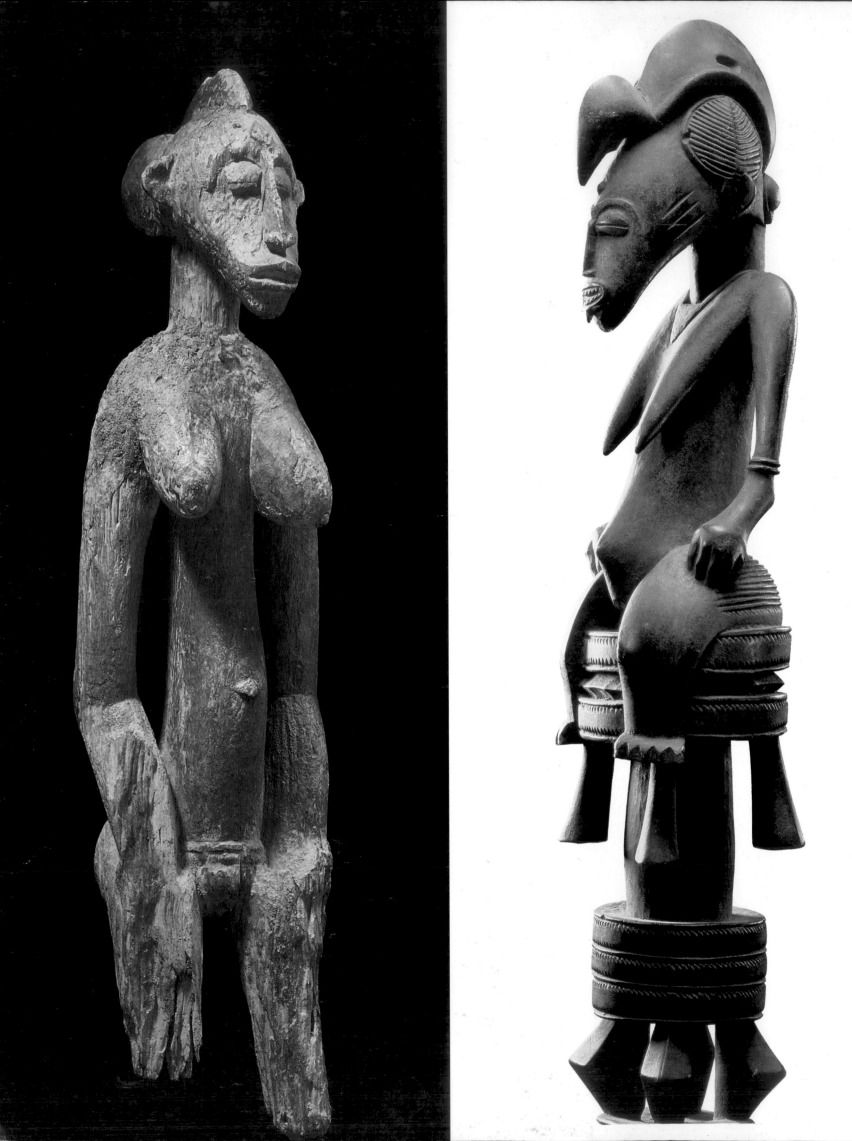

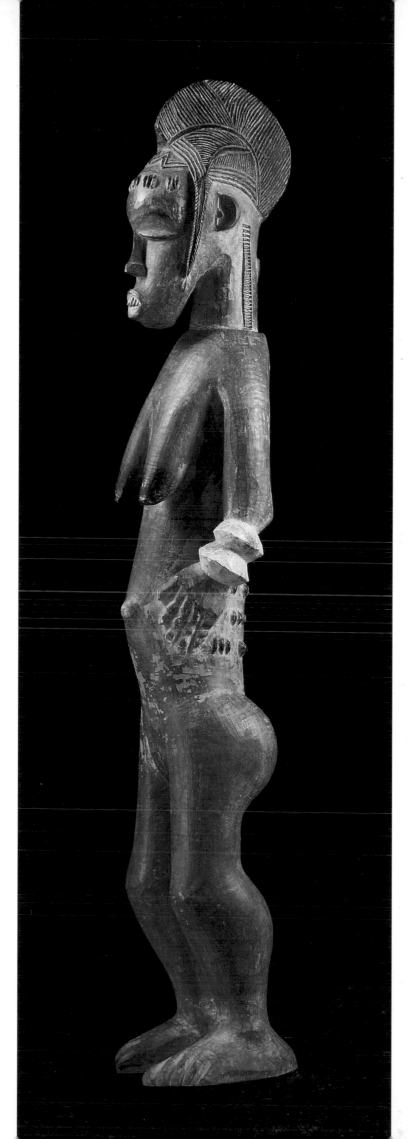

Far left

100 Ritual Deble statue from the Lo society.
Ivory Coast. Senufo (Korhogo Circle). Wood. H: 95 cm. Museum Rietberg, Zurich.

101 Top of a baton awarded to a young "champion farmer".
(Tefalipitya) Ivory Coast. Senufo. Total height: 164 cm. Height of the figure: 34.3 cm. Musée Barbier-Mueller, Geneva.

Left

102 Statuette.
Ivory Coast. Gouro. Hardwood with polychrome traces (white, black and red). H: 80 cm. Musée Barbier-Mueller, Geneva.

117

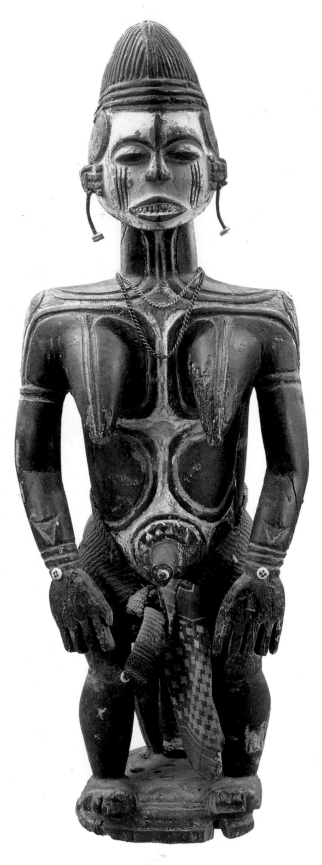

105 Female figure of a spirit (anjenu).
Nigeria. Idoma. Wood with metal ear pendants, European buttons and loincloth. H: 73 cm. Musée Barbier-Mueller, Geneva.

The long artistic tradition of the Baule people, in the centre of the Ivory Coast, has some links with Guro art. It was the Baule statuettes which, early in the 20th century, were the first to be appreciated by French artists. Surprised and perhaps seduced by the novelty of form of this male figure, Vlaminck bought one (fig.103). The work conformed to traditions of Baule statues, however: large head, long narrow torso, arms almost wasted away and held close to the body. Vlaminck also undoubtedly fully appreciated the refinement of the dignified and thoughtful face, the precision in the representation of the hair and the detailed ornamental scarification. For this sophistication of lightly worked surfaces it is probable that the Baule transferred onto wood the qualities applied to jewellery by their Akan neighbours.

In Vlaminck's time this type of figurine was regarded as being an "ancestor statue". This is now known to be wrong and the statues can be divided into two groups. The first may represent natural spirits wandering in the jungle, described in turn as hideous and very beautiful. These spirits were supposed to have the power to possess human beings, to use them as mediums and to become embodied as statuettes intervening in divination séances. Such spirits must above all not be upset, but should be conciliated with an offer of a beautiful image in which to embody themselves. The statuette bought by Vlaminck may perhaps belong to this category.

The second group includes the "wedding couple from the other world'. Every Baule, of either sex, was supposed to have had a spouse in the spirit world, whom he/she had left behind to join the world of the living, thus exposing him/herself to the spirit spouse's anger. If the husband or wife from the other world tormented the living person with sickness or dreams, the latter, with a soothsayer's advice, had a portrait carved and placed on an altar with offerings by way of appeasement. The statuette of the *Pregnant woman* in the Musée d'Afrique et d'Océanie, Paris (fig.104), with its deeply sad face, may express the reproaches of an abandoned spirit wife. However, the great difficulty of knowing which category a Baule statuette belongs to should be noted.

A final series of statues, on the other hand, presents no

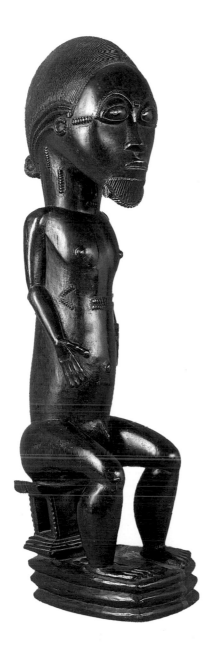

103 Statue of seated man.
Ivory Coast. Baule. Hardwood with shiny black patina. H: 63 cm. Musée d'Art Moderne de la Ville de Paris.
This figure was owned by the artist Vlaminck.

104 Statue of pregnant woman.
Ivory Coast. Baule. Hardwood with dark red patina. H: 55 cm. Musée d'Afrique et d'Océanie, Paris.

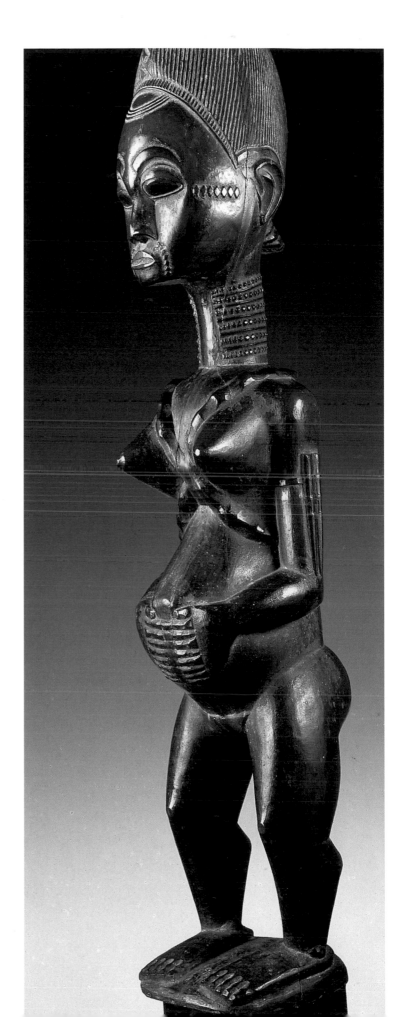

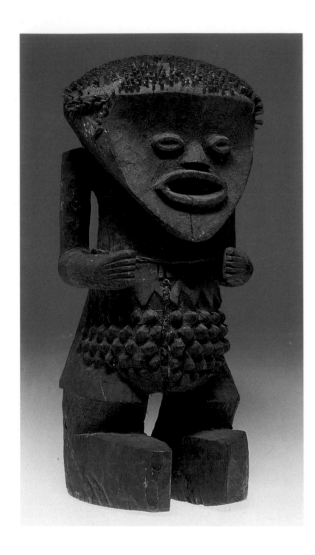

106 Effigy of a male ancestor.
Cameroon. Mambila. Semi-hard wood with black crusted patina. H: 45 cm. Musée Barbier-Mueller, Geneva.

doubt at all: they represent monkeys bearing a cup for eggs to be placed as offerings. They evoke frightening jungle gods, with their coating of coagulated blood. These spirits are addressed as a last resort, when all others have failed.

A mosaic of cultures in eastern Nigeria

The Ibo used to live in this region, until they were pushed back into the forests and high plains by the arrival of the Yoruba people. Certain Ibo statues which have survived are of remarkable quality; generally standing, facing forwards with the body extended in height - a tendency reinforced by the elongation of the neck which was often adorned with necklaces - these are not portraits but stylised images imprinted with great gravity. They are, quite simply, sacred objects.

A *Female statue* laden with heavy jewels may be a female ancestor, an image of fertility whose full breasts and general appearance are somewhat similar to the Deble statues of the Senufo.

The stylised forms and subtle colouring of the *Figures of male ancestors* make them hieratic beings imbued with menacing authority, images well designed to perpetuate the memory of dead chiefs.

In addition to numerous representations of local gods the Ibo in the province of Onitsha have *Ikenga*, statues which are not sanctified and which are accompanied by multiple objects. The spirals of the ram's horns, which the male figure always wears, symbolise growing strength. In one hand the man holds a knife with a long blade and in the other an enemy head carved in wood, the whole accompanied by other accessories relating to the personality of the owner. On his marriage each man buys an *Ikenga*, gaudily decorated with bright colours, while other larger examples are held by communities. All are supposed to bring good luck and prosperity to the relevant social group, family or brotherhood. The *Ikenga* used to be destroyed on the death of their owner, but are now placed on family altars.

To the south of the Benue the Idoma give their ancestors an important place in daily life. The resurrection of the

dead is an important element of their religion and the cult of the spirits of nature, *Anjenu*, is celebrated through the mediation of figures preserved in shrines. In particular, a protective spirit lives in the water or the forest and may appear in dreams. Generally benevolent, an *Anjenu* favours commercial transactions, helps to cure illness and, above all, aids female fertility. This is why men visit the priestess who guards one of these effigies, such as the *Female figure of a spirit* in the Barbier-Mueller museum (fig.105). The evocation of a spirit must be impressive and in this work the sculptor has brought together two elements: the face has the image of a traditional mask in this culture, painted white and showing the usual scarification markings, while for the body he has sought to create an unusually imposing religious image which distances this statue as far as possible from the norm. The aim was to suggest a superhuman power, entirely separate from the world of the living, and from this evidence the sculptor seems to have achieved his aim.

The Ijo from the marshy regions of the Niger Delta are fishermen and farmers who believe that ancestors and spirits may surge up again from the waters. Their images are often reduced to a strict geometry, with altars consecrated to their worship where a central standing figure is set in a wooden frame and surrounded by his smaller servants. These statues, with their ferocious-looking cubist heads, are not made from a single piece of wood - the trunk and limbs are bound together. If another ancestor is to be added to the family pantheon, a further head, sculpted in the round, is set on top of the frame.

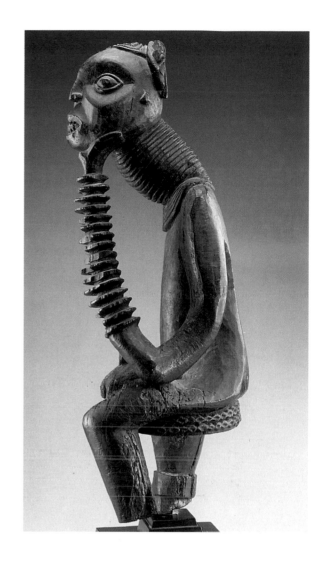

107 Statue.
Cameroon. Bamileke, Bangwa. Wood. H: 81 cm. Collection Dartevelle, Brussels.

In the chieftainries of Cameroon and Gabon

The sculptures in the Grassland region of Cameroon, which are often royal effigies or represent individuals at the court of various chiefs, have been the subject of a special study (see chapter 3). The inhabitants of the villages - all the ordinary people - had their own art, however, which was always vigorous and expressive. Within a general framework of animist beliefs they worshipped tutelary gods, spirits or ancestors.

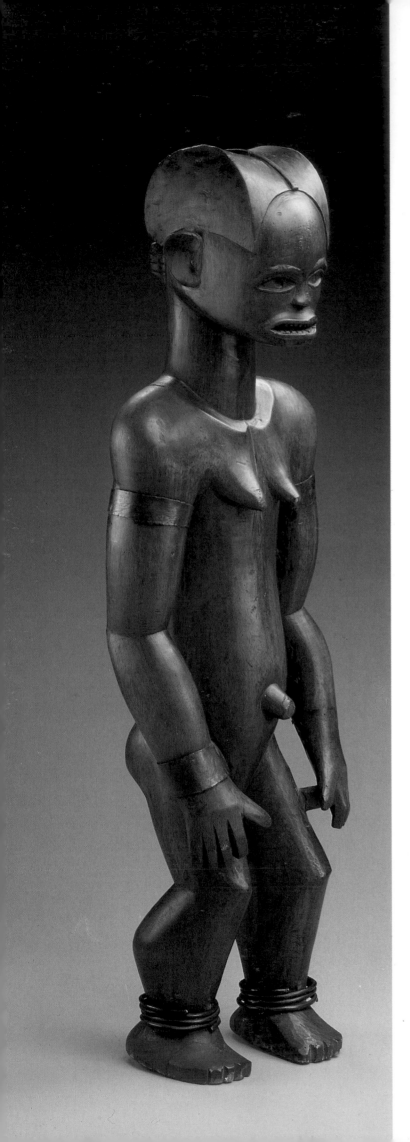

The Mambila, on the Nigeria-Cameroon frontier, believe that ancestor spirits must intercede to secure the well-being of the living, who do not address the supreme being direct. The statues are home to these spirits, which must be appeased with offerings. Full of intensity, vigour and concentrated power, the *Effigy of a male ancestor* in the Barbier-Mueller museum (fig.106) is a fine expression of a vision of the ancestor seen as simultaneously benevolent and malevolent. Offerings were certainly essential to appease it!

Linked to the great ethnic group of the Bamileke, the Bangwa created particularly expressive commemorative statues which were not strictly full-face. One such figure (fig.107), with an emaciated body in the Dartevelle collection in Brussels, gives a vivid image of the "thinker", all its energy apparently concentrated in its head.

Between Cameroon and Gabon, the ethnic group of the Fang has produced ancestor figures of great plastic power with curves that are always firm and taut. The stylised body and the brooding and intense facial expression make it possible to create figurines full of a very strong "presence", as in the *Statue of a Mabea ancestor* in the Barbier-Mueller museum (fig.108).

In Gabon, various cultures living under the shelter of the overwhelming equatorial forest practised a particularly strong cult of ancestor worship which united the living and the dead intimately and permanently (fig.109). To this end the bones of ancestors were preserved in "reliquaries" in the Byeri cult. They are considered separately in chapter 6. Only the independent ancestor statues are touched on very briefly here. Among the Tsogho the Gheonga statuettes are mythic entities, representing dead ancestors, which may intervene in the rituals of ancestor worship, the Bwiti cult, or in family cults. Little sanctified, they are above all commemorative, but are thought to possess a protective force when magical substances are added to them.

108 Statue of an ancestor.
Cameroon. Mabea (Fang). Semi-hard wood with bright patina on the body. Black colouring on the hair. Metal bracelets. H: 70 cm. Musée Barbier-Mueller, Geneva.

Zaire, the great artistic homeland

Zaire, in the River Congo basin, is one of Black Africa's most important artistic homelands, rich in both the quantity and the style of its products, and particularly in all kinds of statues of the dead.

Among the Kuba, in the centre and the south of the country, the most famous works are the *Ndop*, a series of royal statues which are not strictly statues of ancestors, for this type of worship appears to be unknown among the Kuba. However, the royal statues played their part when a king died: before his death, his statue was placed beside him, ready to receive his life-force and to pass it on to the new king who would lie next to the statue during the initiation ceremony. As so often in Africa, the statue is there as support for a dead soul, to act as a staging post while a new incarnation is awaited.

Through written chronicles we know of the existence of one hundred and twenty-four Kuba kings, but only nineteen statues survive. Were they made during the ruler's lifetime, or later? To date, the question remains unanswered. The most famous of these kings, Shamba Bolongongo, the conqueror and philosopher worshipped as a sage and a divine hero, reigned at the beginning of the 17th century. He is said to have summoned talented sculptors to his kingdom, thus inaugurating the tradition of royal statues. Each king is represented seated on a cuboid throne with his legs crossed and his visored headdress decorated with cowries and pearls, as for investitures. In front of each king is an object symbolising a significant deed of his reign; Kata Mbula (fig.110), who reigned from 1800 to 1810, carried as a sign of peace the wooden knife substituted for war weapons by Shamba Bolongongo, and the royal drum stands before him. Full of force and energy, this idealised portrait conveys great dignity and authority.

The Kuba people's northern neighbours, the Ndengese, absorbed their artistic influence. They made fine religious statues (fig.111) which may be portraits of ancestors or funeral effigies. The moulding on the elongated trunk, covered with a close network of scarification, is entirely different from that of the head, which is smooth, expres-

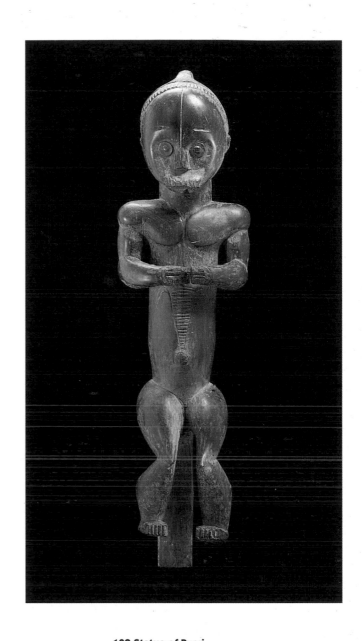

109 Statue of Byeri ancestor.
Gabon. Ndoumou (Fang). Hardwod with dark brilliant patina. H: 54 cm. Musée Barbier-Mueller, Geneva.

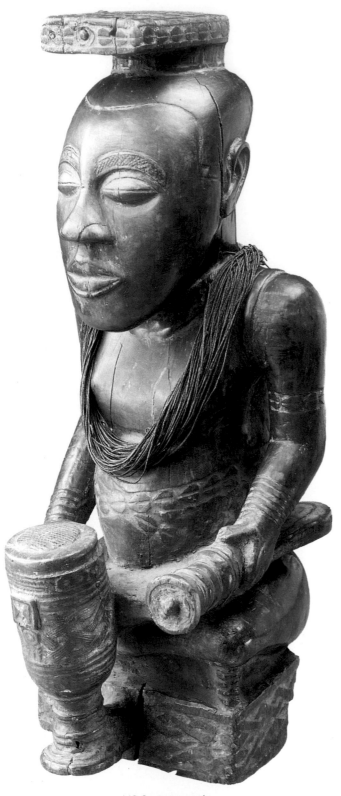

110 Commemorative effigy of Kata-Mbula, 109th king of the Kuba.
Hard polished wood. H: 51 cm. Musée royal de l'Afrique centrale, Tervuren.

sive and dignified. The body is abruptly cut short at the buttocks, which act as a plinth.

Among the Jokwe, to the far south of Zaire, art takes on a warrior inspiration without any true ancestor cults. None the less, certain statues are portraits of genuine ancestors. The *Statue of the principal wife of the chief or the queen mother* (fig.113), in the Barbier-Mueller museum, reflects the dynamism and power of this court art, as illustrated by the hero Chibinda Ilunga, with whom this woman shares certain physical features.

In the area of the lower river, in south-western Zaire, most of the statuettes are "fetish objects" or "nail statues", which are covered in more detail in chapter 7. However, there are also ancestor statues of great importance to the Kongo, who believe that the idealised ancestor always remains among his descendants to protect them. One such statue, in the Musées Royaux d'Art et d'Histoire in Brussels, represents a *Kneeling woman* (fig.114) whose face with closed eyes glows with an intense inner vitality, while her hands resting on her knees express respect and submission.

The Museum Rietberg in Zurich contains another *Commemorative statue* (fig.115), this time from the Sundi culture close to the Kongo - an effigy of an ancestor wearing the cap of high officials of the 19th century. This type of statue, placed in a funeral chapel, often represented a famous healer or midwife, and priests came to pay homage and receive advice after offering sacrifices.

Among the large group of the Luba-Hemba people in south-east Zaire, who inherited an important artistic legacy, statues of the dead played an important role. The Luba (fig.116) or Hemba (fig.117) ancestor stood guard in dark funeral chapels which looked like a beehive or a chief's mausoleum. Here all is calm. The body forms are harmonious and smooth joins are dominated by a face with noble curves. All this suggests a calm inner life. The large closed eyes help to create an impression of concentrated thought, almost of sadness, suitable for a chief conscious of his responsibility to his people. Even from the spirit world he is responsible and attentive to the requests of his descendants as they call upon each of the dead during ancestor worship.

The Luba cup-bearers are also statues of the first female ancestor. One of them is the unforgettable work of the sculptor known as the Master of Buli (fig.155, page 168). Wrongly described as "beggars", the true function of these women was to bring help to women in labour. They were placed in front of the huts of young mothers to accept offerings from passers-by.

In contrast to the harmony and reserve of the Luba-Hemba, the Boyo's art bursts with vigour and dynamism. Their ancestor effigies enable the spirits of dead chiefs to remain and guide their people. A statue in a private collection, representing an *Ancestor of the king* (fig.118) is a wonderful incarnation of this area of the chief's duties. The powerful and sharply-drawn shape adds to the vigorous joints, destroying any hope a potential enemy may have. Even the decorative elements contribute unerringly to this cohesion; authority here is based on the strength expressed by a powerful artistic design. Brother Joseph Cornet, the great authority on Zaire art, saw in this statue "one of the essential items of Congolese art".

In comparison to all the masterpieces produced in the centre and south of Zaire, the north appears less prolific. Yet among the Ngbaka there are, in addition to some unpolished pieces, a few powerfully stylised creations showing a strong plastic sense. These statues do not represent ancestors, for ancestors no longer have human faces; they embody guardian spirits, those of the legendary couple Seto and his sister Nabo. The head of the family brings these figurines out of his hut at dawn and begs them to protect him throughout the day, offering sacrifices if need be.

Who were the statues for?

European logic demands that a statue be displayed in a public place, a church, a garden, a street, or in a private setting like a palace. It must always be on view. This is not necessarily the case in Black Africa. Some statues, held by secret societies such as the Poro, are kept in sacred places or thickets, and are shown only to the initiated. Other figures are normally kept wrapped up and hidden

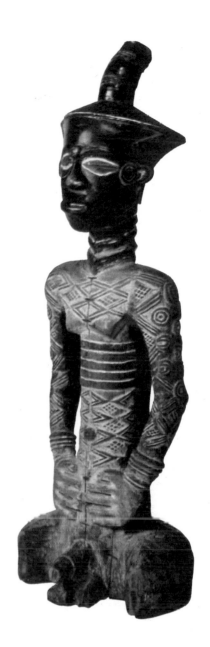

111 Commemorative statue of a chief.
Zaire. Ndengese. H: 68 cm. Ethnology collection, University of Zurich.

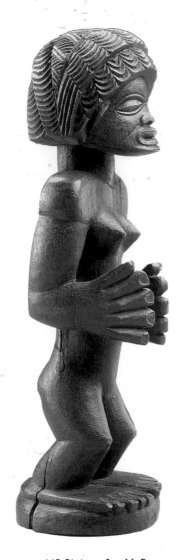

when not in use for ritual ceremonies. Among the Yoruba people, images of dead twins are kept by their mother in a closed gourd. There are even reports of an Ife priest who has no right to see the head of the ram whose cult he celebrates.

At the beginning of the 20th century Africans still believed in genuine powers possessed by these statues and assumed that anyone who infringed their laws would fall ill or die. Pregnant women were advised not to look at these figures "for fear that their child would be like the statues with big eyes and a long nose".

113 Statue of a chief's principal wife or a queen mother.
Angola. Jokwe. Hardwood with brilliant patina. H: 33 cm. Musée Barbier-Mueller, Geneva.

114 Kneeling woman.
Zaire. Kongo. Wood. H: 57 cm. Musées royaux d'Art et d'Histoire, Brussels.

Right

115 Commemorative statue.
Lower Congo, Sundi. H: 51 cm. Museum Rietberg, Zurich.

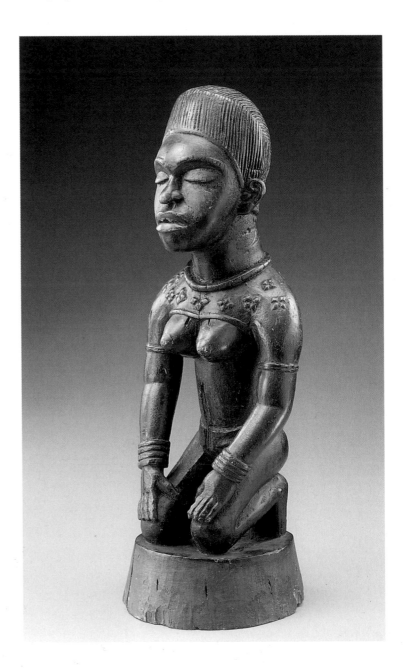

126

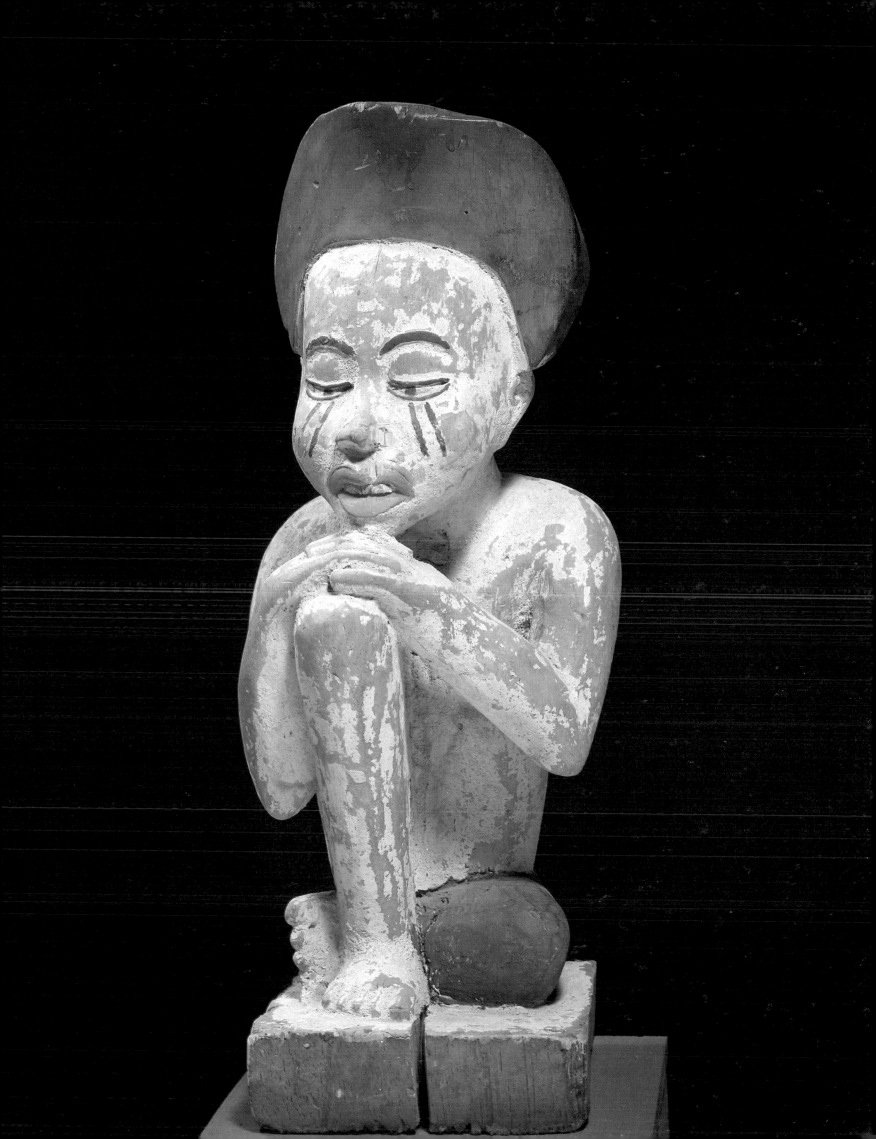

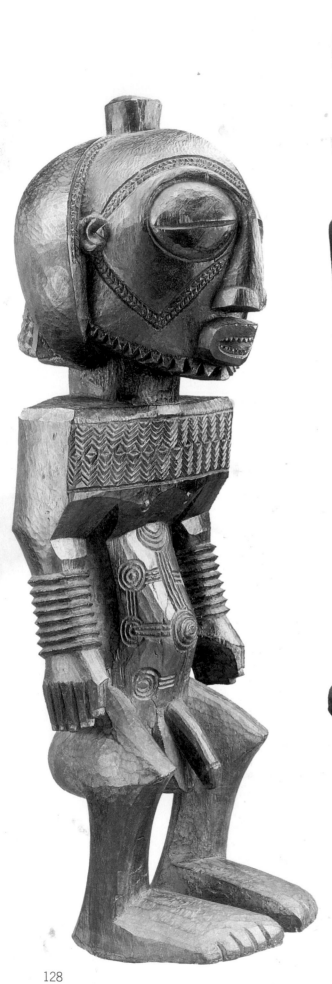

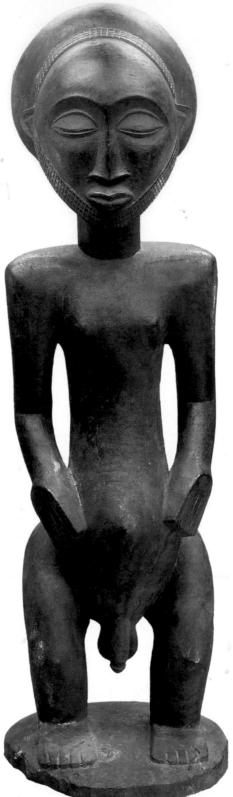

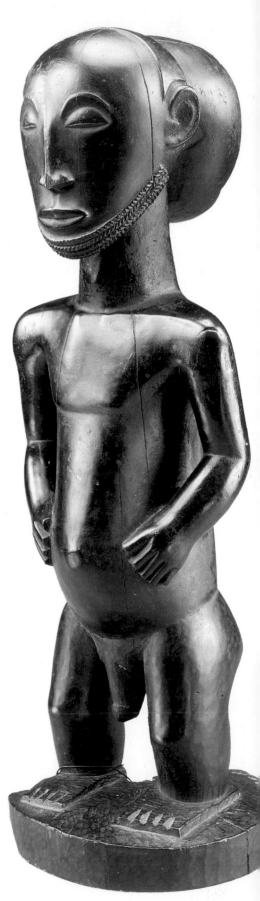

117 Effigy of an ancestor of the king.
Zaire. Hemba. Semi-hard wood with matt patina. H: 75.5 cm. Musée Barbier-Mueller, Geneva.

116 Statue of an ancestor.
Zaire. Luba. Wood. H: 62 cm. Private collection. Brother Cornet said of this figure that "it establishes a true classicism of negro art.".

118 Statue of an ancestor of the king.
Zaire. Boyo. Wood. H: 98 cm. Private collection.

128

119 Statuette.
Zaire. Ngbaka. Wood. H:
26 cm. Private collection.
An image of Seto, the
male image of the
primordial couple. The
heart-shaped face is
typical of this art.

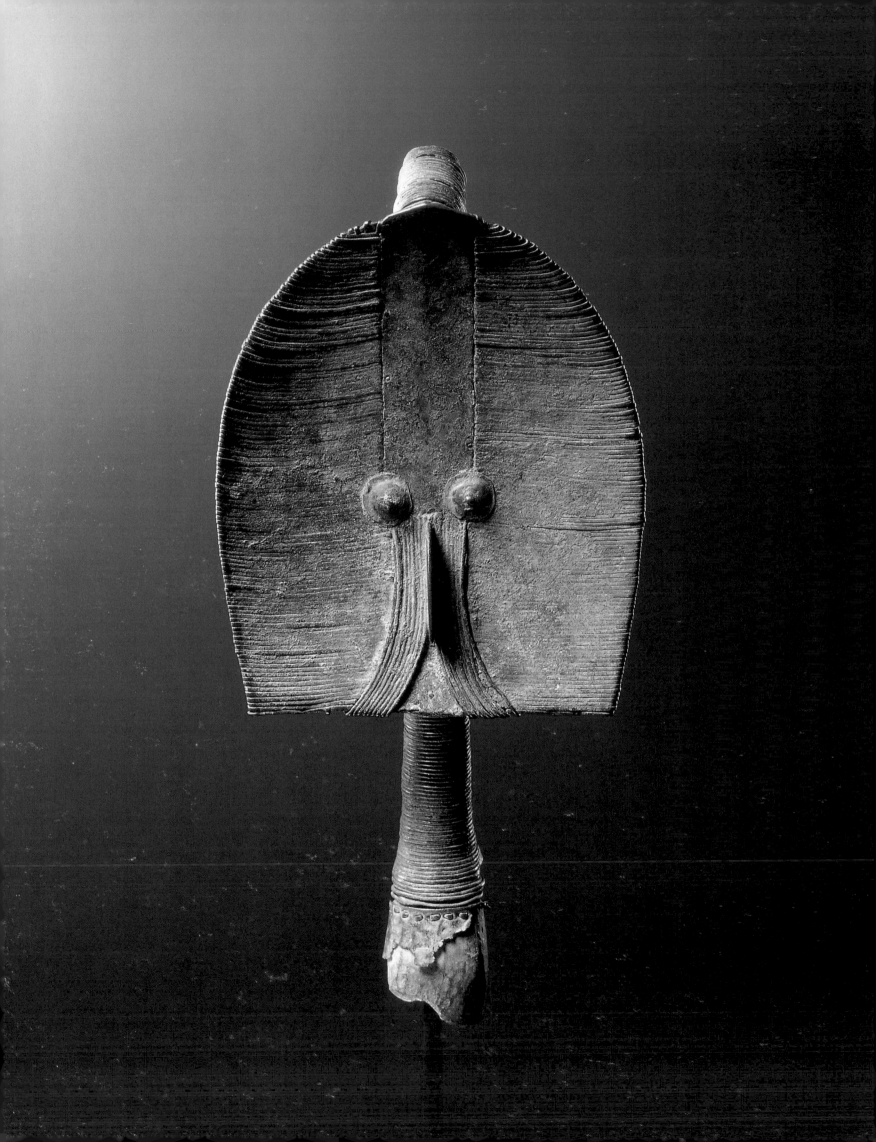

Reliquaries
to conciliate
occult forces

Among the great multitude of more or less realistic ancestor statues, designed to perpetuate the memory of the founders of tribes through family or community worship, there is a separate category of objects which united human remains, skulls and/or bones and a statuette or carved head. This ensemble is known to western collectors as a "reliquary". It expresses forcefully the persistence and authority of the dead, who thus remain doubly present - on a material level, first, since the bones are preserved, and also on a mythical level, in the figurine which is not a portrait but an abstract evocation of the ancestor. It is the bearer of signs which all those who have been initiated will understand.

Care must be taken not to confuse relics, which are associated with human remains within the setting of ancestor worship, with fetishes, which contain only magical objects to ward off evil.

The visual and psychological impact of reliquary figures is intensified by their non-figurative style. They suggest an unreal being, often more of a ghost than a representation of actuality, designed to act as receptacle and dwelling-place for the spirit of the dead person, while simultaneously concentrating on him the conscious and unconscious impulses of the living.

120 Reliquary figure, Bwiti.
Gabon. Mahongwe. Wood decorated with brass strips and plates. H: 38.2 cm. Musée Barbier-Mueller, Geneva.
A non-realistic image of rare perfection of form, this figurine remains disturbing even for the western observer. It should certainly be classed among the world's great art treasures.

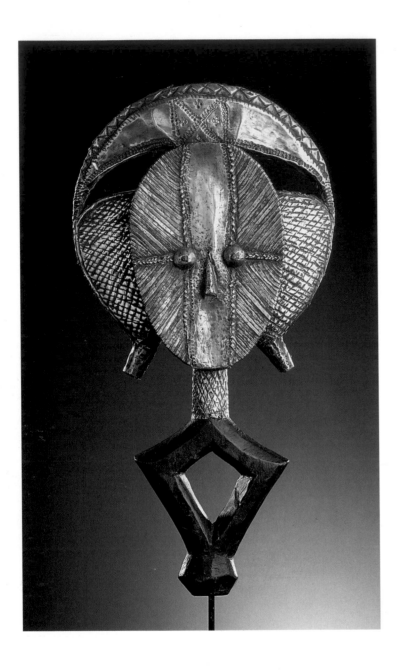

121 Reliquary figure, Mbulu Ngulu.
Gabon. Obamba
Ndoumou. Wood
decorated with copper
strips and plates. H: 42.8
cm. Musée Barbier-
Mueller, Geneva.

African attitudes to reliquaries

Until very recently, relics inspired in Africans intense feelings of uncontrollable terror and respect. The ethnologist Georges Balandier tells, in *Afrique ambiguë* (1963) how, during one of his voyages, he saw the reaction of Africans around him when he showed them a Fang reliquary at close quarters. Astonishment, recoil. "One of the young men was bold enough to confirm "It's a Byeri. The heads of families used to have them in their huts." Balandier states that the statuette was set on red-tinted skull-caps piled up like pieces of crockery, sprinkled with very fine black specks which the African observers saw as "black *Nsou*, the most terrible of our fetish-makers' poisons. Don't touch it yourself or you will die!". Nothing could make them change their minds.

Balandier's informants correctly placed reliquaries in a vague "once upon a time" period, one or two generations earlier, but they originally dated back to much more distant times.

In view of the shifting location of the peoples living in south Cameroon and in Gabon, in the Ogoue basin, it is impossible to retrace the precise history of, among others, the Kota, Mahongwe, Ambete, Fang, Tsogho and Sanga cultures. Certain ethnological and sociological aspects of their life are relatively well-known, however, and we also know that the secret societies were numerous and powerful. The best known was the Bwiti or Bwete, which was particularly active among the Tsogho people. This was a brotherhood restricted to men, who joined it after a painful initiation involving a hallucinogenic plant liable to induce visions of spirits. Other brotherhoods were meant for women and helped them in their social life.

Among the Tsogho, the Bwiti celebrated ancestor worship. Among the Fang similar rites were performed within the framework of the Byeri referred to by Balandier. Bwiti and Byeri were similar in their concepts, which also underlay family cults designed to complement those of the brotherhoods.

The aim of these rites was always to sustain close contact between the living and the spirit world. In the eyes of the Africans of the equatorial regions, life was only a

passing and incomplete feature of a cosmic whole; the other aspect of this ensemble, the spirit world and death, was no less real. As Louis Perrois remarks in *Art ancestral du Gabon*: "Nothing happens by chance, neither birth (reincarnation) nor death (witchcraft). Familiar spirits, ancestral spirits or fearful monsters in nature, ghosts of the unhappy dead or even doubles of living people - the immense crowd of shadows is omnipresent in the daily experience of the living.".

A political dimension was added to the religious role of the reliquary: it legitimised the chiefs' power through the possession of the skulls and various relics of the successive chiefs who had previously led the clan.

It should be noted that the relative importance of the carved figurine and the bones has different meanings for Blacks and for Whites. The latter concentrate on the figurine, which seems to be most important, while for a Black, on the other hand, it is the bones and relics which are the essential core of the ceremonies. Louis Perrois again: "The wooden object is only the material symbol of the image one has of one's ancestors. It helps to recreate the image of the dead and to restore a sort of symbolic life to them.".

As for material representation, reliquaries had very different forms depending on the culture concerned. Sometimes a figurine or a head was set on a stem in a bundle of relics contained in a basket or fabric. Elsewhere it may be a statuette or a head mounted on a box containing skulls, and elsewhere again the statue may be hollow with the bones kept inside.

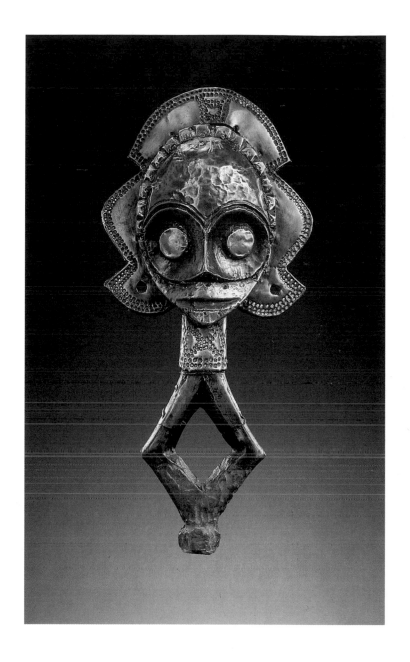

122 Reliquary figure, Mbulu Ngulu.
Gabon. Obamba Ndoumou. Wood decorated with strips and plates of brass and copper. H: 41 cm. Musée Barbier-Mueller, Geneva.

The various cultures known as "Kota"

The name Kota is used to designate many cultures in eastern Gabon. Aesthetically speaking, they are all descendants of the same northern culture, but their figurines take various forms.

The oldest relics appear to be those previously attributed to the Ossyeba but now thought to belong to the Mahongwe. They are also the most abstract and by far the most impressive. Made of a flat wooden construction in the shape of a leaf, they are entirely covered with fine bla-

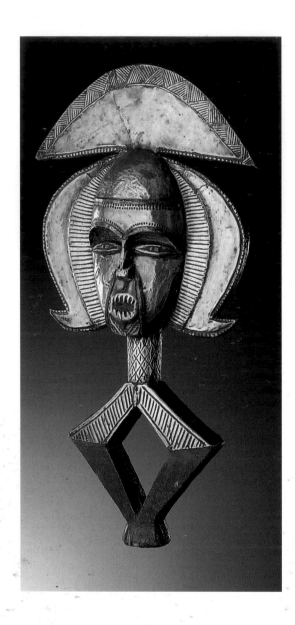

123 Two-faced reliquary figure.
Gabon. Ndassa Woumbou. Wood decorated with plates of copper, brass and iron. H: 54.2 cm. Musée Barbier-Mueller, Geneva. The concave/convex and abstract/realistic contrasts were undoubtedly highly significant, but the meaning is now unclear.

des of brass. The shape was once seen as the head of a *Naja* snake, but this was only the imaginative opinion of an ethnologist and has not been confirmed by local information. The figurine's details (fig.120) suggest a spirit-world entirely separate from the world of the living. Of the senses, only sight functions, with the round eyes set low, their importance emphasised by the fact that they are the only features shown. The vertical brass threads beneath the eyes may represent tears. The mouth is unnecessary and has therefore disappeared. There is no message from the other world. The nose is reduced to a fine blade and the dominant chignon may recall the traditional hairstyle of the old Mahongwe initiates.

The long support stem, a stylised abstract neck beneath these features, further emphasises their sense of an unreal world, turning them into fantasy apparitions of strange fascination.

The Shamaye relics are of a style which lies between the Mahongwe and the Kota proper. Some rare items have the almond-shaped face set within a closely enveloping headdress. As with the Mahongwe, the mouth has been eliminated; sometimes it is replaced with a small plate of brass carved with decorative motifs, expressing forcibly how difficult it is to communicate with the spirit world.

Less abstract, the various Kota relics appear nearest to the world of the living (fig.121). The *Mbulu ngulu* of the Obamba and the Ndoumou are classic pieces, the face always covered in metal (copper or brass) in the form of either sheets or close-set threads. Although intended as two-dimensional, the play of convex and concave surfaces on these faces produces a definite relief effect. The general design is strictly geometrical and is emphasised by the treatment of the metal surface in strips or squares. The oval outline of the hair harmoniously echoes the face.

The figurine is set on a lozenge-shaped base reminiscent of the canoe motif of central Gabon with its sexual connotations.

Other relics have varied motifs on their backs, for example a large slit, a triangle, or a lozenge, whose significance is unclear. They may be tribal or brotherhood emblems, magic symbols of protection or more straightforward female symbols.

124 Reliquaries seen
by P.S. de Brazza.
"Voyages dans l'Ouest
africain". Le Tour du
Monde, Paris, 1887.

125 Complete reliquary
Mbumba Bwiti.
Gabon. Sango. Wood,
copper strips and nails
(basket with human
skulls). H: 30 cm. Musée
Barbier-Mueller, Geneva.

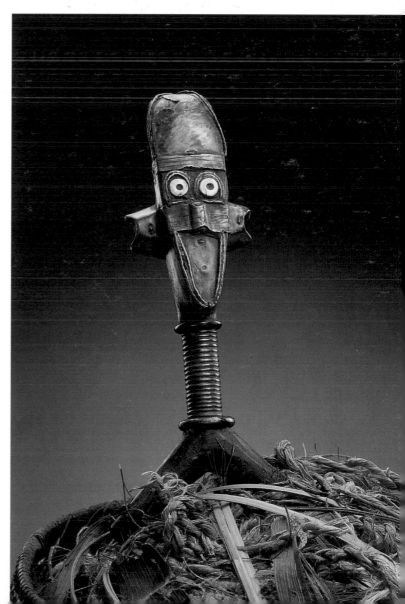

Variations in form are numerous. Still with the Obamba and Ndoumou, there is a figurine (fig.122) which, combining copper and brass, hints at a search for polychrome effect beyond the rounded harmony of its forms. The metallic threads or strips covering the surface are replaced here by plaques worked with fine hammered motifs and the effect is less austere.

Questions arise over the meaning of certain two-faced figurines (fig.123) which show an abstract concave face without a mouth, backed by a realistic convex face with a mouth and clearly visible teeth.

All these Mahongwe and Kota reliquaries were originally set in a bundle of relics. A drawing illustrating P.S. de Brazza's description of West Africa in *Le Tour du Monde*, Paris 1887-8, shows them in position and confirms this point (fig.124).

Reliquaries with their bundle of relics have been found among the Sango in southern Gabon (fig.125). These were linked with rites celebrated among the Bwiti. With these figurines, the face is set on a disproportionately long neck, with the outline distorted so that it is not always clear whether the traditional lozenge corresponds to the arms or the

129 Statue whose head forms the top of a reliquary.
Congo. Ambete. Wood.
H: 80 cm. D: 22 cm.
Musée de l'Afrique et de l'Océanie, Paris.

127 Reliquary head.
Gabon. Betsi sub-style, possibly Okano valley. "Sweating" wood and copper. H: 36 cm. Musée Barbier-Mueller, Geneva. A double socket on top of the head held either eagle or touraco feathers.

Right

126 Male ancestor statue, eyema-o-byeri.
Gabon. Northern Fang, Ndoumou sub-style. Light brown polished wood. H: 44 cm. Musée Barbier-Mueller, Geneva. An example of a statue with elongated proportions, found among the northern Fang. The legs are lost. When complete, the statuette was seated on a reliquary chest.

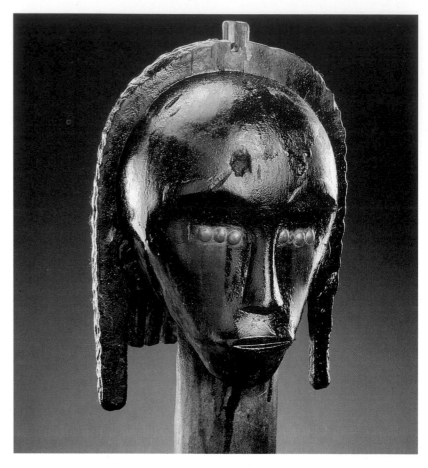

legs. The face is covered with fairly large metal plates. Terms such as Abstraction or Realism are inappropriate here, for this is an example of the most extreme stylisation.

The reliquary skulls were normally invisible inside the basket but initiates could take them from this wrapping to receive offerings and sacrifices, with sprinklings of blood to ensure that the dead looked kindly on the living.

Metal was regularly rubbed with sand to revive its shine and was designed to strengthen the psychological impact of these figurines when, gleaming in the dark, they were presented during nocturnal rituals. At all other times the reliquaries were grouped by clan in the shadows of a consecrated hut, sheltered from profane eyes but close to the village.

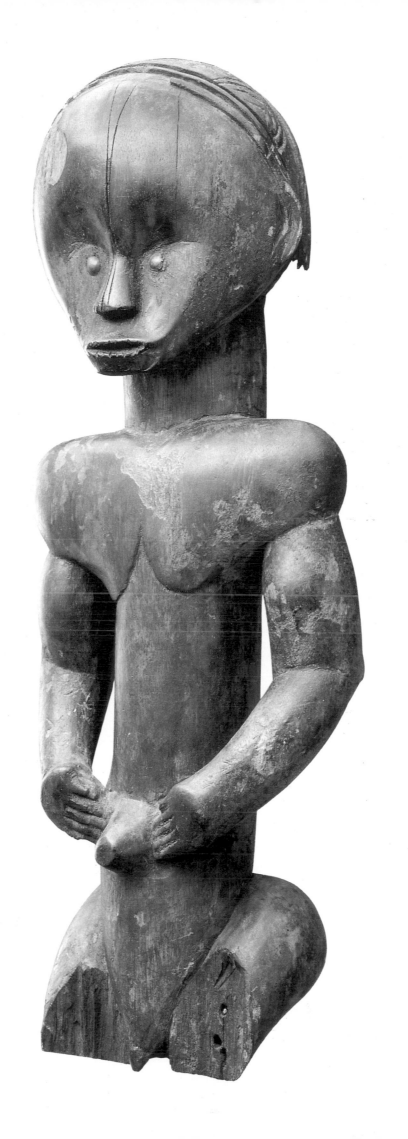

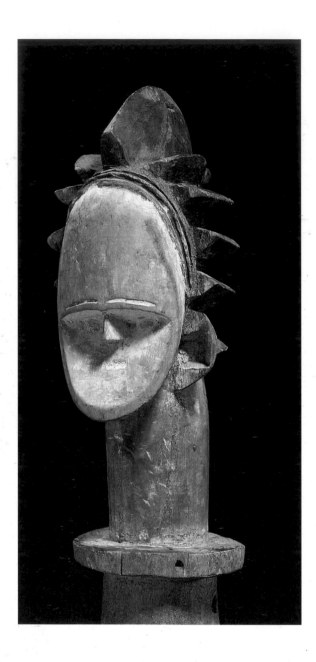

130 Reliquary cover.
Congo. Ambete. Wood.
H: 36 cm. Museum
Rietberg, Zurich.

Among the Fang

Here the picture is a complete contrast to what we know of the Kota. The Fang and their allied tribes (the Ndoumou, Okak, Betsi and Nzaman) live in the north and west of Gabon and the south of Cameroon. In the past their ancestor worship conformed to the traditional ritual established by the brotherhoods, particularly the So and the Byeri.

The Fang tradition of statues has produced numerous figures of ancestors which, for the Byeri ritual, might be seated on large round reliquary boxes of bark containing the bones of ancestors (fig.126). It was their task to guard or evoke them.

Sometimes elongated (among the Fang of the north) and sometimes short (among those of the south), the Fang statuettes always consist of solid, hard and tense forms.

Among the Fang of the south the reliquary very frequently consists not of a statue but only of a head (figs. 127 and 128) coiffed with a helmet wig, either with tresses or with a three-fold central crest. More rarely there may be a transverse chignon set as a crown. These faces have all the formal tension which characterises the statues' bodies. Beneath the heavy bulbous forehead the nose area is shallow, but the chin juts forward with the mouth generally pouting and lips tightly compressed.

Whereas the Kota reliquary figurines were simply shown to the faithful who were permitted to see them, among the Fang the individual responsible for the rites separated the statuettes or the heads from their relics and used them as puppet figures, waving them above a cloth stretched between two trees to present them to the assembled audience. Their three-dimensional structure is thus fully justified.

Reliquaries integrated into a statue

With all the reliquaries discussed so far, the statuette or figurine stood above relics. Alternativety, the relics could

be set inside the statue, as was done by the Ambete, or Mbede, tribe living in the part of the Congo near the northern frontier of Gabon. The upper body of the statuette is particularly elongated in this case and the back hollowed out with a box-shaped cavity accessible through a small door held in place with a thread. It is thought that this would hold the long bones of hunters who had played an important role in tribal life. The faces of the Ambete statues show a prominent forehead overhanging a hollow receding face with a rectangular mouth and broadly carved features, so that the original tree-trunk form is still visible. The arms are often fixed to the body and the hands and feet barely discernible.

The Musée de l'Afrique et de l'Océanie in Paris owns three of these Ambete reliquary statuettes, on two of which the head forms a lid for the cavity containing the relics (fig.129). This practice is not merely a plastic solution to the problem of uniting two different forms (statue and relics); when the two elements interact materially there is greater emphasis than elsewhere on the supernatural function and its visual expression.

In the Museum Rietberg in Zurich there is an interesting *Ambete head* (fig.130) which was used as the top of a reliquary. Surmounted with a very high crest, it is heavily stylised, which lends metaphysical weight to this evocation of a dead ancestor.

The Kuyu tribe in the Congo, to the south of the Ambete, also frequently adopts the pattern of the body reliquary. Access to the relics is from above, at the top of the hollow trunk, with the removable head acting as a "stopper". There are often no arms, the body is elongated and occasionally the face is covered lightly with various motifs representing scarification.

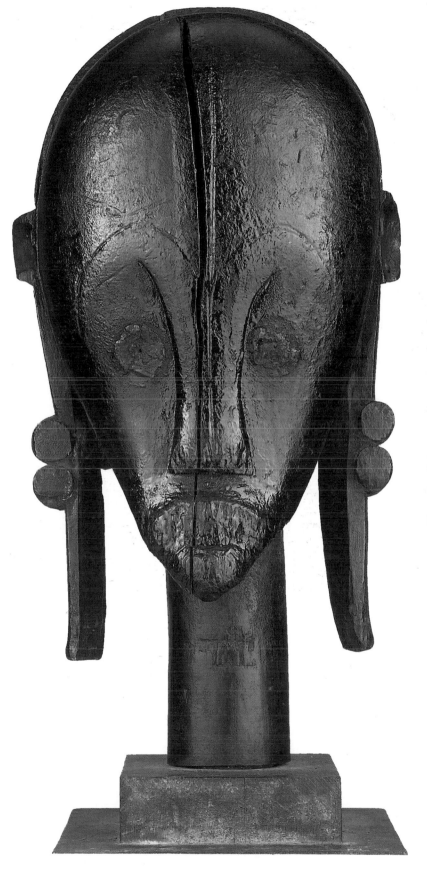

128 Giant head for a reliquary.
Gabon. Fang. Wood and metal. H: 47 cm. The Metropolitan museum of Art, New York.

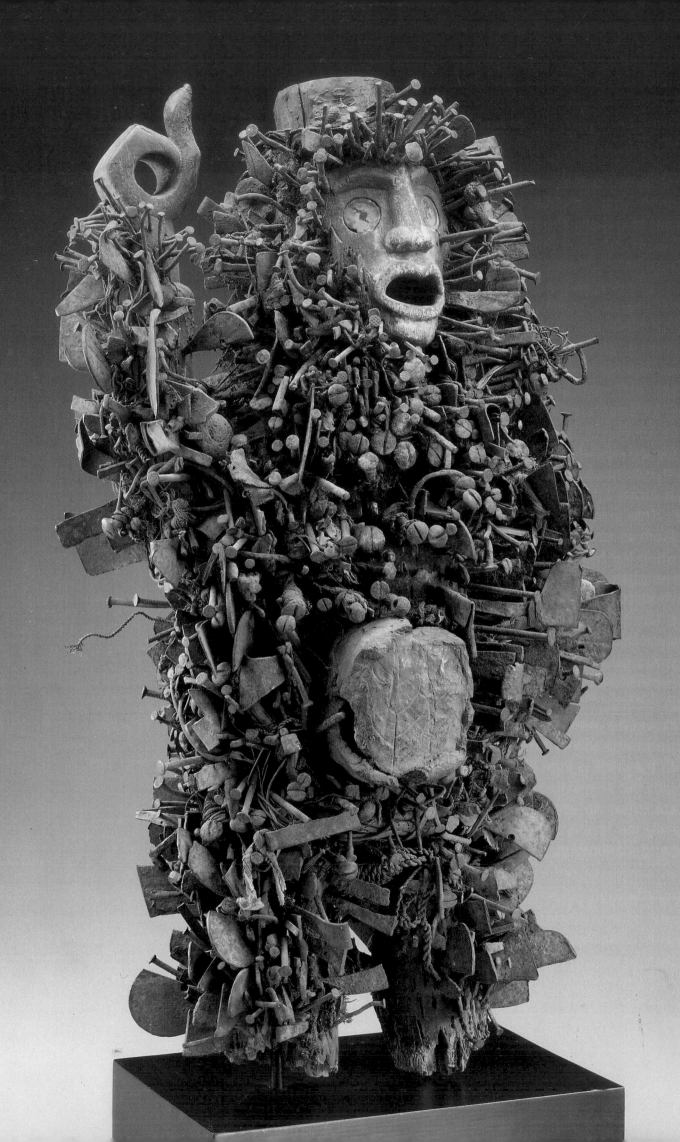

Large
and small
fetishes

Magic is practised throughout Black Africa, but there are distinctions to be made among those who participate in it. The witchdoctor is seen as someone who undertakes on his own account a personal communication with evil powers -suspected of casting spells, he is feared and rejected as the most dangerous individual in the tribe. The accusation of sorcery is a serious one.

The diviner, or fetishist, operates in principle for the good of all. His help is sought in times of need, for he is seen as the mediator between members of the tribe and all the powers of darkness. For this reason he also acts as healer.

The various attempts to influence the fearsome powers of the supernatural through the mediation of statues or fetishes have acquired particular intensity in the regions round the mouth of the River Congo, home of the Kongo, Yombe and Vili tribes, and this is also the case in the east of Zaire, among the Songye.

Magical objects were for many years little known in Europe, as Christian missionaries working in Africa tracked them down and had them burnt. Certain statues which were brought back to Europe by religious men, allegedly for documentation, were kept in secret and could not be studied. They were much feared for they seemed, even to

Left

131 Nail fetish.
Zaire. Kongo. Wood, nails and metal blades, with assorted materials.
Musées royaux d'Art et d'Histoire, Brussels.

141

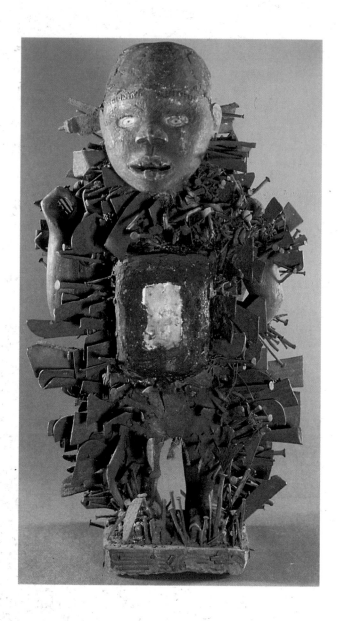

132 Nkisi Nkonde statuette.
Popular Republic of the Congo. Cabinda. Vili, Kongo. Wood, iron blades and nails, with composite materials, skin and mirror. H: 53 cm. Musée d'Ethnographie, Geneva.

Right

133 Sculpture covered with nails. Nkonde.
Lower Zaire. Yombe. Wood, nails, wooden spear and fabric. H: 97 cm. Musée Barbier-Mueller, Geneva.

European eyes, to have real power, a belief almost universally accepted in 17th-century Europe. Olfert Dapper was the first to look dispassionately at these "fetish" objects and to dare to describe them.

Recent work has led to a better understanding. They are wooden carvings, either anthropomorphic or zoomorphic, which are covered with a variety of objects such as nails or metal blades. The cavities in their back or stomach contain "medicines" - grains, hairs, teeth or fingernails - which are held together with various binding materials. Pieces of fabric, feathers or lumps of clay are sometimes present. Finally, bits of mirror, shiny metal or shells are used to close the cavities or to mark the eyes (fig.131). Very often the faces alone are carved in detail, while the rest of the body - destined to be hidden under these various additional features - is sculpted more summarily (figs.132 and 140). The figure's genitals may even be missing, either becaue they have never been carved or because they have been removed by a zealous missionary.

These figures have only a remote ancestral connection and they are distinguished from reliquaries by the absence of skulls or large bones, although some may sometimes fit into either category.

Generally grouped as *Nkisi*, they were the result of the combined work of two men, the carver and the fetishist. The former created the shape, but without the latter (the *Nganga*) the figure had no meaning. It was the *Nganga* who filled it with magic substances and completed the rituals which gave it supernatural powers.

Large nailed statues, the "Nkonde"

All statues possessed magical powers but their roles varied according to their size. The largest, the *Nkonde*, standing between 0.90 and 1.20 metres high, appeared at collective ceremonies and were pierced with nails or metal blades. More of these were added after each vow of commitment, in order to give the illiterate public a way of ratifying their action. The fetishist acted first to "awaken" the *Nkonde* with his touch - part of the surface was left clear of nails for this purpose - and then a sharp blade or nail

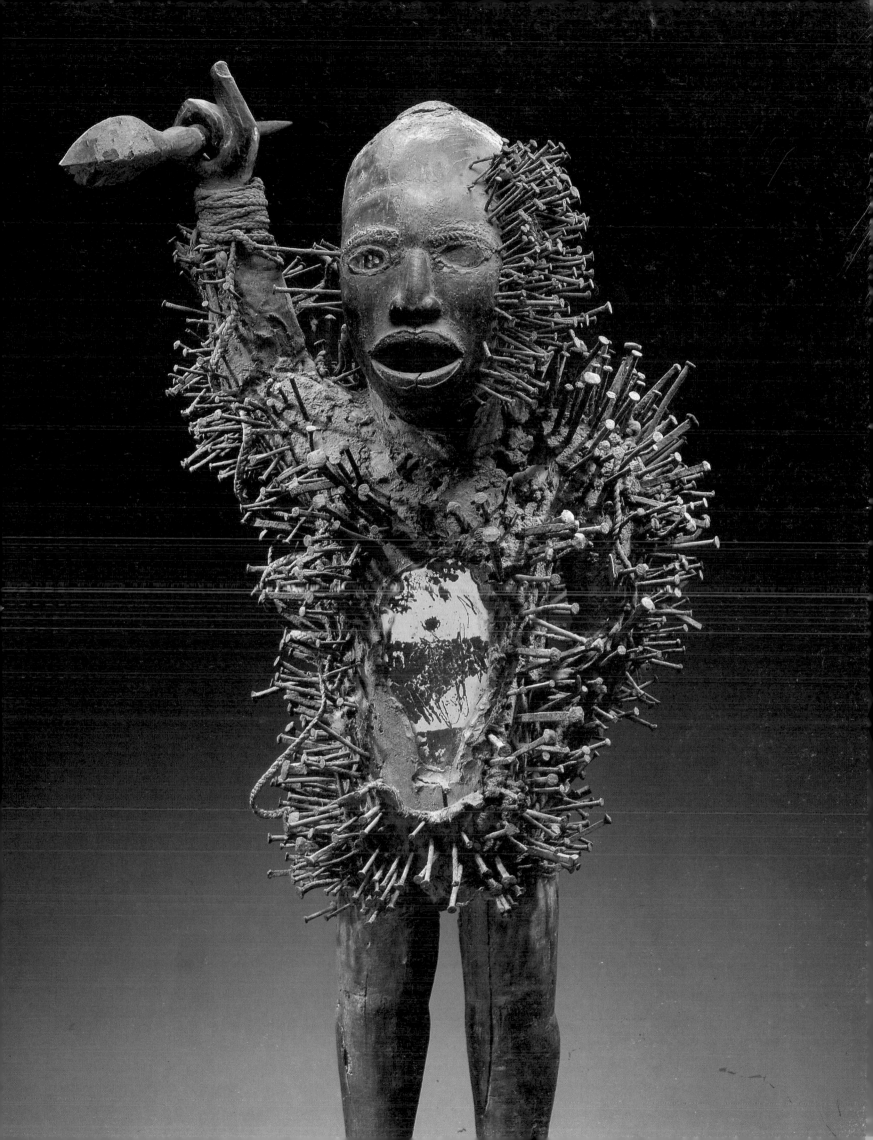

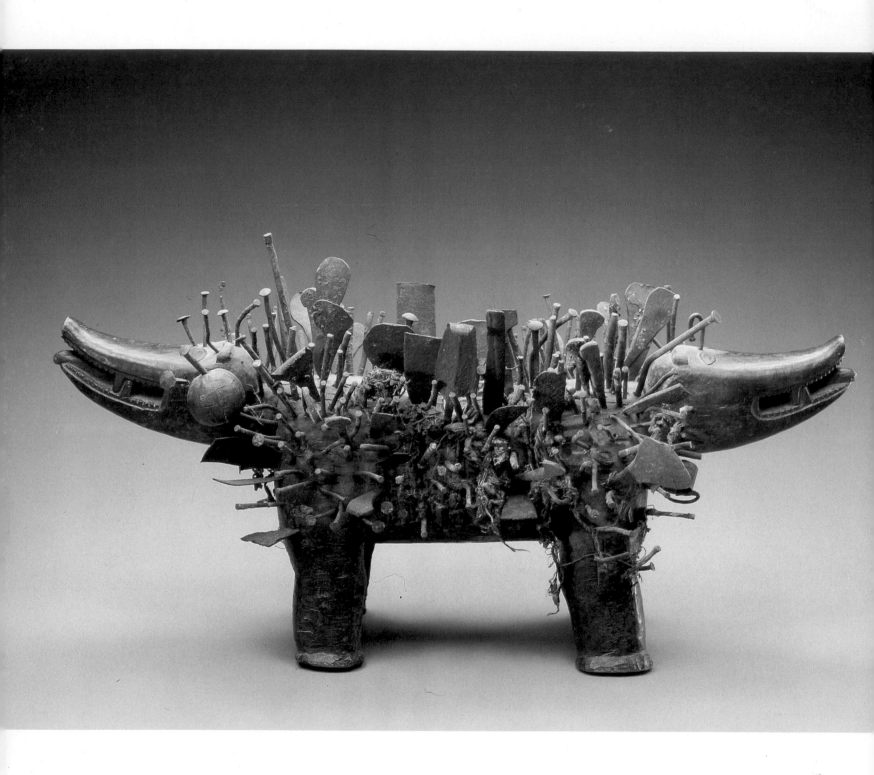

135 Sculpture of a two-headed dog, covered with nails.
Nkonde.
Lower Zaire, Kongo.
Hardwood, nails, and
iron blades. H: 67.5 cm.
Musée Barbier-Mueller,
Geneva.

was set into the body of the statue, to remain there until the contract was completely fulfilled.

The fetishist was primarily a witness, and an important one in view of his supposed relationship with the world of the supernatural. Woe to anyone who failed to keep his promise! The *Nkonde*, as guardian of collective memory, would inflict sudden sickness on any defaulter, or even bring about his death, but he protected the innocent. The *Nkonde's* face is always aggressive and deliberately terrifying; the mouth is always open, as if shouting a warning to the person making a vow. Was that person also required to chew or lick the nails? The fact that a tongue is occasionally visible may suggest this, although there is no concrete evidence.

In the presence of a *Nkonde* there is greater interplay of glances. There is the *Nkonde's* gaze, his metallic eyes seeming to transfix the man who takes an oath, and following him through space and time. And in return this man is held fascinated and cannot detach his gaze from the fragment of mirror on the *Nkonde's* stomach which conceals the supposedly magical substances, hiding their striking poverty and hinting at their power. Once again African traditions manage to bring considerable natural and wholly psychological powers into play, operating through the manipulation of relatively meagre material factors.

Depending on the statue's attributes or regional variations - factors which remain uncertain - the physical attitudes of the *Nkonde* might differ. Those holding a weapon in their raised right arm (fig.133) are the most dynamic, but the figures with their hands on their hips and with their beards of clay and resin are clothed in majesty. Finally, there are many with their hands set close to their navel, a possible reference to their lineal origins.

Surprisingly, some animal forms of *Nkonde* also have certain features similar to human statues. The *Crouching monkey* (fig.134), with open mouth and eyes fixed on its human brothers, is firmly classed among the animals by his bent stance, long arms and realistic fur - yet this makes it particularly disturbing. Two-headed dogs have also been found (fig.135). Each muzzle has the traditional lolling tongue. Their role, as with real living dogs, appears to have been to protect families and give warning of danger.

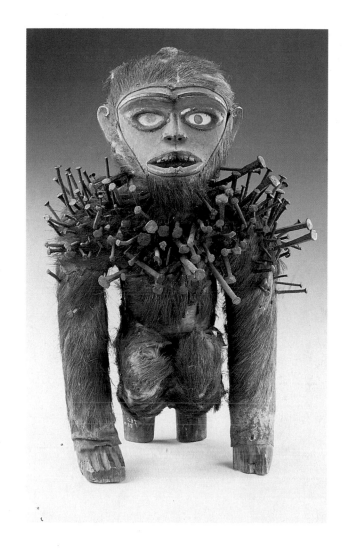

134 Nkisi statuette of a crouching monkey.
People's Republic of the Congo. Vili, Kongo. Wood, iron, glass and skin. H: 35 cm. Rijksmuseum voor Volkenkunde, Leyden. (Photo: Musée Dapper, Paris.)
The small size of this statuette places it in the Nkisi category, although the nails would indicate an Nkonde figure.

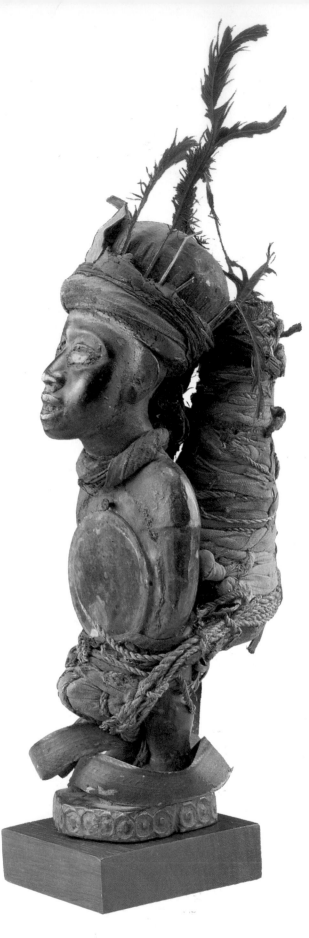

136 Wood statuette.
Zaire. Kongo. H: 36 cm.
Private collection.
With ritual cockerel
feathers on its head, this
Nkisi statue carries a load
of particularly important
magical materials on its
back.

Professor Th. Obenga, director general of Gabon's international centre of Bantu civilisations, offers interesting details on the social role of the Nkonde in his article in *Dossiers d'archéologie*. He sees the nails as "nails of malediction". And, extending the debate, he adds: "The principal role of the *Nkonde* is to engender respect for the country's laws, to aid the reign of civic peace, to seek out and denounce thieves and to wrcak vengeance on wrongdoers". On the *Nganga* (fetishist) he offers a soundly based opinion: "These are skilful and intelligent men. Their historic skills, their extended knowledge of both fauna and flora, of the environment, the group and psychology, gave them, and still give them, powerful ascendancy over the minds of the people and over the imagination of society as a whole."

Smaller statues

The small statues, *the Nkisi*, (fig.136) were less ambitious than the large *Nkonde* and were designed for the individual or the family. Never more than 40 centimetres tall and without nails, they often had a feathered hat on their head after they had been consecrated by the fetishist. The fabrics wrapped round them were covered with a crusting of red powder. As with the *Nkonde*, they had a cavity in their back or stomach which held "medicines" and magic substances placed there by the fetishist. These consisted essentially of white clay from the marshes, red clay used for ancestor worship, and tukula (sawdust from red wood).

These *Nkisi* were supposed to protect their owner's health and transmit to him the vital strength with which they were endowed. The owner could give them offerings to escape from difficult situations.

Similar to the *Nkisi*, the small commemorative statuettes known as *Phemba* (fig.137) were designed for women who had lost a child and wanted another. These carvings, generally sophisticated and very graceful, were thought to favour such a happy event.

Among the Songye

Far from the Kongo tribe, the Songye, settled in the south-east of Zaire, are not known for being gentle - indeed, they have a well deserved reputation for being tough. They can, however, be compared to the Kongo and the Vili in their overriding attention to magic. Fetishes are far more numerous here than ancestral statues.

In these fetishes the lower part of the face is elongated, the cheeks are hollow and the neck very long, so that coloured necklaces can be worn. They are not nail fetishes; their magical substances are inserted into the stomach or in one or two antelope horns set on top of the head. Such materials are carefully selected for a specific purpose. For the hunting fetish, for example, there might be "a piece of a dog's muzzle, a swallow's wing and, if possible, a finger from a pygmy, the outstanding hunter,' as Brother Cornet recounts.

Although they do not have ritual nails, the Songye fetishes are decorated with several brass nails which are used as ornaments. A metal plaque may also cover the navel and the magic material. These fetishes are intended to ward off evil, to preserve the tribe or the family from hostile powers, sorcerers or evil spirits, and to aid fertility.

The Luluwa, whose art has been influenced by both the Songye and the Luba people, have created numerous crouching figurines for use as fetishes (fig.139). This is proved by the antelope horn stuck into the skull to hold magical materials. Lacking all other additions, these statues are remarkable for the care taken in the carving of the body and the consistent treatment of forms. Everything is curved and remarkably balanced, with large feet acting as a plinth. The thoughtful expression of the face matches the body in showing a skilful and highly developed art.

137 "Phemba" commemorative statuette.
Cabinda. Kongo. H: 44 cm. Rijksmuseum voor Volkenkunde, Leyden. (Photo: Musée Dapper, Paris.) This statuette shows a woman kneeling with two human figures and three snakes.

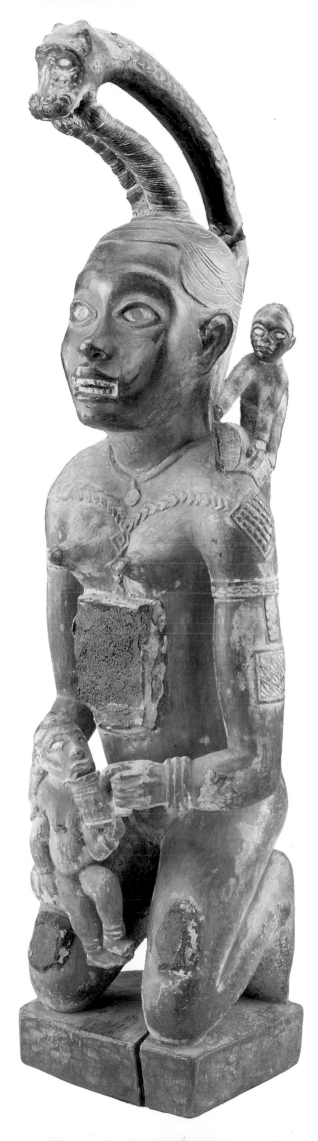

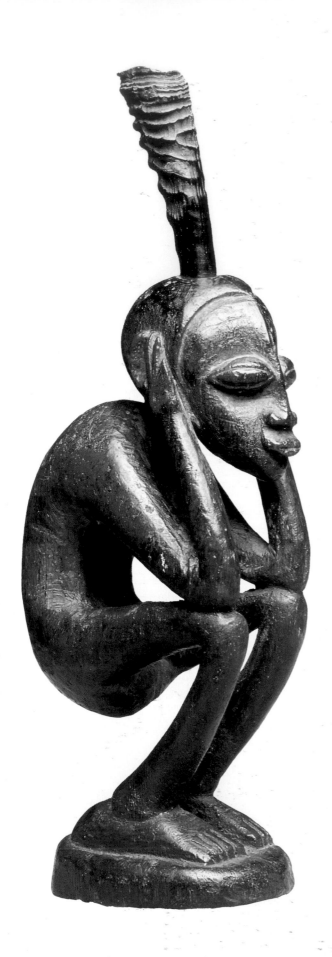

139 Fetish.
Zaire. Luluwa. Hardwood, with traces of white and red pigment. H: 24 cm. Musée Barbier-Mueller, Geneva.

148

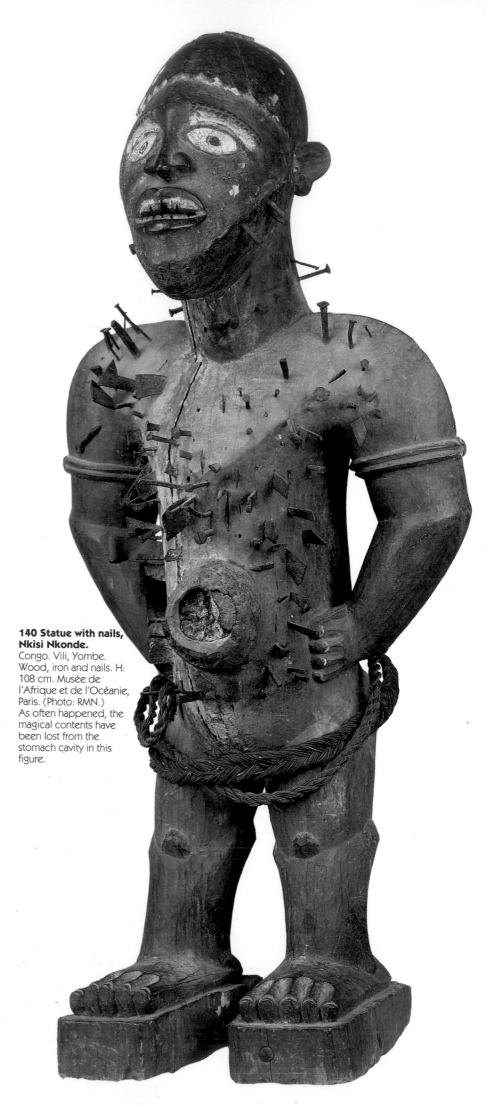

140 Statue with nails, Nkisi Nkonde.
Congo. Vili, Yombe. Wood, iron and nails. H: 108 cm. Musée de l'Afrique et de l'Océanie, Paris. (Photo: RMN.) As often happened, the magical contents have been lost from the stomach cavity in this figure.

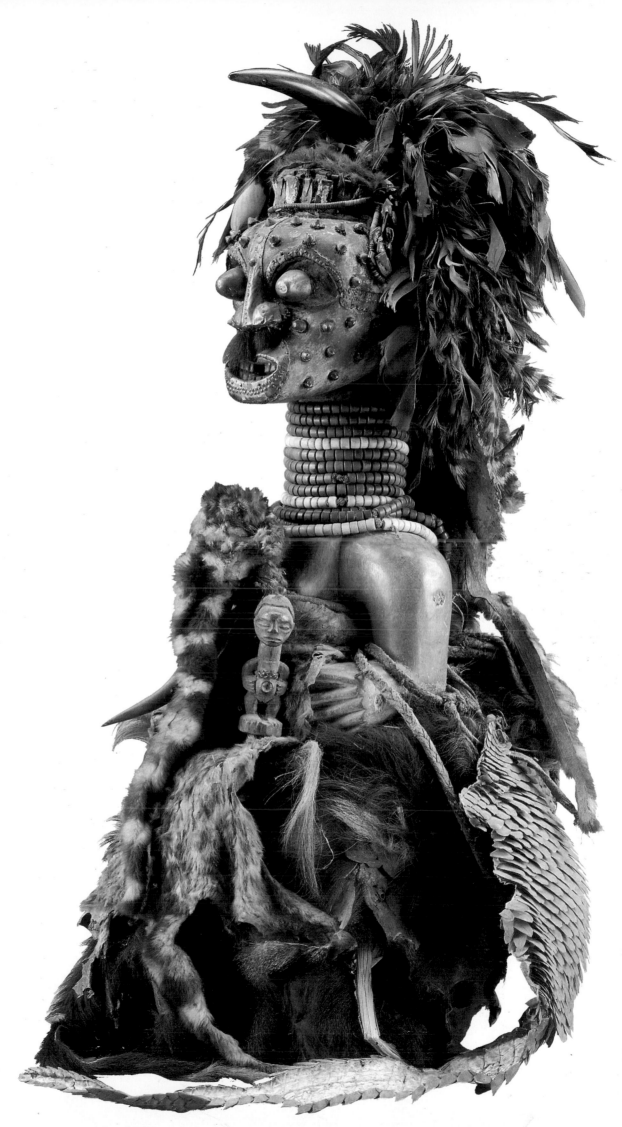

138 Wood statue with various accessories.
Zaïre.. Songye. H: 98 cm.
Private collection.
This large fetish has all the attributes designed to increase its powers: a horn on the head, metallic additions to the face, various feathers and skins, smaller fetishes and horns full of magical materials.

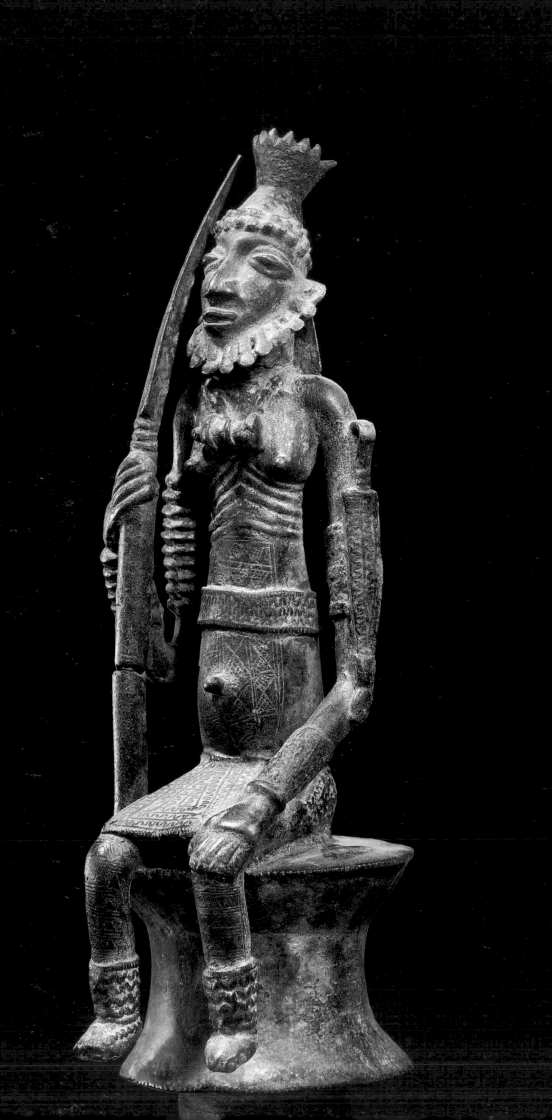

Warriors
and
hunters

The social systems which have held sway in Africa vary enormously according to region. All types can be found, from great empires to small chieftainries.

Emperors who governed vast territories generally demanded taxes or gifts, contributions which were needed to maintain a substantial professional army.

In the smaller chieftainries, on the other hand, the warrior equipment varied according to family or individual. It was a matter of weapons and not of armies.

Three great empires

Three great empires held the basin of the River Niger in succession, between the 11th and 16th centuries - the Ghana, the Mali and the Songhai. Each sought to outshine its precedecessor in wealth and prestige. They are known to us now through the accounts of travellers more than through their very rare archaeological remains.

The Ghana empire, which reached its peak in the 11th century, gained part of its wealth from the gold of the Bambuk, but was unable to resist the assaults of the Moslem Almoravids who sought to convert Africa to Islam. Their domination was short-lived. In 1240 the prince of

141 Sceptre.
Seated male figure. Mali. Niger Inland Delta, or Dogon or Bozo. Bronze and iron. H. 76.2 cm. The Metropolitan museum of Art, New York.

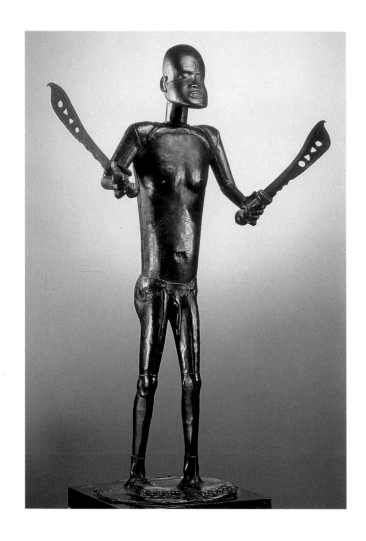

**142 Statue
representing King
Glele as the god Gu,
god of metal and war.**
Brass. H: 105 cm. (Photo:
Musée Dapper.)

Mali conquered Ghana and managed to seize political power, dazzling his contemporaries with his immense wealth and his array of gold. From the 15th century onwards it was the Songhai empire which dominated, but finally, in the battle of Toudibi in 1591, it fell to the Moroccans when they used firearms, hitherto unknown in Africa.

Until then it was the cavalry which provided the greatest strength of the Sudanese armies - there is proof of horses in this region since the year 1000 AD. The Africans rode bare-back, the saddle apparently being introduced by the Moslems. The Arabian traveller Ibn Battuta, who was received by the Emperor of Mali in 1352, recounted that for his audience the sovereign was surrounded by courtesans and generals, all on horseback and carrying a bow in their hands and a quiver on their backs. Two saddled horses were held by their bridles in front of the emperor.

The horsemen described by Ibn Battuta may have been the same as those represented on the terracotta of the Niger Inland Delta, dated by thermoluminescence at between 1240 and 1460 AD. Bernard de Grunne, a specialist in Mali archaeology, considers that they were Kamara. These were the proud warriors who fought with the Mali emperor's army and who were represented on horseback, full of astonishing energy, their rich harnesses giving an idea of their prestige as troops. The details of their weapons have not always survived the passage of time, but we can see that the horsemen wore a cross-belt which would have held the quiver mentioned by Ibn Battuta. One of them had a round shield, and most had their heads protected by a helmet held in place by a chinstrap.

Many other statues have been discovered, in particular a horseman and an archer now in the Washington museum of African Art, which help to flesh out this picture (fig.12, p.22).

The former inhabitants of the Niger Inland Delta have left us a remarkable sceptre from their distant past (fig. 141), made of iron and brass and decorated on top with a small figure of a seated chief. He is shown in perfect detail, both in his bodily scarifications and beard and also in his head-dress and clothing, which are represented with great precision. His arm and ankle rings are also very

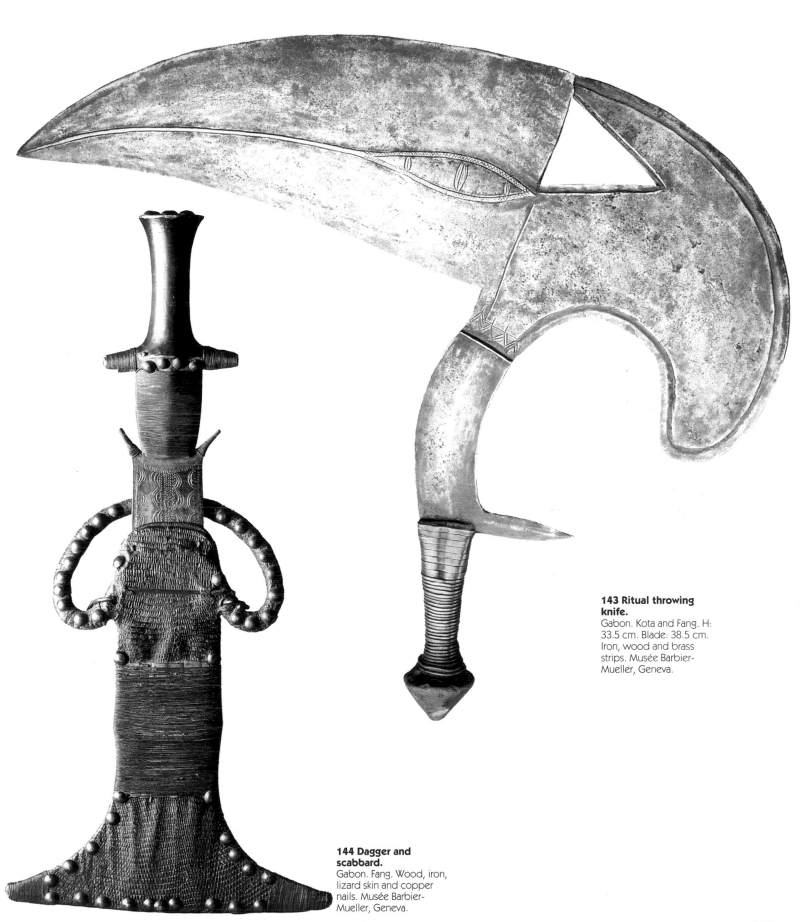

143 Ritual throwing knife.
Gabon. Kota and Fang. H:
33.5 cm. Blade: 38.5 cm.
Iron, wood and brass
strips. Musée Barbier-
Mueller, Geneva.

**144 Dagger and
scabbard.**
Gabon. Fang. Wood, iron,
lizard skin and copper
nails. Musée Barbier-
Mueller, Geneva.

153

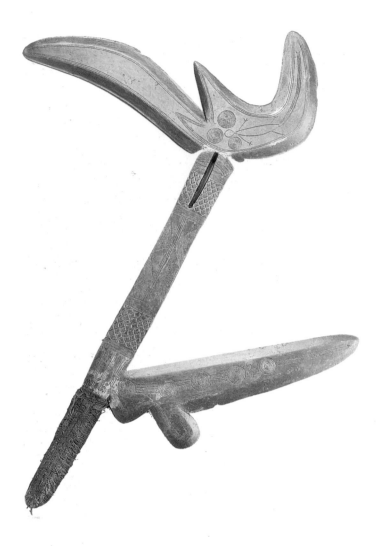

145 Throwing knife.
Republic of Central Africa.
Zande. Iron and plant
fibre. L: 39.5 cm. Musée
royal de l'Afrique
centrale, Tervuren.

Right

146 Bow-stand.
Zaire. Luba. Musée royal
de l'Afrique centrale,
Tervuren.

detailed. The brass-founder (this was made by the lost wax process) paid particular attention to this chief's weapons, the pointed lance in his right hand and the short sword with handle set in a scabbard hanging by his left arm. The man looks calm and confident in his authority.

Benin and Dahomey

From the 15th century onwards, in the twilight of the Songhai empire's power, the kingdom of Benin which emerged in Nigeria was rich in its fine royal art. Its strength was based on armies controlled by the tribal chiefs; the "warrior kings" of the 15th and 16th centuries ruled in a state of semi-permanent war, but the sovereigns preferred to emphasise the monarchy's divine origins and nature. There are few strictly military representations on the brass plaques decorating the royal palace, but one, dating from the 16th century and now in the Leipzig Museum für Völkerkunde, appears to depict the Benin warriors engaged in their victorious war against the Igbo. Wearing large helmets, they brandish their swords. One man, on horseback, has a lance hanging from his saddle, while the footsoldier in the rear carries a shield as well as his lance.

Dahomey, inhabited by the Fon and Yoruba peoples and now the Republic of Benin, was a powerful kingdom from the 16th to the 19th centuries, ruled by ten kings in succession. In the 18th century the well administered kingdom gained most of its wealth from substantial commerce in slaves sold to European slave-traders, but its power was mostly founded on the successful military expeditions of its terrifying armies. In Dahomey and Benin alike there were considerable numbers of human sacrifices. These took place in Dahomey twice a year and on the death of each sovereign. It was the French who in 1892 delivered the final blow to the last king, Behanzin, and deported him.

The royal palace in Abomey, the capital, was in effect a city in itself, with its walls decorated with painted bas-reliefs. The court was steeped in luxury which was evident on all sides, particularly the sumptuous fabrics and metal

crafts. In Dahomey metal-workers constituted a powerful caste who produced weapons and jewels for the king. It was they, in particular, who forged the iron or copper *Asen*, a type of portable altar consecrated to the ancestors of kings and important chiefs.

The god of war and metals, Gu, was represented twice by Dahomey metal-workers. One of the statues, housed in the Musée de l'Homme in Paris, seeks to express ancient myths through a collection of European metal. Dressed like a Dahomey soldier, the god wears a short tunic and his head bristles with arrow-heads, knife blades and iron lances. Slightly off-centre, the figure appears to be walking. Its hands, now empty, originally brandished a sabre and a war-bell. It represented the motto of the terrible king Glele of Abomey, who reigned from 1858 to 1889: "When the sabre of Gu appears the beasts do not show themselves.".

A second statue (fig.142), much more powerful in that it is less anecdotal, shows a clear wish to express the most profound essence of war: a pitiless cruelty. These two exceptional unsigned works have influenced modern western artists, but they themselves may also have been influenced by European statues.

Other Dahomey artists created *recades*, ceremonial gifts for the king to present to his chiefs. They were a type of axe or adze, the metal or ivory blade being carved with a figurative motif - for example, there is a roaring lion on the *recade* in the Musée de l'Homme in Paris. The item, a sign of dignity for its bearer, would as a last resort let loose the sovereign's martial mystic and strengthen his prestige.

In equatorial regions

The luxuriant vegetation and the lack of paths through the thick jungle encouraged the development of restricted social systems which were linked to lineal groups. No great kingdom could develop or expand in such a setting, but although it would be fruitless to seek traces of great armies, the inhabitants were none the less engaged in inter-tribal confrontations. They also had to defend them-

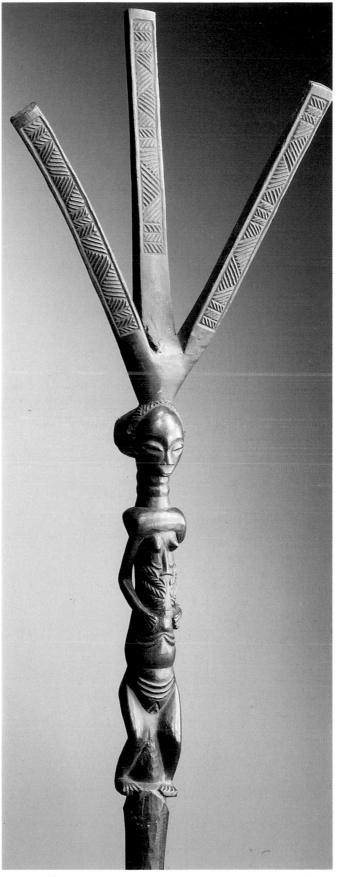

147 Statue of Chibinda Ilunga.
Zaire. Jokwe. Wood, fibre beard, with no genitals. H: 40 cm. Kimbell Art Museum, Fort Worth, Texas.

selves against the raids of neighbouring tribes. The Fang in particular had a reputation for redoubtable ferocity. They would use a variety of weapons: lances, swords of various kinds and throwing weapons.

The *Throwing knife* (fig.143) of the Fang and the Kota was a weapon for fighting as well as a prestige object. It also made its appearance during certain initiations: the leader of the dance crawled along the ground waving the knife while the initiates had to avoid it by jumping as high as possible over him. The blade of the knife was shaped like a toucan's beak and curved over in a line which, despite being designed to be functional, was none the less of a rare purity.

Even if it could not compete with this for elegance, a *Fang dagger* (fig.144) showed similar features in its adaptation of form for practical purposes. The elongated blade, double-edged and decorated with finely carved motifs, was protected by a scabbard covered with lizard-skin and embellished with brass nails, while brass thread strengthened all the fragile parts. Apart from these weapons the Fang used the rifles introduced by European traders.

The Zande in the Central African Republic displayed their particular artistic talents in their warrior equipment, such as a remarkable *Throwing knife* (fig.145) whose blade and handle are decorated with fine engraving in perfect curves and counter-curves. Stylistic links exist between the Zande and Mangbetu in northern Zaire. It is thus not surprising to find among the Mangbetu knives with curved handles which clearly show signs of deliberate shaping, above all when made of ivory. The result, however, is heavier and cannot be compared with the elegance which distinguishes the finest Zande or Fang knives.

In the Congo Basin

In the past some states came into being through the union or confederation of a number of tribes or chieftainries. This happened with, among others, the Kuba, the Luba and the Jokwe. The arts of war retained all their vigour here, at the heart of an artistic production of the highest standard.

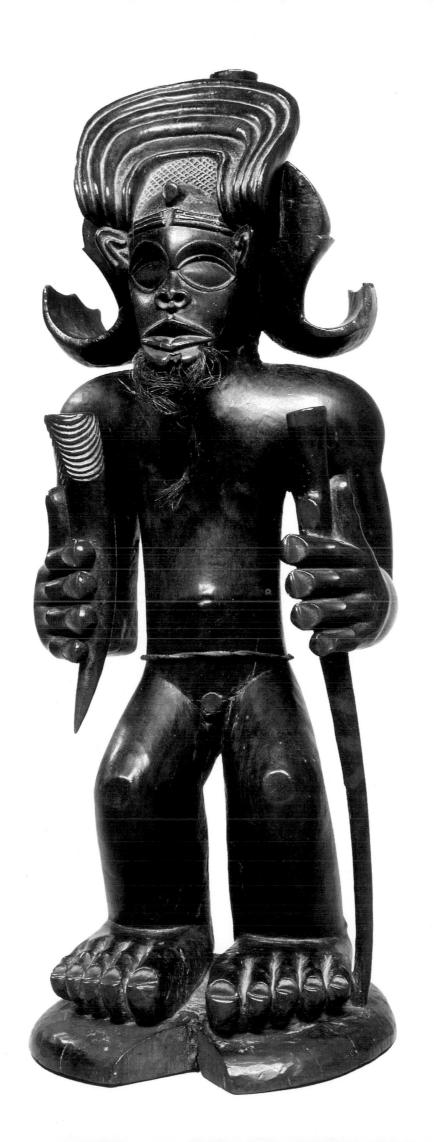

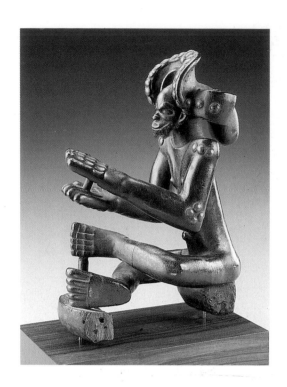

148 Seated Chibinda Ilunga.
Zaire. Jokwe. Wood. H:
25 cm. Private collection.

Right

149 State lance.
Angola. Jokwe. Iron,
wood and copper. H:
106 cm. Height of figure:
20 cm. Museum Rietberg,
Zurich. (Photo: Wettstein
en Kauf, Zurich.)

A confederation of Kuba tribes was originally created under the domination of the Bushoong, the royal clan of the Kuba, whose name means "men of throwing iron" or "men of lightning", the lightning of the gleaming blade. The name indicates the importance attached to this weapon, of which some richly worked examples survive. However, this warlike instinct was channelled and watered down by successive Kuba kings, who were depicted in peaceful guise in their royal portraits (*Ndop*). By 1650 Shamba Bolongongo, a philosopher king, had in fact sought to replace the throwing knife with less aggressive weapons.

Among other Zaire peoples, like the Makaraka, there were many decorative weapons. The Teke people were famous blacksmiths, producing iron anvils and weapons and axes which drew European admiration as soon as they arrived. All these non-firing weapons did not prevent the use of firearms: several Bembe statuettes show a warrior carrying a traders' rifle in one hand and a dagger in the other.

The Luba empire was the result of the 16th-century unification of a large number of small Bantu chieftainries. One of the first Luba chiefs, Kalala Ilunga, was a great hunter, whose power was symbolized by the bow-stands (fig.146) which later became one of the Luba chiefs' most precious emblems of authority. Closely identified with royalty, they were involved in the succession of new chiefs and were kept in a special room by hereditary guards who were among the most important officials of the kingdom.

Among the Jokwe

In southern Zaire, and among the various Jokwe tribes of Angola, the warrior myth centred on Chibinda Ilunga, a civilising hero who never the less continued to lead his people in the hunt and in combat.

A love story set around the 16th century indirectly narrates the origin of the Jokwe dynasty. Chibinda Ilunga, the Luba emperor's son, devoted all his energies to hunting, his favourite activity, which during one of his trips took him into the territory ruled by the Lunda princess

Lweji. She was impressed by the prince's handsome appearance and the delicacy of his manners, invited him to her court and married him. There was dismay and revolution among the princess's brothers, who refused to submit to the intruder and set off to establish other kingdoms. Although Chibinda Ilunga never reigned over the Jokwe himself, they considered him a model prince. In the 19th century he was depicted in impressive effigies (fig.147) which stand at the forefront of African statues. Jokwe art, at once baroque and lifelike, always exhibits great power. In the statues of Chibinda Ilunga two principal characteristics seize the eye - strength and authority, particularly remarkable in view of the fact that these powerful statues are never more than 50 centimetres tall. Their strength lies in the muscular, athletic shoulders and in the limbs which the sculptor treats like harmoniously articulated solid cylinders. Strength, for the hunters, also meant an aptitude for forest life - the ears are pricked, with an apparent mobility which indicates a man on guard, an impression confirmed by the flaring nostrils.

To represent authority, that exclusively psychological and abstract force, and render it in physical terms, the Jokwe sculptors made good use of the large curved headdress always worn by the chief. They show every detailed groove, modulated and amplified, making them stand out and using every resource of the baroque ensemble to extend this visible symbol of authority round the face. The face itself looks intelligent, with a high and broad forehead extended by the grid at the centre of the headdress. In certain statues, like those in the Berlin Museum für Völkerkunde and the Porto University museum, it is thoughtfulness which takes pride of place. But in the specimen in the Kimbell art museum in Fort Worth the angle of the face in relation to the body expresses primarily the wish to be obeyed and the confidence of possessing a strength which cannot be challenged because it is sacred.

All these characteristics can be seen in the figurines showing the hero sitting and applauding (fig.148) or in those which decorate the tip of sceptres. In the latter cases the head-dress still displays its heavy arabesques but the body is generally replaced by a smooth surface.

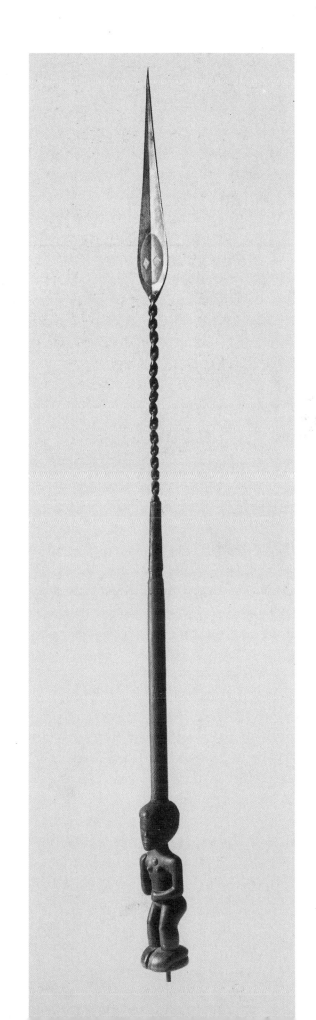

150 Forge bellows with anthropomorphic figure.
Gabon. Shira-Pounou. Hardwood with brilliant patina. H: 62 cm. Musée Barbier-Mueller, Geneva.

This also helps to emphasise the image of the chief, while its abstract motifs separate it from its surroundings.

On a more practical level, Chibinda Ilunga is honoured above all for his knowledge of hunting, which he shared with the Jokwe by introducing them to more sophisticated weapons and more effective spells. He is represented with a walking stick and a "medicine" horn which was later replaced by a firearm (*Statue* in Porto University).

In the 19th century the Jokwe were still passionately devoted to hunting, which had been a speciality of their ancestors. To call their dogs or to communicate amongst themselves, they used little wooden or ivory whistles which were often decorated with a male head. They loved fine weapons carefully made by skilful blacksmiths, who could reproduce on daggers, swords or throwing weapons the decorative motifs so often used by wood-carvers.

Other Jokwe weapons were uniquely prestige objects, such as the extremely elegant *State lance* (fig.149) which, in the context of court art, reveals how chiefs could discriminate when seeking out the finest artists.

The blacksmith

In any society the blacksmith plays an essential role. He makes the farm tools which are necessary for survival, as well as the iron weapons which make combat possible.

In African societies he is always feared because of his links with fire, which hinted at magical practices or even sorcery. He is also feared for his familiarity with metals extracted from the body of the mother-earth. Finally, he can be seen as a somewhat ambivalent character, a mediator between the living and the dead.

The blacksmith's social position varies from area to area, but it is always an extreme one. In Senegal he must come from a single caste; in Mali and the Ivory Coast he is feared, but in the former Congo and in Angola, metal work was undertaken by important individuals. Founding myths recall the hero Chibinda Ilunga who taught the Jokwe how to make and use the best hunting and combat weapons, while among the Kuba, Mbop Pelyeeng was a blacksmith-king who was identified by the anvil at the front of his statue.

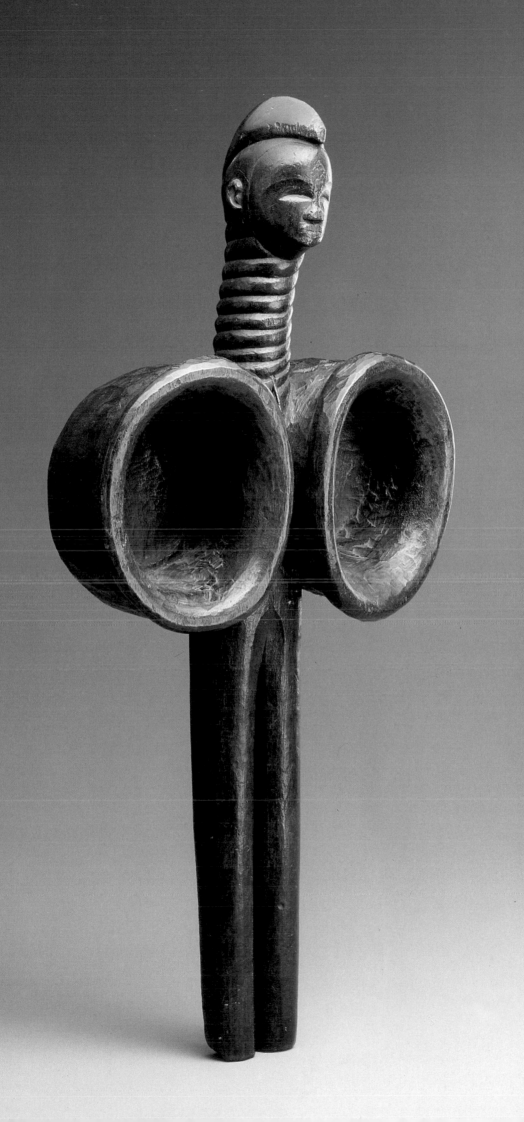

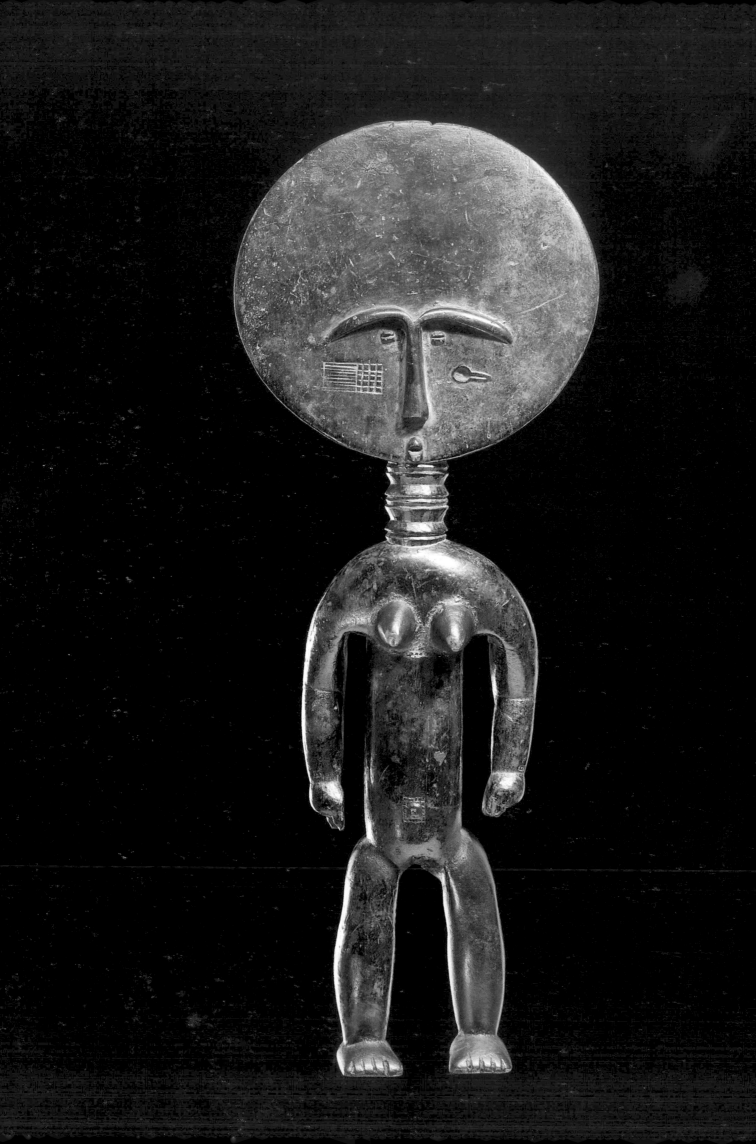

The dignity
of
Black womanhood

Until the middle of the 20th century, African society, whether of a patrilinear or matrilinear structure, was based on kinship and lineal descent. We are not concerned here with the upheavals affecting social structures after 1950, so only events occurring before this date are discussed.

As the mother-figure the woman plays a central role, ensuring that the line continues. Any man without a child would see a break in his ancestral family worship, and on his death there would be no one to watch over the performance of rites which would allow his soul to move on to the spirit world.

The woman also enables the man to prove his fertility, indispensable in certain circumstances - for example, so that the son of a chief can succeed his father. This is the case in the Grassland of Cameroon. Before his enthronement a future Fon must pass every night during his initiation with the young girls presented to him, until one of them becomes pregnant. It is a privilege for the young girls to be chosen for this purpose. They all come from rich families, and the woman who gives birth to the first child thus conceived will always enjoy unanimous respect, in particular from the Fon who through her is able to take possession of his kingdom. Even if she does not become the Fon's first wife, she will automatically belong to the

Left

151 Wooden doll, Akua ba.
Ghana. Akan. Wood painted or stained black. H: 44.5 cm. Musée Barbier-Mueller, Geneva.

163

152 Mask of the Sande Society
Sierra Leone. Mende or Vai. Soft wood with brilliant black patina. H: 45.5 cm. Musée Barbier-Mueller, Geneva.

society of queen mothers. This example, although limited to a special area, indicates the overwhelming importance of fertility for the African women. A woman's social situation was thus dependent on the number and the quality of her pregnancies.

The young girl before marriage

In the eyes of the men of her family line, the young girl represented above all a valuable item for barter. Although she could not live an autonomous life, she would marry and thus allow women of other backgrounds to join the family as wives for her brothers and the men of her family.

Her whole life was a preparation for motherhood, the only event which could give her a place in society. Well before puberty, young African girls would often wear dolls made of reeds or wood as pendants - far from being toys, these little figurines were believed to favour fertility through their magical powers. Various types have been found among the Dan of the Ivory Coast and the Mossi of Upper Volta, as well as among the Jokwe of Angola.

Even in modern times the more elaborate *Akua 'ba fertility dolls* (fig.151) of the Akan and the Ashanti of the Ivory Coast are for young women hoping for a child or already pregnant. The fame of these objects derives from a legend asserting that a woman who has worn one will give birth to a particularly beautiful daughter. They may vary in their degree of realism and the forms differ according to whether the woman wants a son or a daughter. The woman always wears the little figure on her back, like the hoped-for child.

Among the Yoruba of Nigeria such dolls were often found in pairs to give twins, because twins were looked on with particular favour. If one died, the doll received the same attention as the surviving child.

The passage into adulthood for both girls and boys was frequently, but not always, marked by an initiation period in the sacred grove away from the village, supervised by a secret society or a group of experienced women. In general this initiation coincided with the young girl's first menstruation and in the past was accompanied by rituals of excision.

In Sierra Leone the powerful female Bundu or Sande society directed the young girls' initiation. They made use of characteristic *Masks* which, surprisingly, were carved by men (fig.152). They were intended to evoke beautiful and wealthy women. A very elaborate hairstyle, shown in careful detail, multiple folds of flesh round the neck as a sign of prosperity, scented palm-oil on the mask as well as on the body - everything is designed for the same purpose. During the initiation the young girls learn the manners which will direct their lives, and the shape of the mask, with its receding chin and small or even absent mouth, reflects the blind obedience demanded from women.

The role of the Bundu society was not limited to the initiation. Directed by the *Majo*, an experienced woman, the society watched over social life in general.

Marriage

Motherhood was the woman's way of escaping from her inferior social position. To do so, she also needed to marry, but it is clear that marriage was not the result of mutual attraction between two young people - it was based on different systems of financial or material exchange and compensation, designed to sustain the circulation of women outside their own line. Since marriage was of importance to the whole social group, it must not be left to the hazards of individual preference.

Sexual pleasure might be involved, but it was not the sole purpose. Sex was generally associated with fertility rather than pleasure, although the latter was not excluded. Actual images are rare, but they do exist, such as in certain *Luba headrests* representing a young couple caressing each other (fig.153).

After marriage, the couple's greatest wish was to have a child. Among the Bamileke of Cameroon the soothsayers of the Ku n'gan society claimed to be specialists in problems of infertility. The woman would be shown a *Fertility statue* (fig.154) representing a mother giving birth to twins, her mouth open to cry out. Standing upright, she holds her swollen stomach with the first child's head already visible. Consultation with the soothsayer took place in

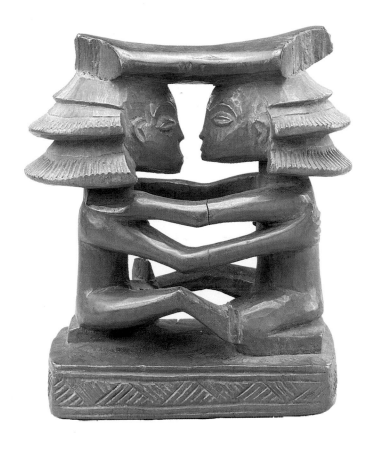

153 Headrest
Zaire. Luba. Wood. Musée royal de l'Afrique centrale, Tervuren. This rare example showing a pair of Luba people bears all the grace of Luba art.

165

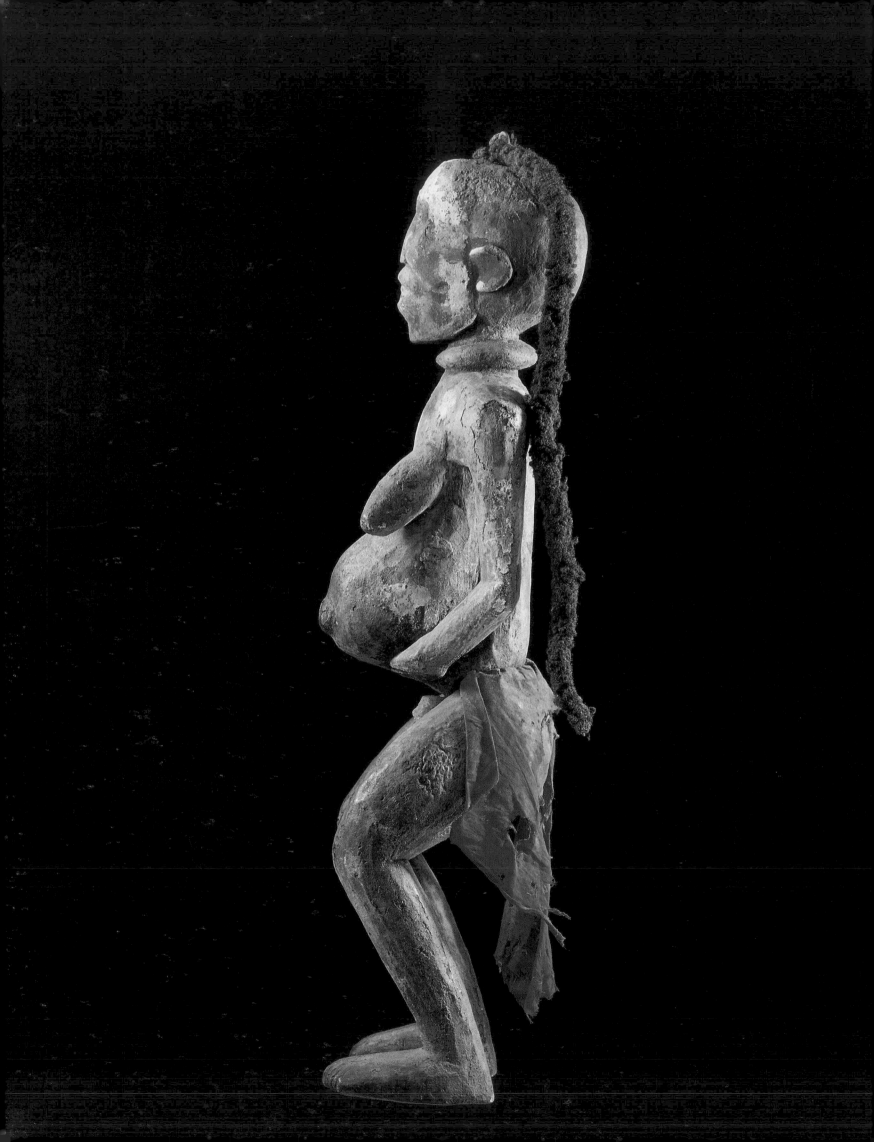

secret and consisted of rituals and offerings. Sterility and death in childbirth, both very frequent, underline the tragic nature of this figure.

Among the Baule people of the Ivory Coast sterility was attributed to a "husband in the spirit world" or a natural spirit. The soothsayer recommended the building of a domestic altar for a *statuette* (fig.104, p.119) carved for the purpose on the soothsayer's instructions. In the harmony of their proportions and the delicacy of their carving, some of these figures are works of art expressing great serenity suitable for calming the distress of a young wife. Such works are entirely different in style from the tragic effect of the Bamileke statues.

Among the Idoma a bush spirit, *Anjenu,* was invoked for the same purpose by men who wanted their wives to become pregnant. The austere and noble *Statue* representing the spirit (fig.105, p.118) clearly exhibits the importance attached to the request.

Childbirth, presided over by two old women or a midwife, was not without its pains. Among the Luba a *Cupbearer* was set at the young woman's door (fig.155 and p.12) to receive the offerings of passers-by and evoke the image of a female ancestor.

Motherhood

The pregnant or breast-feeding mother has always been a popular subject among African sculptors. These are not portraits but ritual figurines which glorify the perpetuation of life. It has also been observed that pregnant or breast-feeding women do not menstruate and are thus nearer to old women or female ancestors, sharing their spiritual force. For these statues of maternity the artist would create the most perfect image of the woman in African eyes, although such visions vary greatly from one culture to another, from the noble austerity of the Dogon to the smiling friendliness of the Yombe.

Among the Senufo, farmers for whom fertility is very important, the evocation of the breast-feeding mother with a child at each breast is powerful (fig.156). The statue in the Barbier-Mueller collection shows her raised to even

154 Ku n'gan fertility statue.
Cameroon. Bamileke. Hardwood with a crusted patina and a plait made of tufts of hair and raffia fibre. H: 82 cm. Musée Barbier-Mueller, Geneva.

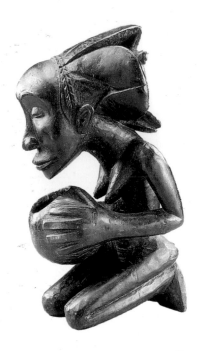

155 Figure with cup.
Zaire. Luba. Wood. H:
45.5 cm. Musée royal de
l'Afrique centrale,
Tervuren. The tension
expressed in this cup-
bearer makes it probably
one of the most beautiful
works of the Master of
Buli, who worked in Buli
in south-east Zaire.

Right

**156 Figure of a woman
breast-feeding, Poro
brotherhood.**
Ivory Coast. Senufo.
Hardwood with black
patina. H: 65 cm. Musée
Barbier-Mueller, Geneva.
The figure oozes with oil
from past sacrifices.

greater symbolic stature by a cup holding magical
materials. The many applications of oil this figure received
during the Poro ceremonies were proof of the devotion it
aroused and it also had links with the Sandogo, the secret
society of women soothsayers. For the Bambara people of
Mali the highly stylised maternal image (fig.157) may
express the calm dignity of the woman who finds self-fulfil-
ment through her child. The even more stylised Dogon
figure of motherhood appears to be reduced to a geome-
trical extreme. According to legend the twins on her back
are endowed with particular vital force.

In the matrilinear society of the Mbala in Zaire, maternity
was celebrated very specifically. A symbol of the chief's
authority and the capital part of ancestor worship, it
inspired powerful evocations of the clan's female founder,
the true force of nature (fig.158). Despite their sacred
character these statues are very lifelike, often designed with
a slight asymmetry which gives them particular spontaneity
and personality. Still in Zaire, the Kongo and Yombe statuet-
tes present us with more smiling and familiar "mother and
child" images (fig.159 and p.10). The woman sitting
cross-legged on the ground holds her child in front of her.
The many scars on her shoulders and body, fashioned like
jewellery, indicate that she belongs to a wealthy family.
Despite her almost smiling appearance of humanity this
statue should be seen as an element of ancestor-worship,
which was highly developed among the Kongo.

Daily life

The much respected mother often appears as the
"sustaining pillar of the chieftainry", a concept presented
in literal fashion by Yoruba sculptors who often created
Verandah posts (fig.160) showing a woman with her child
on her knees. Designed for royal palaces, temples or the
houses of rich officials, these carvings give the woman an
authoritative expression which is the speciality of an artist
whose name is for once known, Oshamuko; in about 1920
he created the carved post which is now in the Barbier-
Mueller collection.

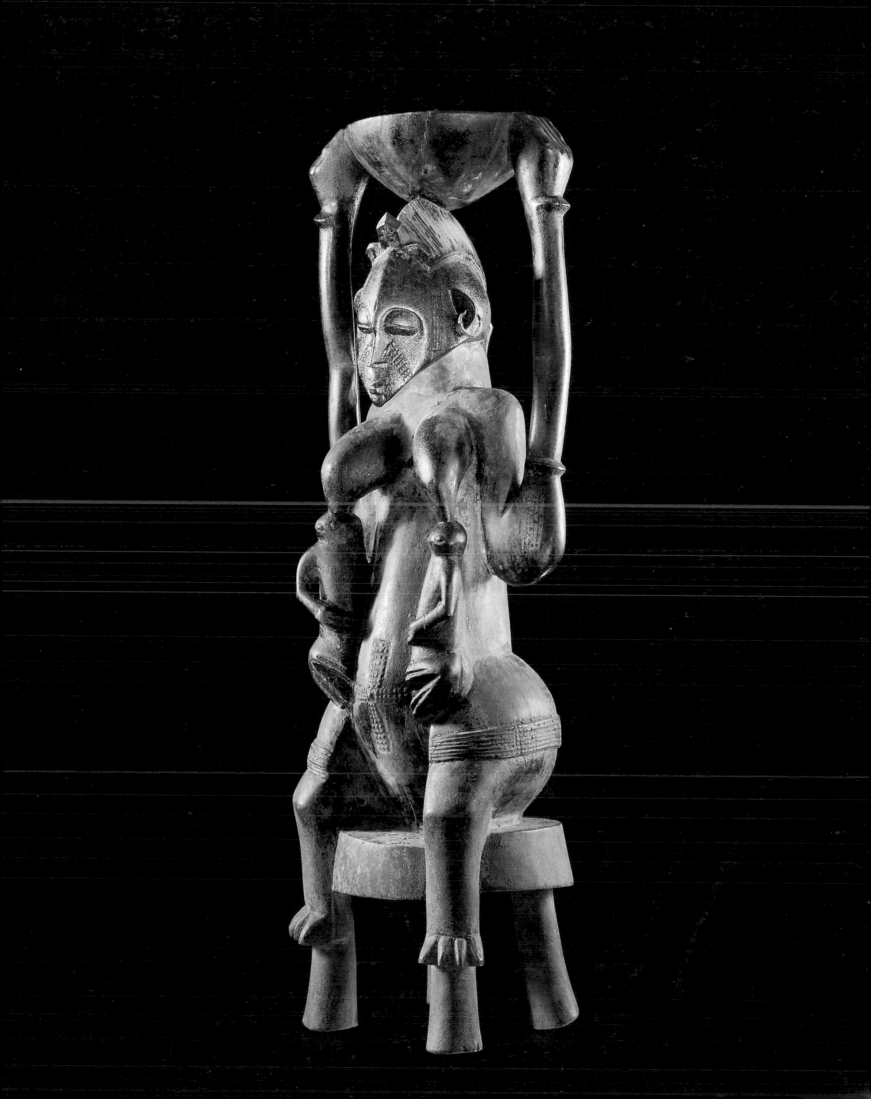

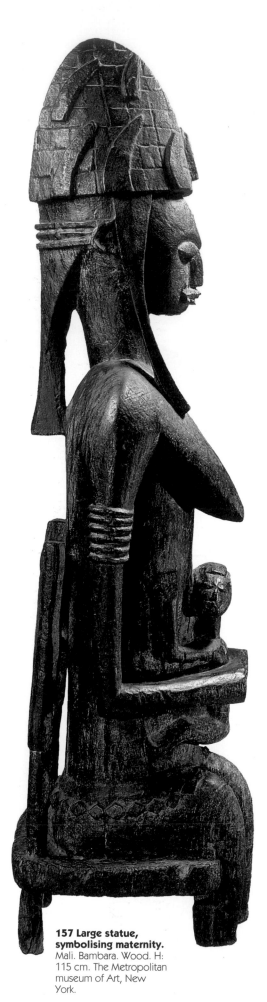

157 Large statue, symbolising maternity. Mali. Bambara. Wood. H: 115 cm. The Metropolitan museum of Art, New York.

158 Mother and child. Zaire. Mbala. Wood. H: 54 cm. Musée royal de l'Afrique centrale, Tervuren.

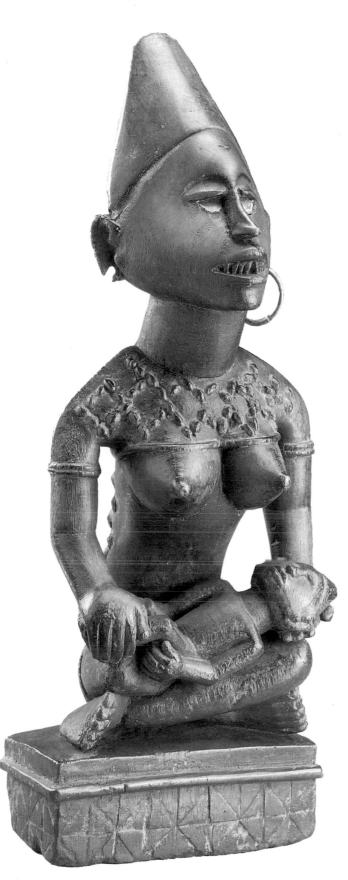

159 Mother and child.
Zaire. Yombe. Wood. H:
42 cm. Musée royal de
l'Afrique centrale,
Tervuren.

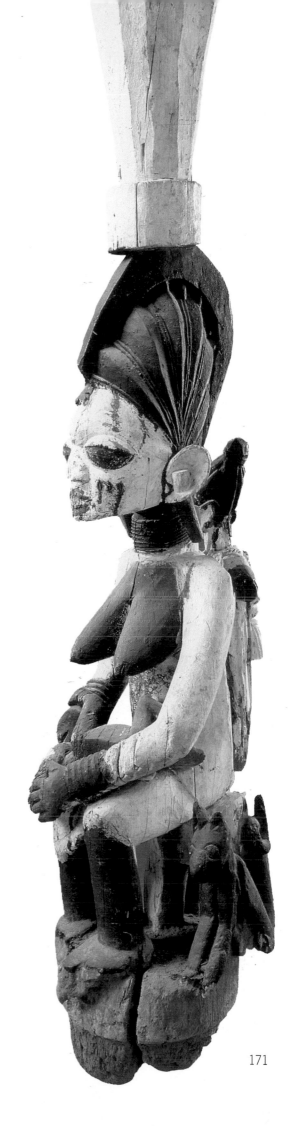

160 Veranda post.
Nigeria. Yoruba.
Hardwood, remains of
white paint of European
origin. H: 142 cm. Musée
Barbier-Mueller, Geneva.

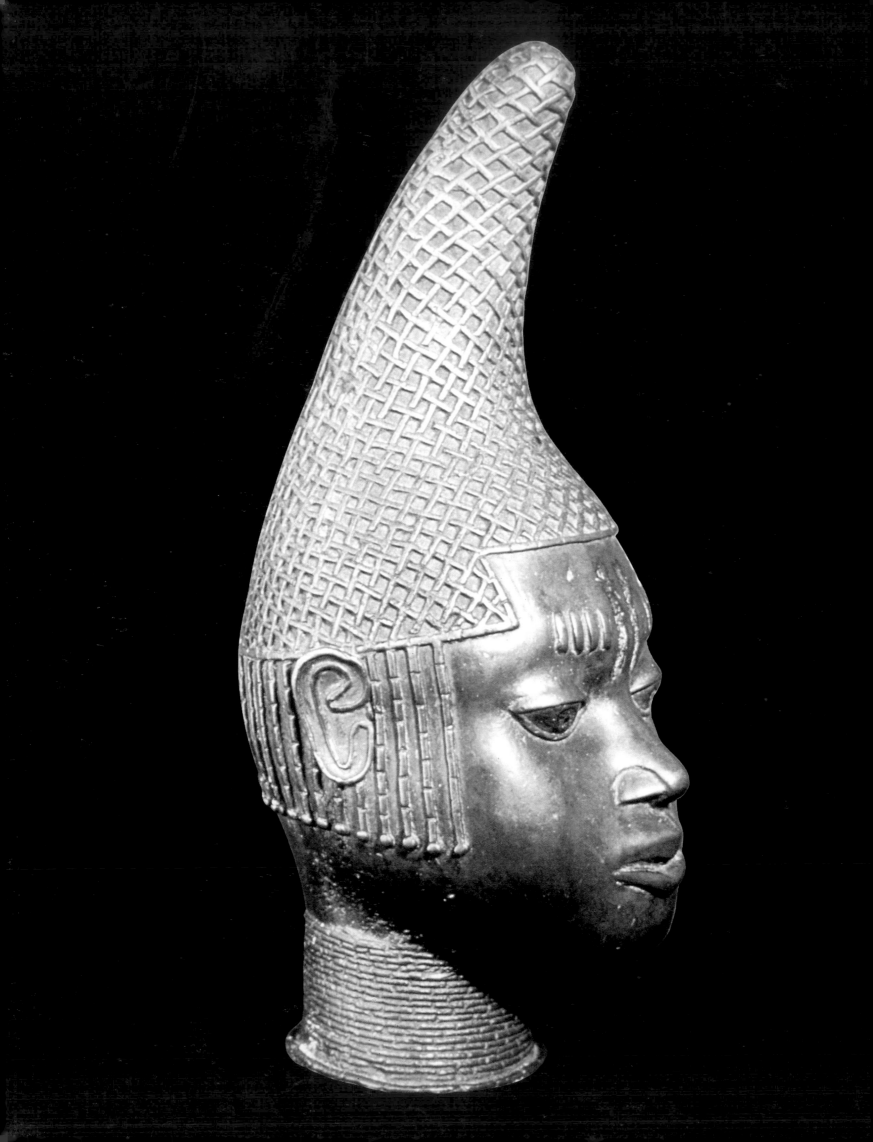

The husband and wife might suffer from psychological difficulties. Discreet submission was demanded of the wife, but among the Woyo of Cabinda, if she wished to have her point of view heard she could use pot-lids on which proverbs were shown. Her mother gave her a set on her marriage, and she could use one to explain her problems and ask for advice when her husband received friends. On one of the lids the woman lying flat on her stomach appears to beg for sympathy, but on another a bird escaping from a trap indicates: "I shall go back to my parents if I want to."

However skilfully the lids were used, they could not resolve all problems. "Women's affairs" were very frequent and provoked armed confrontation between clans, while adulterous women were cruelly punished and might even be put to death. This scene is represented by a soapstone Kongo carving: an angry husband who has already killed his wife's lover is preparing to strangle her.

Most women led lives of constant painful labour, even when they were pregnant. Among the Dogon, long speeches at funerals celebrated the labour of men and women; relating to women, the ethnologists D. Paulme and G. Dieterlen have recorded the following phrases: "Thank you for yesterday. Thank you for working in the fields. Thank you for having children, with God's help. Thank you for preparing meals. Thank you for meat, thank you for millet beer, thank you for water. Thank you.".

The Dogon statue of a *Woman with mortar and pestle*, a *Millet grinder* (fig. 161), of which there are several variations, might be the visual equivalent of this type of prayer. Standing on the family altar, the statue would perpetuate the memory of the dead mother's never-ending labour.

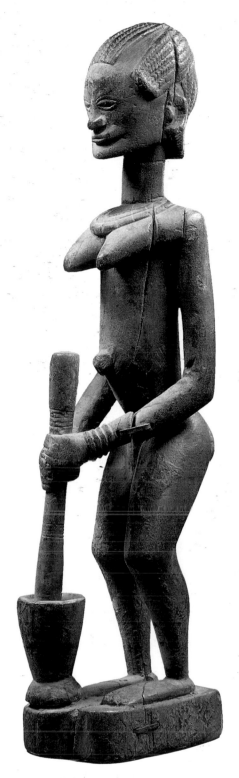

161 Woman with mortar and pestle, known as "The Millet Grinder".
Mali. Dogon. Wood and iron. H: 56.6 cm. The Metropolitan museum of Art, New York.

Left

162 Queen mother's head.
Nigeria. Benin. Brass. British Museum, London.

163 Pair of funeral statuettes.
Ghana. Culture known as "Komaland". 13th-16th century. Terracotta. H: 23 and 25 cm. Musée Barbier-Mueller, Geneva.

On the ancestral altar

The queen mother generally held a very powerful position in royal families. Her authority is further apparent in the bronze heads representing the *Benin queen mothers* (fig.162) who had a right to an altar of their own, while the Afo-a-Kom group in Laikom, Cameroon (fig.47, p.65) shows an unforgettable figure of a queen mother on her throne.

Whether in a royal or an ordinary family, on ancestors' altars the woman was often represented as the man's equal. The ancestral couple, the originators of life, cannot be disunited. Terracotta statuettes (fig.163) recently discovered in Komaland (Ghana) are evidence of this: no physical ties link these two people, but they would lose much of their significance if they were separated. This is also true of all the ancestral couples mentioned in the chapter on this topic.

In all these examples the female statue marks the final stage attained by a woman who has won a place in society and through her pregnancies guarantees the continuation of her line.

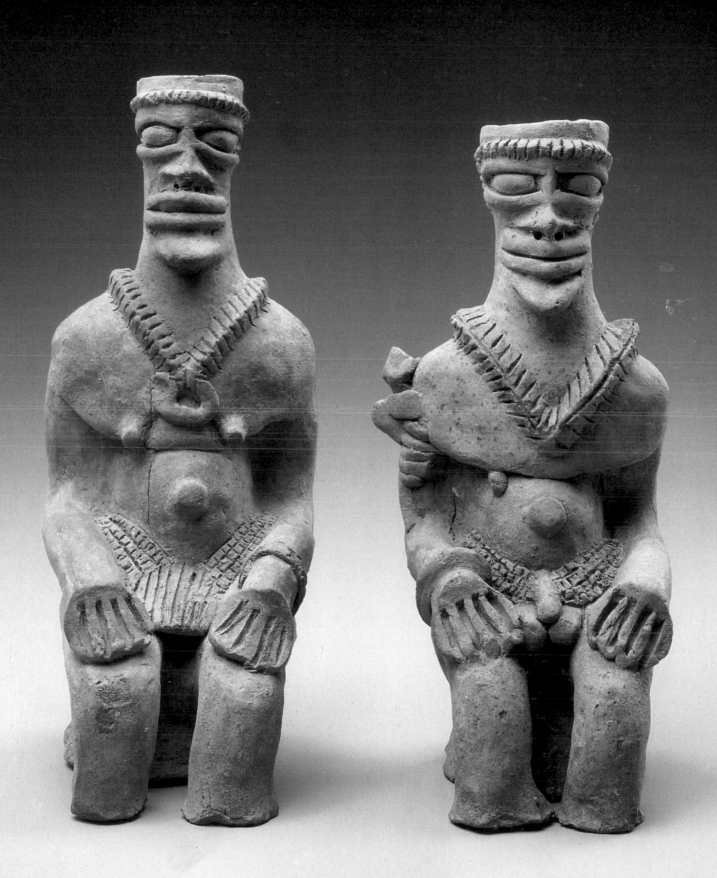

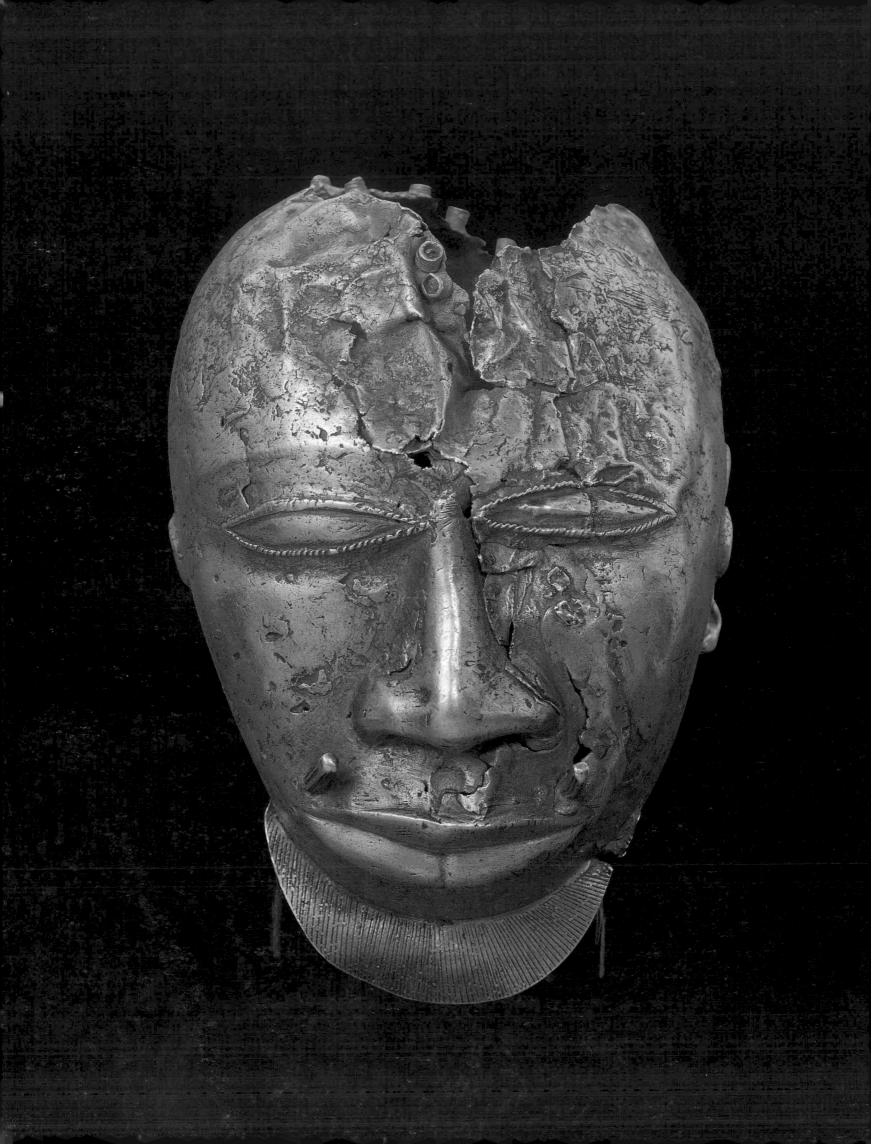

Gold
for decoration
and ceremony

For thousands of years Europeans have regarded precious stones, jewellery, regalia and gold as possessing great value, each enabling a privileged social class to display its superiority. Africa is very different. Copper was originally the most highly prized metal, and it was the Arabs who, through intermediaries, taught Africans from the 7th century onwards to appreciate the market value of gold.

The goldsmith's art did not develop evenly throughout Africa. It has been noted particularly in western Africa in two broad areas, one in the dry Sahel region from Senegal to Mali and Niger, and the other in the forest regions of Ghana (formerly the Gold Coast) and the Ivory Coast, both populated by the Akan nation. There are vast areas with no indigenous tradition of gold work, for example Burkina Faso, Liberia, the west and north Ivory Coast, the east and north of Ghana, Togo, Benin, Nigeria and Cameroon.

Despite the enormous amount of gold which was extracted from these lands over a period of fifteen centuries, very few actual objects have lasted until modern times. There are several reasons for their disappearance. Primarily, they were melted down to be used as money or simply to follow fashion. In Senegal, very few pieces of jewellery can be found which are more than forty or fifty years old. Trade also helped to strip western Africa of its

Left

164 Head from the royal treasure of the Ashanti.
Ghana. Ashanti. Pure gold. Weight: 1.5 kg. Wallace Collection, London.

166 Peul woman.
Barbier-Mueller Archives,
Geneva.

**167 Peul goldsmith at
work.**
Near Jenne. Barbier-
Mueller Archives, Geneva.

gold, as it was exported across the Sahara to North Africa, Egypt and Europe. Those treasures which did remain were subject to the vagaries of war: many defeats were settled by the seizure of wealth as booty. Sometimes, indeed, when the victors were European, war indemnities paid in kind permitted the preservation of valuable items, as was the case with the pieces seized by the British at Kumasi in Ghana in 1874 (fig.164) and by the French at Ségou in Mali in 1893. Finally, when a king managed to retain his treasure and it was laid with him in his grave, there was a serious risk of looting, despite the religious laws. Archaeological research in Africa has very rarely uncovered major gold items: the only notable find is the *Pectoral* discovered in a royal tomb near Rao in Senegal. This may date from either the 17th or the 18th century.

Looking at African gold

In such conditions it is difficult to see far back into the past. The oldest jewellery and regalia in museums or private collections date from the mid-19th century, and most from the early 20th century.

Where the 17th and 18th centuries are concerned we are fortunate in having the information recorded by a French traveller, Jean Barbot, in his *Journal de Voyage*, the diary of his long stay in the Gold Coast in 1678-9. Careful sketches (fig.165) prove the existence at that time of designs which were passed on to the Akan goldsmiths of the Ivory Coast and which are still being made in modern times.

Unexpected confirmation of Barbot's researches was found recently with the archaeological search of the hull of a ship wrecked off the coast of Cape Cod, Massachusetts, in the United States. This was the *Whydah*, which was wrecked in 1717. Built for the British Royal Company, the ship was no doubt named after the city of Ouidah, in modern Benin, an important staging-post in the slave trade during the 18th century. After exchanging European goods for slaves, ivory and gold, the ship sailed for Jamaica where the human cargo was sold. It then fell into the hands of pirates, whose leader kept a mistress in Cape

Cod. He wanted to visit her but the ship was caught in a storm and sank with almost all her crew during the night of 26 April 1717. Unable to raise the hull, the administrators of the Colony of Massachusetts could only record where it lay.

The legend of the ship survived in Cape Cod until a local professional treasure-hunter, Barry Clifford, managed to locate the hull still resting on the sea-bed. In 1984 Clifford brought coins, gold bars and small jewels to the surface. A ship's bell engraved with the inscription "Whydah Gally 1716" eliminated all possible doubt as to the origin of the finds and the hull, seen as an archaeological site, was then searched scientifically.

If Clifford had hoped to retrieve works of art of great value from the sea-bed, he was to be disappointed. The gold recovered was in a poor state, consisting only of small, worn and broken pieces of jewellery which had been compressed to take up less space until they could be melted down. From the point of view of historical documentation, however, they are of outstanding interest, for these are the oldest pieces of African jewellery which can be dated with any certainty. Very similar to the forms sketched by Jean Barbot half a century earlier, they also appear to be the direct antecedents of the Akan and Ashanti goldsmiths of modern Ghana. Finally, they prove that African gold craftsmanship had not at that time fallen under the European influence which was later to prove so powerful.

Gold in Africa

For centuries western Africa has figured as a rich gold reservoir, with an average total production of two tons per year from 1400 to 1900. The gold-bearing zones are small in size, but large in number. The first to be exploited, possibly as early as the 4th century AD, were the Bambuk and Bure deposits in Senegal and Guinea. Other gold-bearing zones exist in Ghana, the Ivory Coast and, less productive, in Burkina Faso. Most were already being exploited before colonial times.

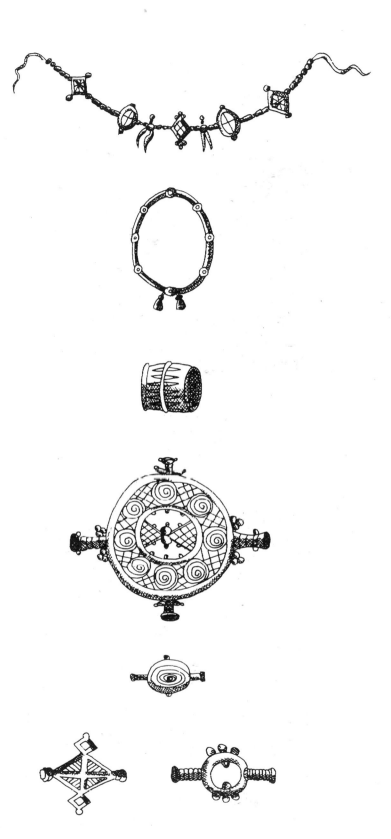

165 Akan jewellery.
Sketched by Jean Barbot to illustrate his manuscripts of 1679 and 1688, and his book published in 1732.

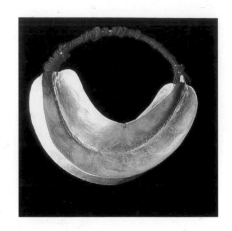

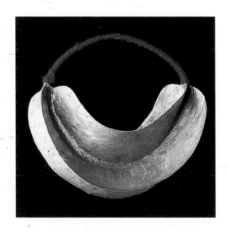

168 Peul gold earrings.
Mali. Hammered gold.
Mid-20th century. Musée
Barbier-Mueller, Geneva.

Right

169 Ornaments.
Senegal, Mali and
Mauretania. Tukulor,
Sarakole and Maure. Gilt
silver. Musée Barbier-
Mueller, Geneva.

The shafts in the mines were between 10 and 20 metres deep, just wide enough for one man. Crouching at the bottom, the miner attacked the gold-bearing rock with his pick and the fragments were hauled up to the surface in a basket. He often paid for his finds with his life, for accidents were frequent in these unsupported pits.

Less dangerous, but much less productive, was the popular practice of washing sand or the alluvial soil from certain river-beds. Gold washing was a hereditary activity in western Africa, and was undertaken after it had rained, because the rain made the tiny particles glitter. The women washed the sand and tipped it into gourds. Olfert Dapper recounts in his *Description de l'Afrique* (1668) that in order to find sand which was richer in nuggets, divers would sometimes seek them out in the depths of river beds.

Despite its well known wealth of gold, southern Africa has not produced notable pieces of jewellery. Archaeological digs in Zimbabwe have uncovered only small quantities of gold jewellery, while among the Zulu the preference is for multi-coloured glass beads.

Gold's evil powers

Africans have ambivalent feelings towards this gold which has cost them so much. For years the precious metal has been feared: its enduring gleam appears to have a life of its own, the life of an evil spirit ready to bring madness on anyone who uncovers it, or to annihilate his family. Its origins remained obscure. According to 10th-century Arab geographers, it was thought to grow as a plant and increase in the earth. George Niangoran Bouah, the leading modern African specialist on gold and professor at the higher education institute in Abidjan, reports a belief among certain Africans that gold comes from the heavens and appears in the form of a rainbow.

At all times, ritual ceremonies accompanied the gathering of the dangerous metal, danger which was always liable to reveal itself in the violence of rock falls and splits. Its negative powers had to be neutralised with sacrifices, and the Bambuk and Bure peoples would call on a

Moslem to recite verses from the Koran at the opening of a new mine. Among the Akan animists, a priest carried out a sacrifice to ancestral spirits and miners were required to respect numerous laws. In the middle of the 20th century the appearance of a very large nugget could still cause consternation: all work ceased, until a young red-coated bull could be sacrificed.

In modern times the Akan or Ghanaian Africans can be seen wearing gold nuggets threaded through as bracelets or necklaces. These are regarded as fetishes with protective powers. Belief in magical powers still exists but has become a positive factor. The nations of north Africa appear to have had some influence in this development; in their eyes gold was beneficial and in any case they very quickly appreciated its market value and commercial significance. Through trans-Sahara contacts they helped the Sahel people to overcome their fear of gold.

The Arabs who overran the Maghreb in the 7th century soon guessed that there was gold beyond the Sahara, but never managed to locate it. The particularly rich deposits among the Akan were unknown among neighbouring nations until around the 14th century, when substantial trade began.

The three great empires - Ghana, Mali and Songhai - which followed each other in western Sudan between the 11th and 16th centuries, left a memory among their contemporaries of an incredible wealth of gold. According to travellers' tales, the courts of Ghana and Mali were torrents of gold; horses were covered in gold cloth and even the dogs wore little gold bells.

This abundance of precious metal did not fail to attract the attention of Europeans, who began to arrive by sea in the 15th century and competed with the trans-Saharan trade. Coastal cities expanded and enormous quantities of gold were exported to the Old Continent.

There is a world of difference betweeen these lost marvels and the relatively late objects which have survived, but we can still admire some very fine pieces from the 19th and 20th centuries, including examples of several different styles.

Left

170 Spherical or pear-shaped beads.
Senegal. Tukulor, Wolof. Gilt silver. These beads of various shapes were worn as hair ornaments. Musée Barbier-Mueller, Geneva.

**171 Set of filigree
jewellery.**
Senegal. Wolof. Gilt silver.
Musée Barbier-Mueller,
Geneva.

Left

**172 Necklace of 108
beads.**
Ghana. Akan. Gold. L:
49.5 cm. Weight: 84 g.
19th century. Musée
Barbier-Mueller, Geneva.

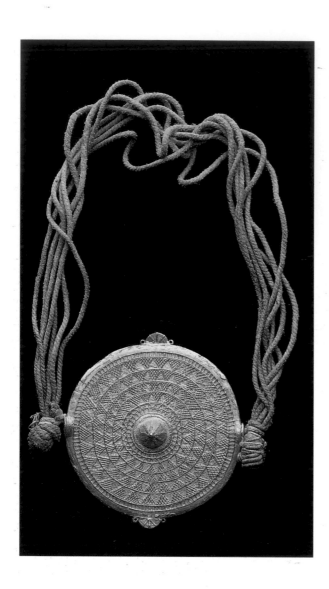

**173 Pectoral disc
strung on fibre threads.**
Ghana. Akan. Gold and
silver alloy. D: 10.6 cm,
weight: 127 g. Musée
Barbier-Mueller, Geneva.

From the coast of Senegal to the plains of Mali

The goldsmiths of Mali (fig.167, p. 178) can be justifiably proud of their creations, which are among the finest pieces of African jewellery (fig.166, p. 178). These are the Fulani (Peul) women's earrings, truly abstract works of art (fig.168, p. 180). They are made by hammering, starting with a small gold bar which is flattened down to produce four ribs and finally curved round in a crescent-shape. Their wide polished surfaces, sometimes embellished with light engravings, gleam with multi-faceted radiance, but their weight (between 50 and 300 grammes) means that a red leather or fabric supporting strap must be worn over the top of the head.

The Senegalese goldsmiths' style is entirely different from that of the Mali craftsmen. There are no smooth surfaces here, as the craftsmen emphasise the complexities of granulation and filigree which in turn enable them to show effects of light and depth. Among these motifs are the *lion's claws*, (fig.169, p. 181) the local name for a type of pendant in the shape of a swastika with curved branches.

Filigree was also used to create large round or biconical drops (fig.170) which could be threaded onto necklaces and spherical or pear-shaped head-dress ornaments grouped in twos and threes in the hair.

These jewellery shapes cannot be attributed to any particular region because they were widely copied and easily transportable. The Peul people, after all, are nomads - and the goldsmiths themselves were travellers.

A Maghreb or Mauretanian influence can be seen among the oldest Senegalese pieces, and similarities have even been noted with 11th-century pieces of Islamic-style jewellery found in Jerusalem. Moorish women's love of jewellery is well known, but this is mostly silver.

Europe has unfortunately had a great influence on Senegalese gold jewellery. It was probably first felt in the 17th or 18th centuries in the city of Saint-Louis in Senegal, leading craftsmen to work commercially with European clients in mind. The techniques of which they were masters - filigree and granulation - were adapted to accommodate the most banal of motifs, such as butter-

flies, stylised flowers or baskets of flowers, modern versions of ancient Sahel designs embodying an ancestral dream of flowers round the edges of the Sahara (fig.171).

In modern times the pieces of jewellery worn in Senegal and Mali respond to a desire for coquetterie and social prestige, and are designed exclusively for women. In the past they were also worn by men, but that custom died out with the spread of Islam.

Finally it should be noted that until recently Sahel jewellery craftsmen did not specialise in gold-working: they were also blacksmiths capable of working with all metals and often used silver.

The Akan people of Ghana

The term Akan is often applied to the six million people of various cultures who live in Ghana and the Ivory Coast, famous for their wealth in gold and the abundance of jewellery and regalia worn by their kings and retinues at public feasts. Not being Moslem, they are not subject to the restrictions in the Koran regarding men wearing jewellery. To organise and expand the metal trade over long distances, the Akan people employed the skills of another race, the Mande who, unlike the Akan, were Moslems and knew how to write. The Mande introduced the use of gold dust as money for exchange and brought in the custom of weighing it against special brass weights. It was also the Mande who supplied the Akan with the copper they needed for certain alloys and taught them certain techniques, in particular lost wax casting.

When Jean Barbot visited the Gold Coast in 1678 he sketched Akan jewellery. Although his text mentions many figurative designs, particularly of animals, the beads in his drawings show abstract forms such as discs, spirals, rectangles, lozenges, cones and tubes. Some of these designs have survived down the centuries (fig.172). A round and delicately worked *Pectoral* (fig.173) in the Barbier-Mueller collection is very similar to Barbot's drawings and its design is equally reminiscent of the *Rao pectoral*. These discs, worn in the past by dignitaries in the king's entourage, are still brought out on ceremonial occasions.

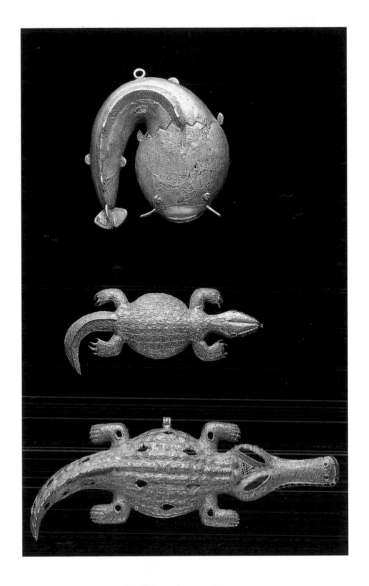

174 Fish and crocodile sword ornaments.
Ghana. Akan. Gold.
Musée Barbier-Mueller, Geneva.

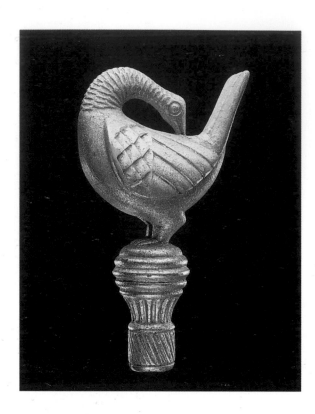

176 Top of a messenger's staff.
Ghana. Akan. Carved wood covered with gold leaf. H: 26.8 cm. Musée Barbier-Mueller, Geneva.

Right

175 Ritual swords.
Ghana. Akan. Iron blade and a pommel of carved wood covered with gold leaf. Musée Barbier-Mueller, Geneva.

Their origins may lie in the gold dinars which are often transformed into decorative items to the north and south of the Sahara.

Rings were rare and plain among the Akan. Barbot drew only one, which is undecorated. Later, however, we see a surprising proliferation of all kinds of figurative elements - animals, birds, fish, insects, fruit and even human heads. Rings like this very often have a meaning, referring to a popular proverb or aphorism, and, without losing any of their artistic value, are closely linked to the collective unconscious.

An example of this is the porcupine, which very often signifies the invincible warrior and the chief's power. The frog is not a very common royal symbol, but when it appears it is a reminder that: "The full length of the frog is only visible after its death". This can be interpreted as: "A man's full worth cannot be recognised during his lifetime". On the other hand another royal symbol, the mud-fish (fig.174), is ambiguous. It is often associated with the crocodile, as in the proverb: "If the mud-fish swallows something precious, he does it for his master," i.e. the crocodile.

This specialised bestiary may also adorn an infinite variety of objects, from decorative elements on swords and helmets to the tops of royal shafts. The message from coiled snakes on the helmet of the chief's bodyguard is unmistakable: "A snake bites when it is angry," meaning, "Do not arouse the chief's anger".

Sometimes a head cast in gold representing a conquered enemy can be found attached to the throne of Akan kings, or it may appear on their ceremonial swords. Among the war booty brought back from Kumasi by the British is a Head (fig.164), cast in pure gold and weighing 1.5 kg, which represents a chief killed in battle - Worosa, king of Banda or perhaps Adinkra, king of Gyaman.

Ceremonial swords (fig.175), with their unsharpened blades, were not designed for use in battle, but they do have a purpose. The large seed on the pommel, made of wood and covered with gold, is a symbol of fertility or wealth, while another sword with a gold and white pommel had its place in a ritual ceremony when the "soul washer" was supposed to purify the king's soul. In addition, the

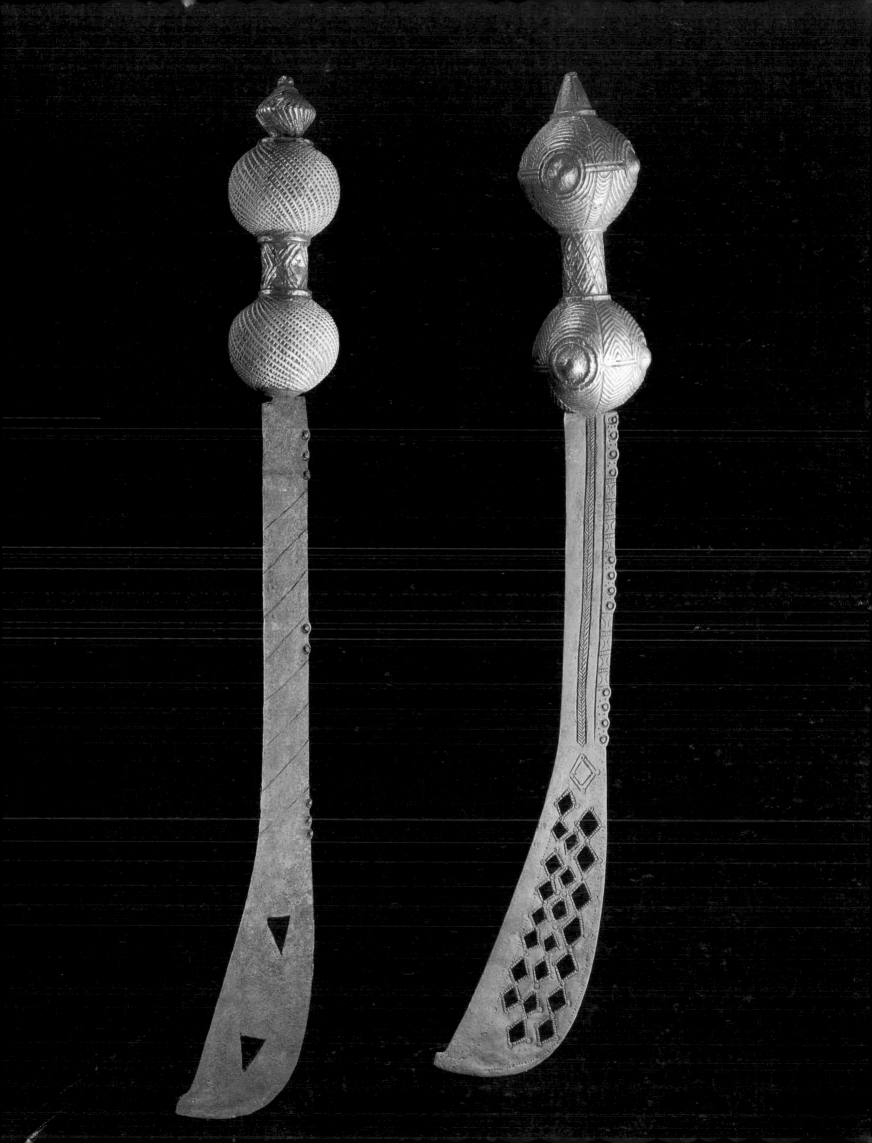

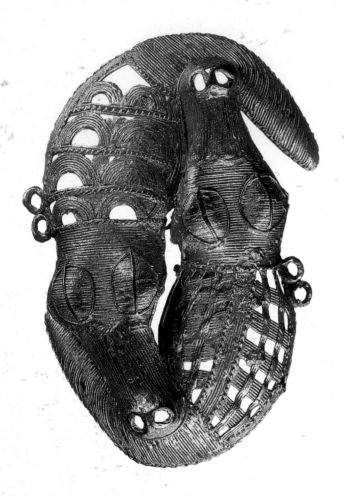

178 Pendant.
Ivory Coast. Baule. Gold.
H: 9.5 cm. Musée
d'Afrique et d'Océanie,
Paris. (Photo: R.M.N.)

Right

**177 Bracelets
belonging to a chief
and a queen mother.**
Ghana. Akan. Carved
wood covered with gold
leaf for the chief's
bracelets, gold or gold
and silver alloy for the
queen mother's bracelets.
Musée Barbier-Mueller,
Geneva.

king would place his hand on a state sword as he took his oath.

Once enthroned, the king sits on his throne beneath a sunshade decorated with animal designs and his messengers carry batons with matching decoration. One such stick, made of wood covered with gold (fig.176) and with a bird at the top, looks to European eyes like a splendid and very attractive carving in the gentle harmony of its shape - but to the Akan this *Sankofa* bird is connected with the proverb: "Gather what falls behind you;" in other words, "Take advantage of your past experience".

Among the middle classes, bracelets are not often worn by either Akan men or women. However, the chiefs and their wives or queen mothers make up for this by the enormous size of their bracelets. To reduce both the weight and the price they are cast in two halves with a hollow centre. Their complex decoration combines points and carved designs (fig.177). Elsewhere, numerous gold ornaments attached to the chiefs' headdresses or their sandals further enhance the display of wealth in their treasury.

All Akan jewellery and regalia is predominantly figurative in form, only the bracelets and certain pectoral discs having abstract motifs. Other ornaments are beautiful three-dimensional miniature sculptures in which special attention is paid to the interplay of the surfaces. These characteristics differentiate the productions of the Akan from the light filigree and more ordinary jewels of the Seneglaese goldsmiths, just as they distinguish them from the abstract or stylised visions of the Ivory Coast peoples.

Ivory Coast cultures close to the Akan

The inhabitants of the centre and south of the Ivory Coast connected to the Akan are either the Anyi, Baule and Nzima group or the numerous Lagoons peoples cultures. The scattered gold-bearing areas, less rich than in Ghana, supply the primary material needed by the many goldsmiths working in the villages. Their creations consist above all of personal jewellery, particularly beads and pendants, their ancient native production including very few rings. The regalia are less significant than in the courts

179 Pendant in the form of a human face.
Ivory Coast. Ghanaian frontier region. Possibly Anyi or Abron. Gold and copper alloy. H: 8.5 cm, weight: 75 g (approx.). Musée Barbier-Mueller, Geneva. This miniature "mask" cast by lost wax may be an Akan trophy head, representing a slave or an enemy killed in battle.

of the Ghanaian kings, for here the chiefs reign over smaller territories which are sometimes barely more than a village. They therefore have limited resources.

The gold finery of the Ivory Coast differs noticeably in style from that of the Akan. Figurative forms and animal representations are replaced in the Ivory Coast by stylised interpretations of similar themes, and on occasions by totally abstract geometric forms.

Ivory Coast gold-working undoubtedly developed after the 17th century, but no trace of it remains. In the 19th century many objects were made of gold cast by the lost wax process, but more recently, in order to reduce costs, greater use has been made of wooden items covered in gold-leaf. It is difficult to distinguish between Baule products (fig.178) and those of the Lagoons peoples cultures, but it is probable that the most perfect castings come from the Baule. The work of the Lagoons goldsmiths is less technically advanced.

The most remarkable creations of the Ivory Coast goldsmiths are their pendants which take the form of a stylised human face. An isolated face formed in low relief looks out, without a neck. Certain heads are quite realistic and occasionally resemble the heads of Baule statues (fig.179), while others are reduced to an oval perforated with triangles (fig.180) in a surface of close-packed gold threads. Ivory Coast goldsmiths generally consider that the perforated pendants with the largest heads come from the Lagoons people. These pendants have no connection with dance masks - they may be hung from a necklace or set in the hair. Nor are they portraits, although they may on occasion represent an ancestor.

G. Niangoran Bouah also sees the pendants as primarily defensive. He writes: "When a man was on the point of being struck in a fight, he could claim that he had a man's head, thus placing himself under the protection of his ancestors and warning off the aggressor.". These pendants did not protect the wealthy alone, for the same powers were attributed to heads made of copper.

Other pendants represented animals which were so stylised as to be no more than a piece of pure design (fig.181). "Treasures" consisting of a collection of such gold objects were also exhibited at great feasts, "the feast

of the generations", and helped to raise the head of the family's standing to that of a dignitary.

Some remarkable beads, generally flat and designed to be strung in necklaces, can be found among the Baule creations. Unlike the Akan beads, they are not figurative; their strictly geometrical forms are probably derived from old Akan models such as those drawn by Jean Barbot. With their splendid simplicity, they are essentially variations on the theme of a circle or rectangle. Close-set gold threads create various motifs on their surface, but this is not filigree; everything is cast. In the centre of each bead a tubular channel allows for stringing (fig.182). According to old goldsmiths, these beads used to be known by poetic names, such as "pool of water" or "setting sun" for circles, and "bamboo door", "chicken feather" or "back to back" for certain rectangular designs.

180 Human face pendant.
Ivory Coast. South-east region. Gold. H: 6.9 cm, weight: 38 g. Musée Barbier-Mueller, Geneva.

Manufacturing techniques

Hammering and cutting. A gold rod is heated and, when the metal softens, is shaped with the hammer. This is the method for making the Fulani women's earrings.

Wooden forms covered with gold. The craftsman carves the wood, then hammers out a very thin gold sheet which is stuck onto it.

Direct casting or casting by lost wax. The practice is the same as for the Benin works. In the case of the Baule beads which consist of close-set threads, the goldsmith forms a wax thread less than one millimetre thick and moulds it into the desired shape. A matching surface is then stuck to it. Finally, the craftsman puts this wax model into a mould for a lost wax casting.

Filigree. Here the craftsman produces the gold thread, stretching it through holes in a sheet of iron, with the thread passing through increasingly narrow holes. The metallic thread thus obtained is placed according to design, leaving some empty spaces. The finished motif is finally placed on a gold-leaf surface.

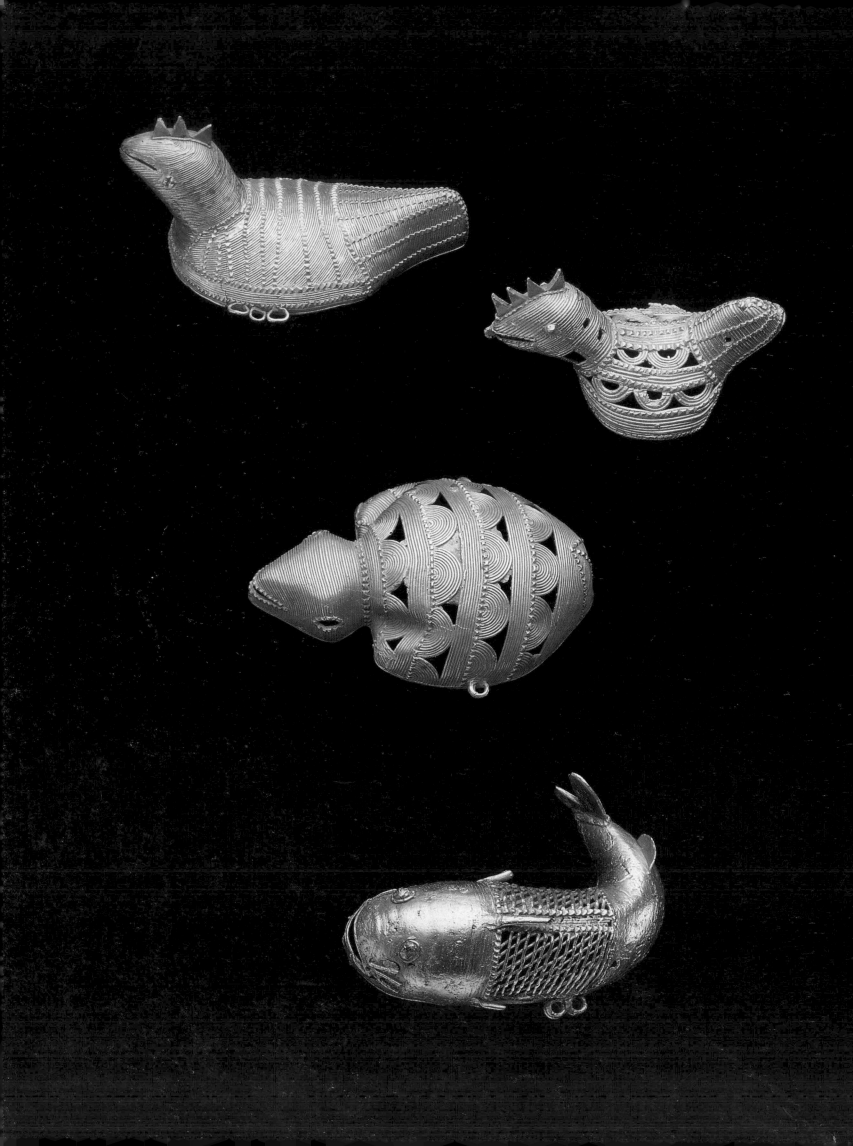

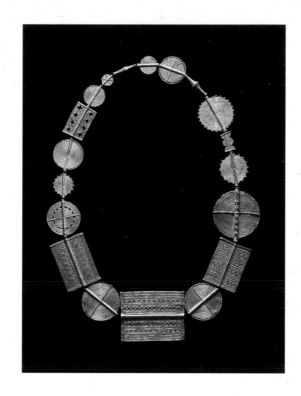

**182 Twenty-one bead
necklace.**
Ivory Coast. Baule. Gold.
Total length: 84 cm. Size
of the central bead: 6.7
cm. Weight: 252 g. Musée
Barbier-Mueller, Geneva.

Left

**181 Stylised animal
ornaments.**
Ivory Coast. Probably the
Lagoons region. Size:
between 8 and 9.5 cm.
Musée Barbier-Mueller,
Geneva.

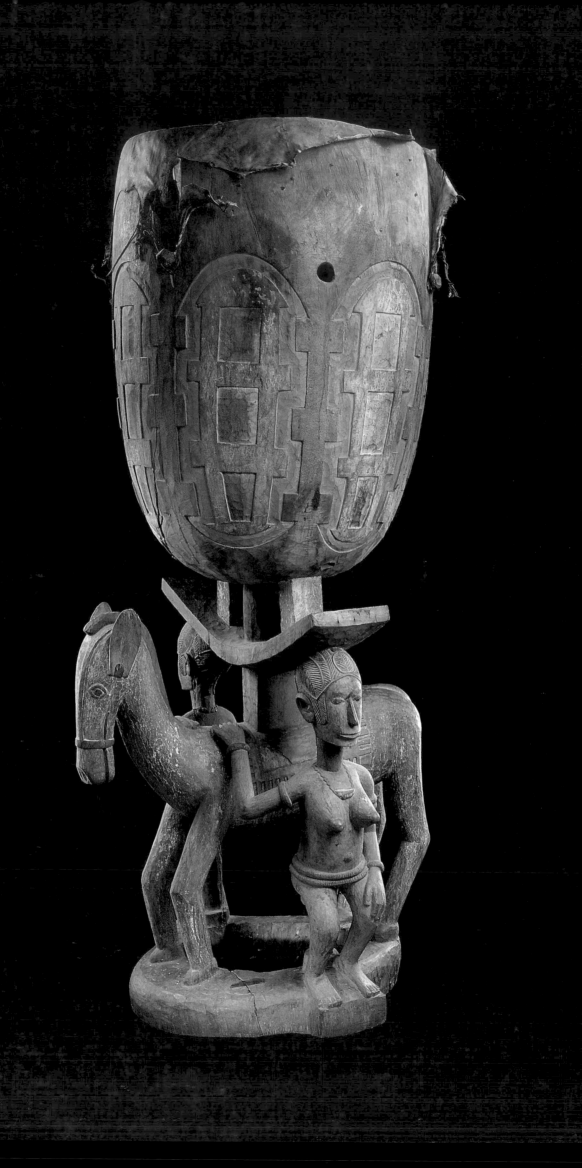

The significance of
beautiful
objects

A great many African objects are embellished with abstract designs and sometimes with figurative carvings. In both cases this added ornamentation has more than merely decorative value: it is usually weighted with a very precise significance, its role being to give visual information about the owner's social standing and to add to his prestige. However, it may also be used in a ceremonial context and to evoke a myth familiar to the assembly. Almost without exception, then, such decoration has implicit symbolism.

We have already seen that in Cameroon the use of pipes was regulated by a code: the individual was not free to select just any pipe. Depending on his status as either an ordinary member of the tribe or a grand initiated member of a brotherhood, the individual might or might not be allowed to pride himself on a pipe embellished with carved designs whose message was unmistakable to all.

This is only one example. In categories of objects as varied as musical instruments, seats, doors, vessels or spoons, the decoration or the form had to have significance. For the Africans, who were sensitive to beauty and who associated it with prestige, the decorataion had to be as beautiful as possible. This is particularly true for sceptres (see chapter 8), champions' batons (see chapter 5) and regalia (see chapter 10).

Left

183 Drum.
Guinea. Baga. Hardwood and skin. Polychrome, partly worn away, in red, white, blue and black. H: 172 cm. Musée Barbier-Mueller, Geneva.
Among the Baga the body of the drum was sometimes set, as here, on a carved base whose significance is not entirely clear. A female caryatid stands on each side of the horse -the reason for this is unknown, as is the reason for the horse's presence. The Baga certainly never had horses, because they could never have survived in Guinea's climate. The horse's presence may be explained by its symbolic value, as in Africa it is linked to military or public power.

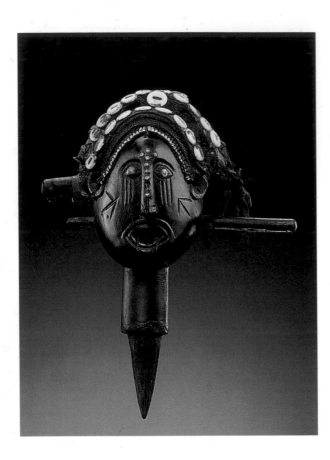

184 Head of a stringed instrument.
Angola. Imbangala.
Polished hardwood, nails, buttons, beading and cotton. H: 23 cm. Musée Barbier-Mueller, Geneva.

Right

185 Bowed harp with five strings.
North-east Zaire. Mangbetu. Soft wood with light polish and poker-work decoration. Vegetable fibres, skin and bark. H: 68 cm. Musée Barbier-Mueller, Geneva.

Carved musical instruments

Musical instruments were, and sometimes still are, closely linked with the chief's function. In Cameroon the Fon of Kom, photographed by Louis Perrois, sits between statues of his royal ancestors and instruments of sacred music (fig.44, p.62).

In the Bantu lands of Central Africa, drums with slots (or gongs) or membrane drums have always played an important social role. The consecration of a chief's drum required its own special ceremony, a distinction not made for instruments designed to accompany secular dances. In west Africa the ceremony for *Membrane drums* (fig.183) was always linked to male power and reserved for boys' initiations or old men's funerals.

The category of stringed instruments covers citharas, lyres, lutes and harps, where the sound is created by vibrating strings stretched between fixed points. Among the Imbangala people in Angola the *Kakosha* is a very rare stringed instrument shaped like a standing woman. There are very few known examples. Two threads of fibre stretched on pegs extend from her mouth to a ring which is fixed between her legs. The Barbier-Mueller museum contains a *Kakosha head* (fig.184) with a very powerful expression, all the more surprising because the Imbangala have otherwise produced very little in the way of carved items.

Harps in particular have a special mystique, expressed through highly sophisticated carvings and their great social prestige. They are royal instruments, the subject of legends and their frequently anthropomorphic shape makes them almost an extension of the soul, a feature enhanced by the fullness and range of their sound. The Mangbetu have produced very fine anthropomorphic harps (fig.185). The lozenge-shaped sound box is covered with skin and has five strings fixed to the cross-piece of the instrument, which is carved in the form of a human figurine often shown with the hairstyle favoured by women of high social rank.

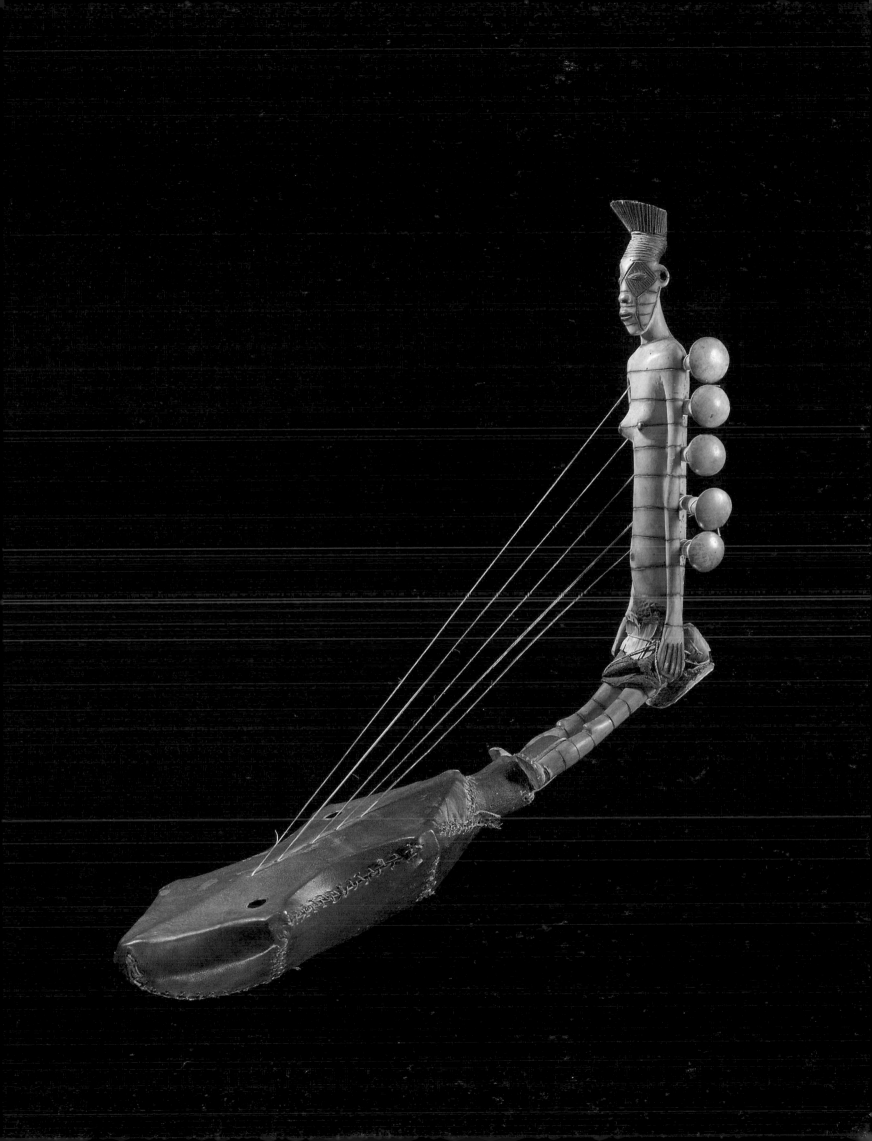

186 Ceremonial stool.
Cameroon. Oku kingdom.
Semi-hard wood, with
roughened polished
patina. H: 54.5 cm. Musée
Barbier-Mueller, Geneva.
Wearing the headdress
appropriate to effigies
commemorating royal
ancestors, the male figure
symbolises the legitimacy
of the reigning dynasty,
with further authority
added by the leopard
and the snakes.

200

Chiefs' seats and dignitaries' doorways

The chief's throne was the essential indication of his status. Three extraordinary seats carved out of a single quartzite block have been found in Ife. The king of Benin is known to have had luxurious brass stools and the Cameroon chiefs had seats of highly complex design (fig.186), often with added beads which gave a colourful silkiness (figs.51 and 52, p.70).

Among the Luba, the Hemba and also the Songye in Zaire, seats with caryatids of a fascinating beauty have been found. Several of them, all quite similar in conception, are attributed to an artist known as "the Master of Buli" (fig.187). This is because two works of this style seem to have originated in the village of Buli, in the north of the Luba country. Was there really a single Master of Buli? It seems possible to distinguish two slightly different hands in the group of works concerned, which would suggest that they are the products of a school or workshop. Whatever the truth, the style of these most impressive works is unforgettable. It is characterized by ascetic and emaciated bodies whose angular faces bear painfully sad expressions and whose large hands are placed on either side of their ears. Also attributed to the Master of Buli is the poignant *Female cup-bearer* in the Musée royal de l'Afrique Centrale in Tervuren (fig.155, p.168).

Marking the division between the interior and the exterior, between private and public life, carved doorways were first designed to show the passer-by the high social status of the householder. A *Senufo door for a master magician* (fig.188) is carved in bas-relief with a group of highly symbolic motifs. On the other hand a *Baule door decorated with fish* (fig.189) was carved by a master craftsman and appears to have been primarily decorative, unless it alludes to the conviviality of a superb meal of fish or illustrates a proverb. The design on the bar is often carved with particular care; the *Senufo door* shows a finely carved lizard (fig.188) while the *Lock of a Dogon granary door* (fig.190, detail) is surmounted by a pair of statuettes representing the founder of the line and his wife, who guarded the harvest contained in the granary.

187 Seat with caryatid.
Zaire. Luba-Hemba. Attributed to the Master of Buli. Wood. H: 61 cm. Late 19th century. The Metropolitan museum of Art, New York.

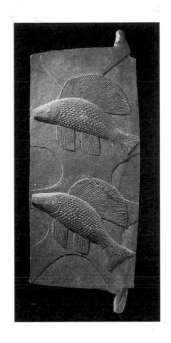

189 Door.
Ivory Coast. Baule.
Hardwood. H: 146 cm.
Musée Barbier-Mueller,
Geneva.

Left

**188 Bas-relief door for
a master magician.**
Ivory Coast. Senufo.
Hardwood with deep
patina. Height with hinge:
160 cm. Musée Barbier-
Mueller, Geneva.
This door was made by a
kulebele, a wood-carver
possessed of occult
powers. He has placed
the motif of the "mother's
navel" at the centre, a
reference to the myth of
the creation and also
symbol of the village
microcosm. The upper
and lower bands show
groups of three warriors.
The rest of the space is
marked out with narrow
lines, clustered together
and then crossing at the
centre. The latch is held in
place by a crocodile, a
frequent element in
Senufo art, and which
may be a reference to the
forces of evil and sorcery.

**190 Lock of a granary
door (detail).**
Mali. Dogon. Hardwood.
Musée Barbier-Mueller,
Geneva.

Spoons for special occasions

The world of spoons is infinitely diverse in Africa. They can be found everywhere but their uses vary widely. In everyday life, Africans generally ate with their right hand. Spoons were used for special meals, for sharing sacred food and banquets on festive occasions. Alternatively a king would use a spoon if his supposedly divine nature prevented him from being observed while eating.

An external sign of wealth and prestige, the spoon was more than purely functional. Its carved design linked it with myth.

In practical terms too, the sculptor had to combine two separate factors in a single object: the bowl of the spoon was a normal shape, while the decorated handle often represented a human being or part of a body. The craftsman might combine the two with a linking element, as often happened with the Dan people (fig.191), or he might use a longer linking piece decorated with a finely-worked spiral, as on certain Fang spoons. He could also join the figure and bowl directly to each other, without using any form of link, a solution adopted by certain Mangbetu carvers (fig.192).

When a spoon bore a carved figure the style was the same as for a free-standing statuette. The traditional designs of each culture were respected, so the metal spoons made by the Akan of the Ivory Coast might have handles decorated with lost wax motifs. Designed for weighing gold, these spoons could be used as strainers once they had been perforated.

The Dan and the neighbouring We of the Ivory Coast made a large number of very fine spoons. The handle consists of either a female torso or of legs which extend the elongated bowl. When piled high with rice this gives the swollen effect of a pregnant woman's stomach. There may even be a double bowl evoking breasts full of milk.

The Dan spoon is a ceremonial item which singles out the woman (the *Wadeke* or *Wunkirle*) to whom it has been awarded. She is judged to be the finest cook and manager of feasts, renowned for her generous hospitality and supported by the other members of a female society. The tribal chief calls on her when particular circumstances,

191 Spoon.
Liberia. Dan. Wood. H: 48 cm. The Metropolitan museum of Art, New York.

Right

192 Ceremonial spoon.
Zaire. Mangbetu. Wood. H: 31 cm. Museum Rietberg, Zurich.

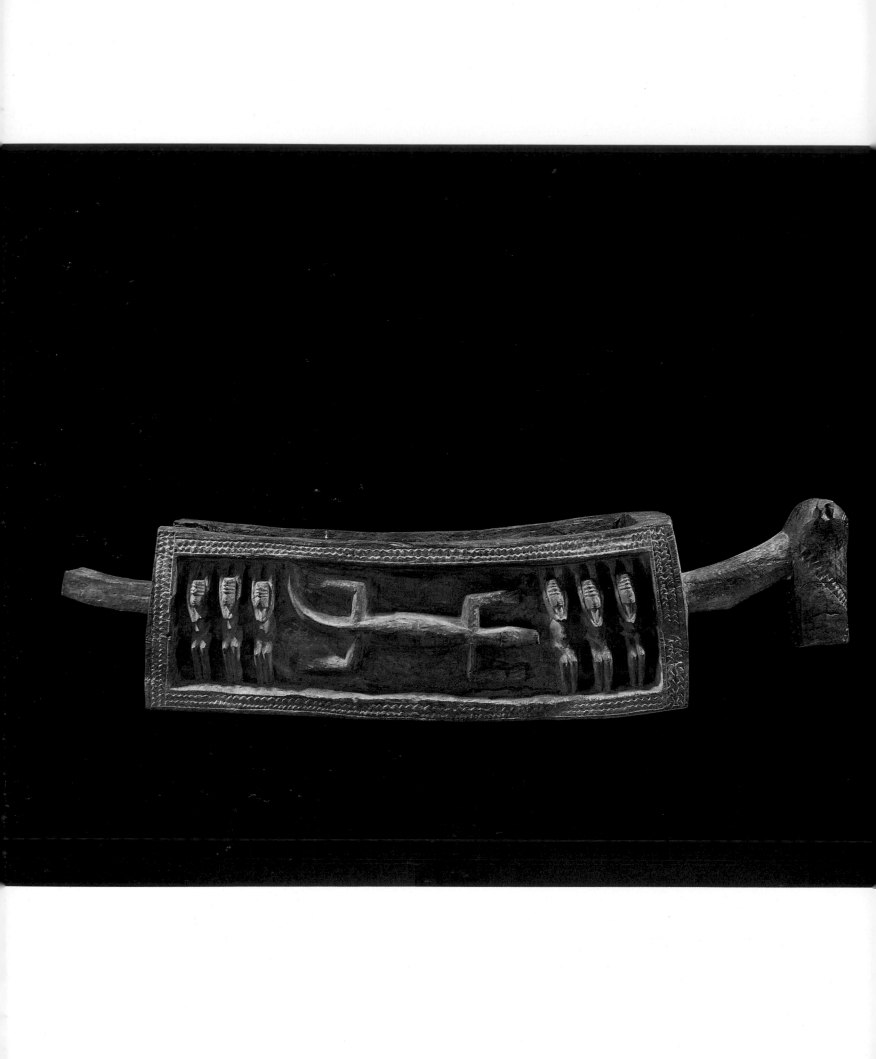

notably a funeral, require a feast. The spoon will then be used to distribute the rice and meat from the stores of the woman or her little flock. To accomplish such tasks successfully she needs the help of a spirit which is embodied in the large spoons. Through their mediation, the spirits come to help prepare the banquet.

Sacred or secular vessels

As numerous as the spoons, various carved receptacles are found in Africa. Their purposes are equally varied, ranging from the sacred to the secular. Among the ceremonial vessels there is, for example, the Dogon's *Ancestors' dish*, also known as *The ark of the world* (fig.193). This was kept hidden away and taken out only once a year, for the winter solstice ceremony, which brought together all the family's blood relatives. The meat cut from the sacrificed beasts was placed in the dish before being shared out.

Although not strictly speaking a ceremonial dish, the *Baule mouse oracle* should be mentioned here. The finest known example is in the Musée de l'Homme in Paris (fig.194). Used for divining and preserved by a soothsayer, the dish is separated into two levels by a board with a hole in it. When a consultation was required the soothsayer shut a pair of mice into the lower part, having kept them without food. Over them he placed a tortoise-shell containing a small amount of millet and ten small sticks. As the mice ate the millet they moved the sticks and their fresh positions provided the soothsayer with the essence of his reply. The Baule believed that the mice were in communication with the spirit of the earth and the ancestors, and hence were aware of the future. The seated figure is serious and deep in meditation, and could be a representation of the soothsayer pondering on the correct interpretation of the signs. Only two mouse oracles of this type have been found throughout the world. This example is seen as one of the chief works of Baule statuary.

The decorative art of the Kuba, in Zaire, is remarkably rich and enhances all objects of daily life. These items are purely aesthetic and independent of all forms of worship - a characteristic which is very rare in Africa. The dignitaries

195 Anthropomorphic vase.
Zaire. Kuba. Wood. H: 25 cm. Private collection.

Left

193 Ceremonial dish.
Mali. Dogon. Hardwood, cut from a single piece. Length: 164 cm. Musée Barbier-Mueller, Geneva. This ancestors' dish or "Ark of the world" represents the Ark in which Nommo, the father of humankind, and the various gods of the Dogon pantheon (see chapter 5) came down to earth. The carved figures correspond to founding ancestors, their arms raised to pray for rain. The two handles of the dish recall the horse, Nommo's incarnation after the Ark had reached the earth.

194 Mouse oracle.
Ivory Coast. Baule. Wood,
terracotta, vegetable
fibres, leather and
untanned skin. H: 25 cm.
Musée de l'Homme, Paris.

who can afford to possess such objects are delighted and proud to do so. The love of the perfect form is evident in the various carved boxes which often belong to the Bushoong, the royal clan. The finest objects, however, are without doubt the effigy cups, in the shape of a human head or even a whole body. Certain *Anthropomorphic cups* (fig.195) have been seen as portraits, with the face idealised by the features drawn towards the temples and the judiciously placed abundance of geometrical ornaments. These items never suggest effort or repetition.

Far less prestigious, the vases made by the Mangbetu are none the less interesting in their very individual anthropomorphic style. The Museum Rietberg in Zurich, for example, has cylindrical *Boxes* (fig.196) made of bark. The boxes stand on human legs and have a head on top. They were designed to hold honey or the red *tukula* powder, which was said to have magical powers.

Headrests and fabrics

Known in Egypt from 3000 BC, headrests may have reached Black Africa via the Sudan, Ethiopia and Somalia. They have been found in great numbers in the River Congo basin. Luba headrests are complete carvings, full of the harmony which characterises the art of this culture (figs.197 and 153, p.165).

Headrests are relatively rare in west Africa, so it is all the more surprising to find them in Mali, in ancient tombs dating back to the Tellem occupation. The problems that this poses have not yet been resolved, but in one of them (fig.198) there is no mistaking the horse figure often represented in this culture.

Fabrics deserve an entire study of their own. Their colourful presence and the infinite variations of their decorative motifs create a contrast which offsets even the most austere of statues. As an example, in the former state of Dahomey there were the fabrics decorated by Abomey craftsmen with appliqué motifs which corresponded to writing. There were also the personal efforts of the Cameroon king Njoya to promote the manufacture of fabrics decorated with figurative or abstract motifs, which

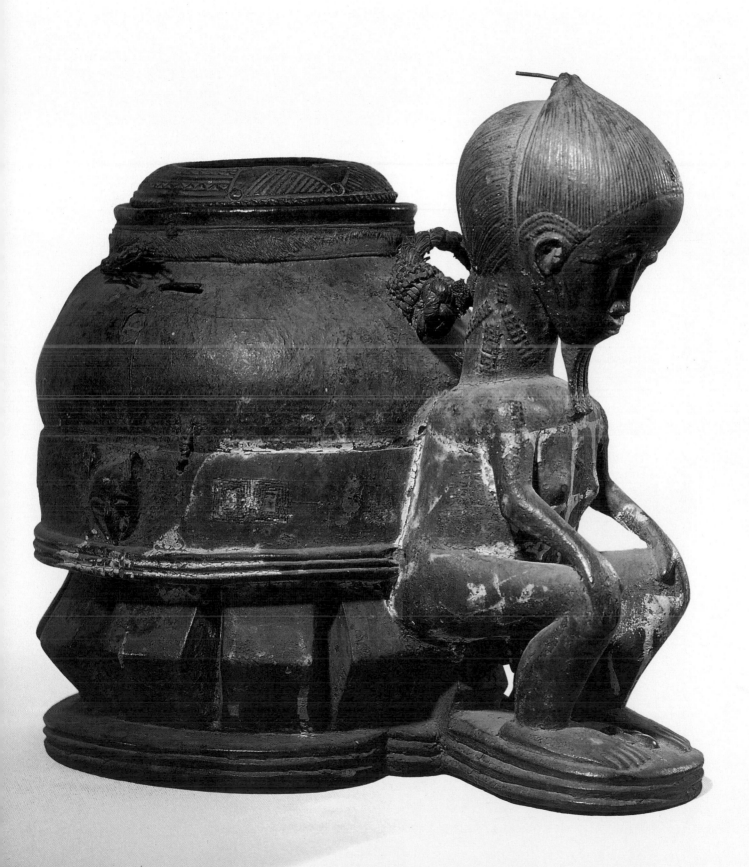

he would sometimes design himself. Above all there are the famous Kasai raffia velvets with their dark mono-chrome patterns and endless tracery (figs 199 and 200). The technique of indigo "tie-dyeing" is widely practised in Senegal, while coloured earths are used in Mali for the *bokolanfini* and in the Ivory Coast for the Korhogo fabrics. In Togo, finally, prestige loincloths are made of numerous bands assembled and decorated with square motifs.

This brief and incomplete study of the objects of Black African art reveals that most of the time they were the result of an aesthetic search. This search was concerned with food as well as sleep, from the past to the present day, and from the secular to the sacred.

196 Two containers.
Zaire, Zande or Mangbetu. Bark and wood. H: 69.4 cm. Museum Rietberg, Zurich.

197 Headrest.
Zaire. Luba. Ivory. H: 17 cm. Musée Dapper Archives, Paris.
The material chosen for this carving, a well-polished ivory, accentuates the gentle effect of Luba art.

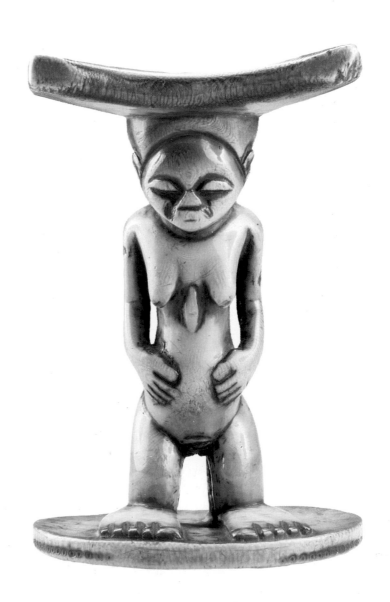

**201 Weaving-loom
pulley.**
Ivory Coast. Gouro.
Wood. Musée de
l'Homme, Paris.

Right

**202 Weaving-loom
pulley.**
Ivory Coast. Gouro.
Hardwood with brilliant
patina. H: 21 cm. Musée
Barbier-Mueller, Geneva.

198 Headrest.
Mali. Tellem. Wood. H: 14
cm. Musée Dapper
Archives, Paris.

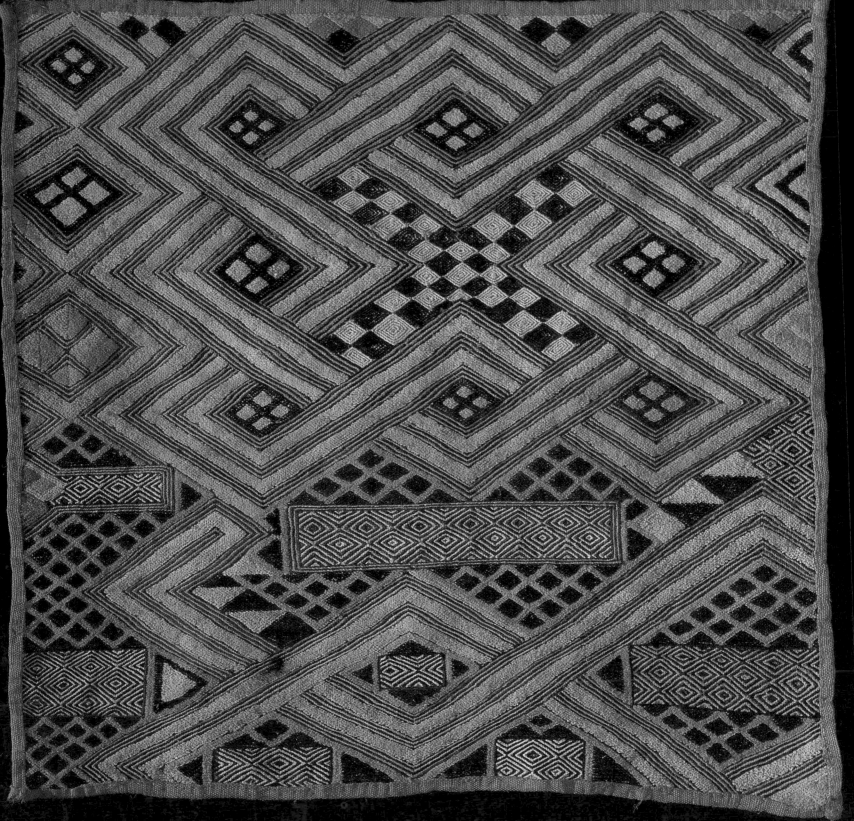

199 Kasai velvet.
Zaire. Raffia. Size: 66 x 59
cm. Musée Barbier-
Mueller, Geneva.

Left

200 Kasai velvet.
Zaire. Raffia. Size: 56 x 54
cm. Musée Barbier-
Mueller, Geneva.

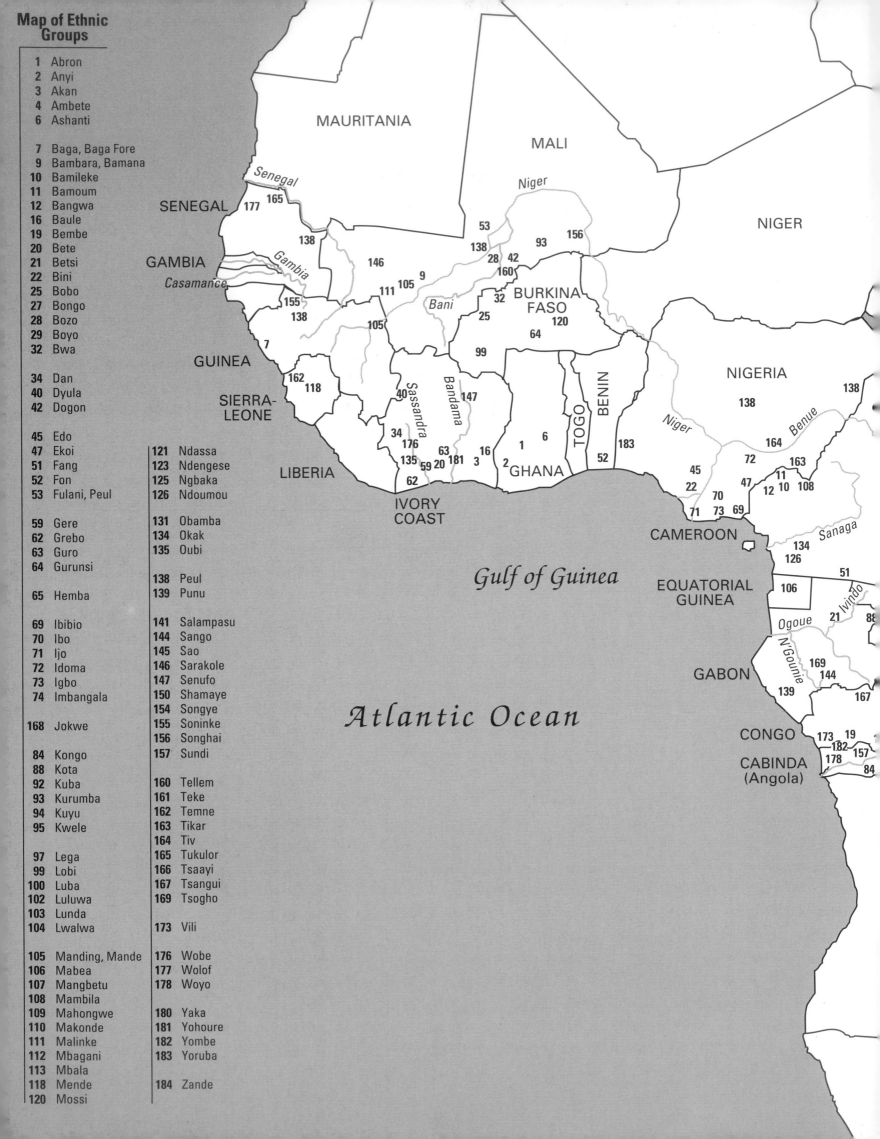

Map of Ethnic Groups

	
1	Abron
2	Anyi
3	Akan
4	Ambete
6	Ashanti
7	Baga, Baga Fore
9	Bambara, Bamana
10	Bamileke
11	Bamoum
12	Bangwa
16	Baule
19	Bembe
20	Bete
21	Betsi
22	Bini
25	Bobo
27	Bongo
28	Bozo
29	Boyo
32	Bwa
34	Dan
40	Dyula
42	Dogon
45	Edo
47	Ekoi
51	Fang
52	Fon
53	Fulani, Peul
59	Gere
62	Grebo
63	Guro
64	Gurunsi
65	Hemba
69	Ibibio
70	Ibo
71	Ijo
72	Idoma
73	Igbo
74	Imbangala
168	Jokwe
84	Kongo
88	Kota
92	Kuba
93	Kurumba
94	Kuyu
95	Kwele
97	Lega
99	Lobi
100	Luba
102	Luluwa
103	Lunda
104	Lwalwa
105	Manding, Mande
106	Mabea
107	Mangbetu
108	Mambila
109	Mahongwe
110	Makonde
111	Malinke
112	Mbagani
113	Mbala
118	Mende
120	Mossi
121	Ndassa
123	Ndengese
125	Ngbaka
126	Ndoumou
131	Obamba
134	Okak
135	Oubi
138	Peul
139	Punu
141	Salampasu
144	Sango
145	Sao
146	Sarakole
147	Senufo
150	Shamaye
154	Songye
155	Soninke
156	Songhai
157	Sundi
160	Tellem
161	Teke
162	Temne
163	Tikar
164	Tiv
165	Tukulor
166	Tsaayi
167	Tsangui
169	Tsogho
173	Vili
176	Wobe
177	Wolof
178	Woyo
180	Yaka
181	Yohoure
182	Yombe
183	Yoruba
184	Zande

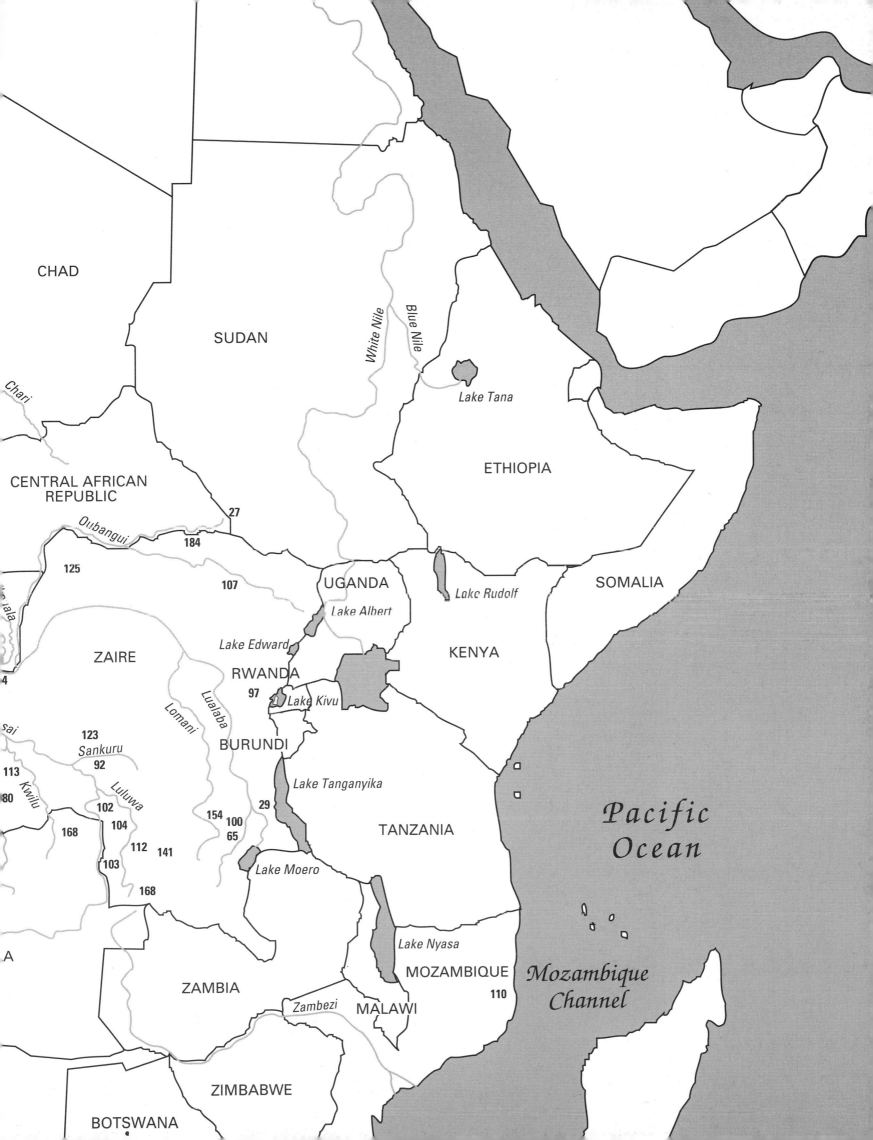

CHAD

SUDAN

Chari

CENTRAL AFRICAN
REPUBLIC

Oubangui

27

184

125

107

ZAIRE

Lomani

Lualaba

4

sai

123

Sankuru

92

113

Kwilu

80

102

Luluwa

168

104

103

112 141

168

White Nile

Blue Nile

Lake Tana

ETHIOPIA

UGANDA

Lake Albert

Lake Edward

RWANDA

97

Lake Kivu

BURUNDI

29

Lake Rudolf

SOMALIA

KENYA

Lake Tanganyika

154 100

65

TANZANIA

Lake Moero

ZAMBIA

Zambezi

MALAWI

Lake Nyasa

MOZAMBIQUE

110

Pacific
Ocean

Mozambique
Channel

ZIMBABWE

A

BOTSWANA

Index

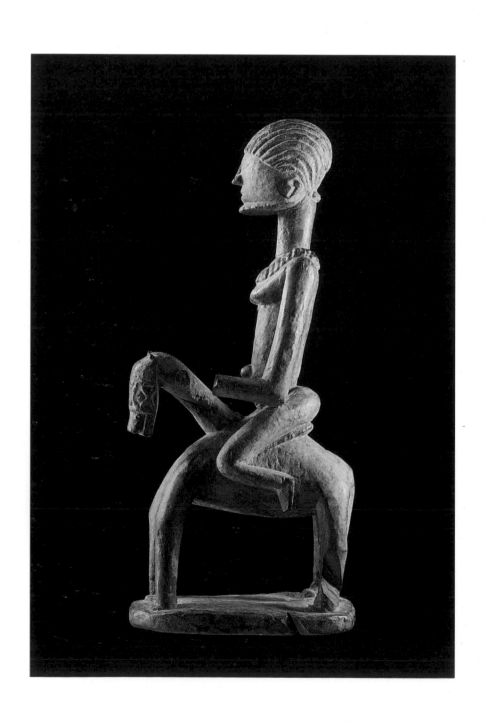

Bibliography

BALANDIER Georges, and others, *Dictionnaire des civilisations africaines*, Paris, 1968.

BALANDIER Georges, *Afrique ambiguë*, Paris, 1957.

BARBOT Jean, *Journal d'un voyage de traite en Guinée Cayenne et aux Antilles fait par Jean Barbot en 1678-1679*, Ed. G. Debien, M. Delafosse and G. Thilmans, Dakar 1979.

BARBOT Jean, *A Description of the Coasts of North and South Guinea*, London, 1732.

BASTIN Marie-Louise, *Introduction aux arts de l'Afrique noire*, Arnouville, 1984.

BASTIN Marie-Louise, *Art décoratif Tshokwe*, 2 vols., Lisbon, 1961.

BEN-AMOS Paula, *Bénin art*, London, 1979.

CORNET Joseph, FSC *Arts de l'Afrique noire au pays du fleuve Zaïre*, Brussels, 1972.

DAPPER Olfert, *Description de l'Afrique*, translated from the Flemish, Amsterdam, 1686. Reissued by the Musée Dapper, Paris, 1989.

DELANGE Jacqueline, *Arts et peuples de l'Afrique noire*, Paris, 1967.

DESCHAMPS Hubert, *L'Afrique noire précoloniale*, Coll. 'Que sais-je', Paris, 1976.

DESCHAMPS Hubert and others, *Histoire générale de l'Afrique noire de Madagascar et des archipels*, 2 vols., Paris 1970-71.

EZRA Kate, *Art of the Dogon*, The Metropolitan museum of Art, New York, 1988.

FAGG Bernard, *Nok Terracottas*, London, 1970.

FAGG William, *Divine Kingship in Africa*, British Museum Publications, London, 1970.

FAGG William and PICTON John, *The Potter's Art in Africa*, British Museum Publications, London, 1978.

FAGG William, *African Tribal Images*, Cleveland, Ohio, 1968.
FAGG William, *African Sculpture*, Washington D.C., 1970.
FEAU Etienne, *L'Art africain dans les collections publiques françaises*, in 'Antologia di Belle Arti' no.17, Rome, 1981.
FEAU Etienne, *L'Art africain dans les collections publiques de Poitou-Charente*, Angouleme, 1987.
GENEVA, Musée Barbier-Mueller, *Arts de l'Afrique noire*, Paris, 1988.
GENEVA, Musée Barbier-Mueller, *Gold of Africa*, Munich, 1989.
GRIAULE Marcel, *Les masques Dogon*, Paris, 1938. Reissued 1963.
GRUNNE Bernard de, *Terres cuites anciennes de l'ouest africain*, Louvain-la-Neuve, 1980.
HOLAS Bahumil, *Cultures matérielles de la Côte d'Ivoire*, Paris, 1960.
HOLAS Bahumil, *Masques ivoiriens*, Abidjan, 1969.
HOLAS Bahumil, *Sculptures ivoiriennes*, Abidjan, 1969.
KERCHACHE, J., PAUDRAT, J.L. and STEPHAN, L., *L'Art africain. Esthétiques et sculptures*, Paris, 1989.
LAUDE Jean, *Les arts de l'Afrique noire*, Paris, 1966.
LAUDE Jean, *La peinture française et l'art nègre*, Paris, 1968.
LEBEUF Jean-Paul and Annie, *Les Arts des Sao*, Paris, 1977.
LEIRIS Michel, *L'Afrique fantôme*, Paris, 1934. Reissued 1981.
LEIRIS Michel and DELANGE Jacqueline, *Afrique noire*, Paris, 1962.
LEUZINGER Elsy, *Afrique, l'art des peuples noirs*, Paris, 1962.
LEUZINGER Elsy, *African sculptures, a descriptive catalogue*, Museum Rietberg, Zurich, 1963.
MAQUET Jacques, *Les civilisations noires*, Paris, 1981.
NIANGORAN-BOUAH Georges, *L'univers Akan des poids à peser l'or*, 3 vols., Abidjan, 1984-1987.
NEYT François, *Arts traditionnels et histoire du Zaïre*, Brussels, 1981.
NEYT François and DESIRANT Andrée, *Les arts de la Bénoué*, Tielt, 1985.
NEYT François, *La grande statuaire Hemba du Zaïre*, Louvain, 1977.
NORTHERN Tamara, *The art of Cameroon*, Washington, 1984.
PARIS, Musée de l'Afrique et de l'Océanie, *Cameroun, art et architecture*, 1988.
PARIS, Orangerie des Tuileries, *Sculpture africaines dans les collections publiques françaises*, 1972.
PARIS, Musée d'Art moderne de la ville de Paris, *Masques et sculptures d'Afrique et d'Océanie*, Girardin Collection, 1986.
PARIS, Galeries nationales du Grand Palais, *Trésors de l'ancien Nigéria*, 1984.
PARIS, Galeries nationales du Grand Palais, *Chefs d'oeuvre de Côte d'Ivoire*, 1989.

PARIS, Numerous publications from the Musée Dapper, in particular:
Ouvertures sur l'art africain.
La voie des ancêtres, 1986.
Aethiopia, vestiges de gloire, 1987.
Art et Mythologie. Figures tshokwe, 1988.
Objets interdits, 1989, (with text by O. Dapper, *Description de l'Afrique*).
Supports de rêves, 1989.
Bénin, Trésor royal, 1990.
Cuillers sculptures, 1991.
PAULME Denise, *Les civilisations africaines*, Coll. 'Que sais-je?', Paris, 1980.
PAULME Denise, *Les sculptures de l'Afrique noire*, Paris, 1956.
PERROIS Louis, *La statuaire Fang du Gabon*, Paris, 1972.
PERROIS Louis, *Art du Gabon*, Paris, 1979.
PERROIS Louis, *Art ancestral du Gabon*, Musée Barbier-Mueller, Geneva, 1985.
SCHMALENBACH Werner, *Die Kunst Afrikas*, Basle, 1953.
SCHMALENBACH Werner and others, *Arts de l'Afrique noire*, Musée Barbier-Mueller, Geneva, 1988.
VOGEL Susan M., *African Aesthetics*, the Carlo Monzino Collection, New York, 1986.
WASSING René, *African Art, its background and traditions*, New York, 1988.
WILLETT Frank, *African Art*, London, 1971.

Journals
Arts d'Afrique noire, Arnouville, France.
African arts, Center of African Studies, UCLA, Los Angeles, USA.
Dossiers d'histoire et archéologie, 'L'art africain', no.130, Sept. 1988.
Archeologia, a journal with numerous articles on African art.
Art Tribal, Musée Barbier-Mueller, Geneva.

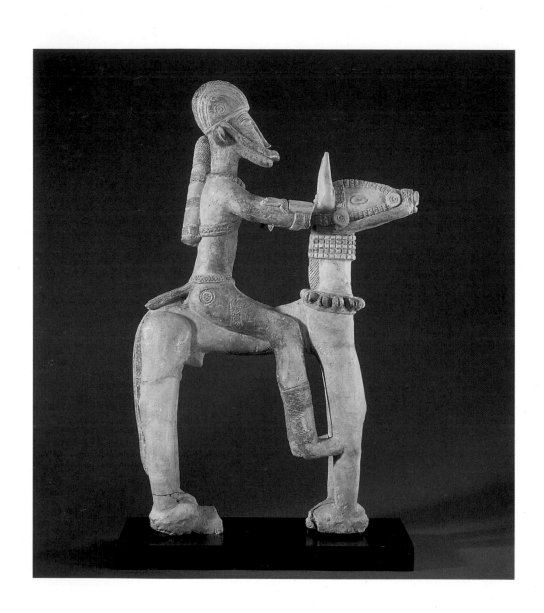

Acknowledgements

My warm and whole-hearted thanks to everyone whose help and encouragement have contributed to this book. Monsieur Jean-Paul Barbier, director of the Musée Barbier-Mueller in Geneva, and Madame Christiane Falgayrettes, director of the Musée Dapper in Paris, have generously read through the whole manuscript and given me the benefit of their suggestions. Madame Marie-Noël Verger-Fèvre, research assistant in the Department of Black Africa in the Musée de l'Homme, has provided similar help with the lengthy chapter on masks.

I have benefited from the exceptional generosity of Monsieur Jean-Paul Barbier concerning the use of photographs of many of his museum's items. Madame Christiane Falgayrettes allowed us to make use of her archive of photographs and Monsieur Louis Perrois, research director at the Office de la Recherche Scientifique et Technique Outre-Mer (ORSTOM), gave us the benefit of his fine land-survey photographs. I would also like to thank the collectors who kindly allowed us to take photographs of some of their finest pieces: Monsieur Dartevelle, Monsieur Marc Félix, Count Baudouin de Grunne and all those who asked to remain anonymous.

Madame Véronique de Fenoyl laboured long and hard to assemble the many slides, while the smiling efficiency of Madame Laurence Mattet was equally valuable.

Laure Meyer

Left

Horseman.
Mali. Niger Inland Delta.
Museum of African Art,
Washington.

223

Photo credits

Printed in Italy
by G. Canale & C. S.p.A.
Borgaro T.se (Turin)